ROME 1300

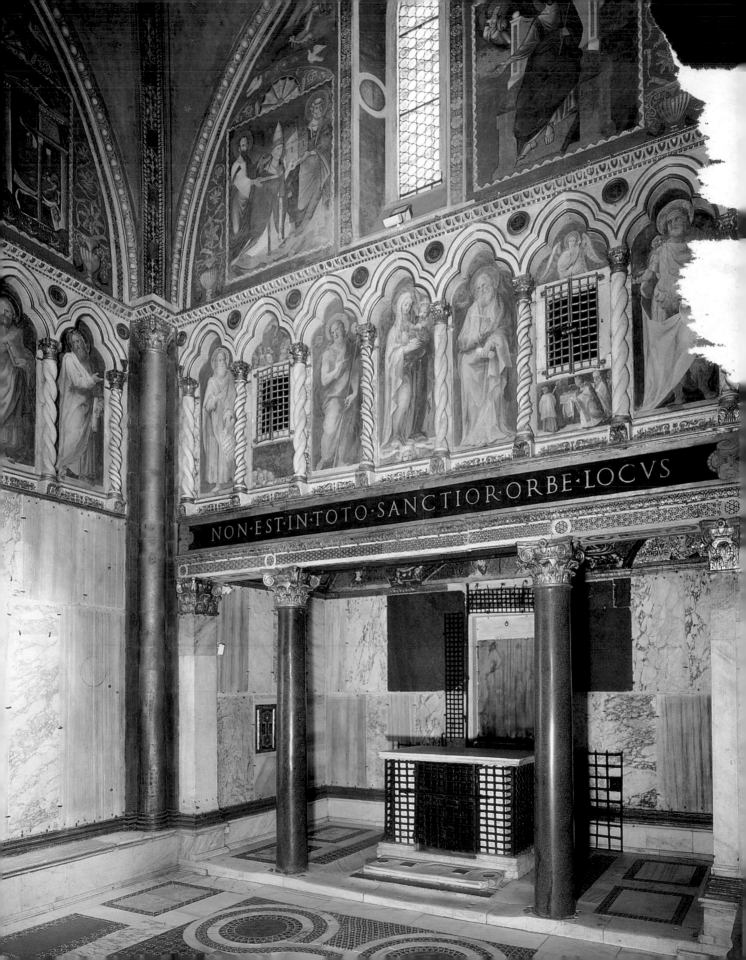

NON·EST·IN·TOTO·SANCTIOR·ORBE·LOCVS

ROME 1300

ON THE PATH OF THE PILGRIM

HERBERT L. KESSLER

JOHANNA ZACHARIAS

YALE UNIVERSITY PRESS New Haven and London

Frontispiece: Sancta Sanctorum, altar precinct.

Designed by Bessas & Ackerman
Set in Charlemagne and Galliard Oldstyle type by Bessas & Ackerman
Printed in Italy by Conti Tipocolor

Library of Congress Cataloging-in-Publication Data
Kessler, Herbert L., 1941–
 Rome 1300: on the path of the pilgrim/Herbert L. Kessler and Johanna Zacharias.
 p. cm.
 Includes bibliographical references and index.
 ISBN 0-300-08153-7 (hardcover: alk. paper)
 1. Art, Italian—Italy—Rome. 2. Christian art and symbolism—To 500—Italy—Rome. 3. Christian art and symbolism—Medieval, 500–1500—Italy—Rome. 4. Christian pilgrims and pilgrimages—Italy—Rome—Fiction. 5. Holy Year, 1300. 6. Rome (Italy)—Church history. 7. Rome (Italy)—Description and travel. 8. Rome (Italy)—Buildings, structures, etc. I. Zacharias, Johanna, 1942– II. Title.

N7952.R6 K48 2000
704.9'482'094563209023—dc21 99-058270

A catalogue record for this book is available from the British Library.

The paper in this book meets the guidelines for permanence and durability of the Committee on Production Guidelines for Book Longevity of the Council on Library Resources.

10 9 8 7 6 5 4 3 2 1

MKZ

SPQR

XOXOXO

CONTENTS

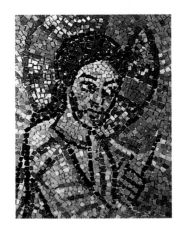

ACKNOWLEDGMENTS

This book grows out of the experience of three Americans living in Rome, Herbert Kessler, a historian of medieval art, Johanna Zacharias, a writer and editor, and their daughter, Morisa Kessler-Zacharias, a schoolgirl and then a university student. The happy fate of this trio was to spend some three years in the Eternal City between 1984 and 1997, and during that time, to explore the city with the guidance of many Rome-smitten scholar friends. Among those who helped us to probe Rome's historical depths were Franz Alto Bauer, Sible de Blaauw, Beat Brenk, Giorgio Filippi, Cristiana Filippini, Valentino Pace, Ursula Fischer Pace, Erik Thunø, Alessandro Tomei, and Gerhard Wolf. Others who preserve the city's treasures in museums and libraries were also extremely generous in their assistance, including the late Father Leonard Boyle, Giovanni Morello, and Arnold Nesselrath.

Acquiring photographs of Rome's monuments is not always an easy task. Franz Alto Bauer, Øystein Hjort, and Valentino Pace were exceptionally helpful in providing rare material. Cristiana Filippini and Alessandro Tomei made truly heroic efforts on our behalf; without them, illustrating this book would not have been possible.

The authors spent 1984–85 at the American Academy, where Herbert Kessler was the National Endowment for the Humanities Fellow. During 1996–97, they returned to the Bibliotheca Hertziana (Max-Planck-Institut), when Herbert Kessler was appointed to be the first Richard Krautheimer Guest Professor. The two great institutions that face each other across the heart of Rome provided resources for research and, even more important, communities of scholars who shared both knowledge of and excitement for Rome's extraordinary richness. Among these may colleagues and friends were Nicholas Bok, Carmella Franklin, Christoph Luitpold Frommel, Julian Gardner, Ingo Herklotz, Julian Kliemann, Klaus Krueger, Thomas Poepper, Brian Rose, Serena Romano, Rainer Stichel, and Matthias Winner.

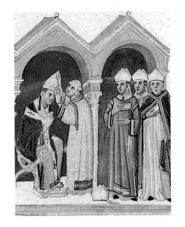

INTRODUCTION
JUBILEE AND PILGRIMAGE

Strange as it now seems, the first Jubilee year of the Christian Church appears to have come as something of a surprise to Pope Boniface VIII and his clerical counselors. Having noted an exceptionally heavy flow of pilgrim traffic to Rome in 1300, Boniface declared that year as the start of what was to become one of the Church's most spiritually important and politically and economically fortifying traditions, the Jubilee or Holy Year. To make the most of an opportunity to consolidate Christians' fidelity to their Church, on February 22, Boniface proclaimed 1300 to be a year in which plenary absolution—that is, forgiveness for a lifetime's sins—would be granted to all the faithful who made the trek to Rome.

Especially from the perspective of the new millennium of 2000, the motivation of an unprecedented influx of travelers to Rome in 1300 seems self-evident. Thirteen hundred was, after all, the start of a new century and, like 2000, a critical moment to prepare to confront the future on earth and beyond in a state of spiritual wholeness and cleanliness. To achieve that purity, one had to expunge from one's soul the taint of all past sins; pilgrimage to the sacred center of Christianity would achieve this purification. For everyone able to undertake a pilgrimage, then, this was the time to do it.

But in 1300, the actual heart of Christianity, the Holy Land of Christ's birth, had long since lain in the hands of Muslims, not Christians or even Jews. So, as a goal of Christian pilgrimage, Jerusalem was not easily accessible. Although there were other holy destinations where Christians, especially those on the European continent, could hope to unburden themselves of a lifetime's wrongdoing, Rome

was the ideal alternative to the Levantine Holy Land. Except for Palestine, no place had figured so centrally in Christian history, nor had so many sainted martyrs lived and died anywhere else.

Origins of the Christian Jubilee

Though new in Christian vocabulary in the thirteenth century, the concept of the Jubilee, like Christianity itself, had ancient roots in Judaism. Indeed, the very word *Jubilee* has a Hebrew root. According to the Jewish creed, the earth, like humankind following God's example, had an imperative need for regular bodily rest and spiritual cleansing. For humankind, repose and purification were required on every seventh day. The earth, of course, could not follow the same weekly cycle. Nor could the natural growing cycle that an agrarian people depended on permit the land to lie unworked every seventh week or month.

The alternative of a year's rest one year out of every seven was physically possible for the earth but economically impossible for humans. The early Jews could ill afford to allow their herds to wander and their fields to lie fallow every seventh year. Moreover, since the rectifying custom arose, on every Jubilee, to restore all appropriated property to its rightful, original owner—which included liberating slaves—a one-year-in-seven timetable would be disruptive at best and a cause of bitter feuding and outright aggression at worst. A cycle of seven times seven was therefore instituted, with a year of rest for the earth after every cycle of forty-nine—that is, every fiftieth year.

For Pope Boniface, whose papacy spanned the turn of a new century, a one-hundred-year period (that is, twice fifty) seemed fitting for a Christian Jubilee cycle. The pontiff, once he recognized the opportunity that was presenting itself to him, therefore decreed that Jubilees would be celebrated at the start of each new century. (Later, it was noted that the ninety-nine-year span between Jubilees, being far longer than practically anyone could expect to live, would deprive a great many Christians of the opportunity to seek a Jubilee year's plenary absolution in Rome and would thus consign most Christians to an afterlife of agony. The cycle was therefore shortened to the original fifty years of the Jewish Jubilee. Later still, it was halved again, to occur every quarter-century, which timetable the Vatican continues to follow today.)

The response to Pope Boniface's offer of pardon was overwhelming. On short order, Rome turned itself into a hostel for and provisioner to hordes of the faithful from all corners of Christendom's vast spiritual empire. According to the eyewitness chronicler Giovanni Villani, a Florentine, pilgrims to Rome numbered two hundred thousand on any one day (the great Dante Alighieri, a fellow Florentine, was among them). At times, pedestrian traffic became so great as to be hazardous, and there were reports of trampling where thoroughfares

narrowed, as they did on a bridge over the Tiber River on the road to the supremely holy church where the bones of St. Peter lay.

For reasons of history as well as spirituality, the timing of the first Jubilee year could hardly have been more opportune. In 1300, Rome had been a Christian city for just a dozen short years shy of a millennium. Although the practice of Christianity had in fact begun before the conversion of the Emperor Constantine in 312, the capital of the pagan empire began evolving into a material expression of faith in Christ with the Edict of Milan in 313. From that moment on, Christian worship and the desire to teach and consolidate faith shaped the form, provided the content, and inspired the splendor of all things made for public use—churches, mostly, and the paintings, mosaics, carvings, and inscriptions that decorated them.

In the year 1300, hundreds of churches stood in Rome, many serving particular groups, various orders of monks and nuns, for instance, or foreigners residing in the city or just visiting. These were governed by the bishop of Rome, called by the Latin word for "father," *papa,* or "pope." For centuries, popes had taken the title Pontifex Maximus, Supreme Pontiff, the ancient epithet of the city's chief pagan priest; and they perpetuated the myth that they presided over a single community of faithful, moving from church to church to say Mass in what was known as the *stational liturgy.* With the removal of the imperial residence to Constantinople, moreover, the popes had assumed powers over Rome and its surroundings that previously the emperors alone had exercised, and steadily they also assumed the accouterments of secular rulers and the lavish surroundings of royal courts.

Boniface VIII was one of the most extraordinary occupants of the throne of St. Peter, and one of the most imperious. Although he was a canon lawyer and the promulgator of the Holy Year, his principal concerns were with property, and his most intense engagements, battles with rival aristocrats, the Colonna of Rome and the French king, over issues of taxation and the like. Boniface's elevation to the papacy in 1294, moreover, had been contested and had followed years of an interregnum and the resignation of his immediate predecessor, Celestine V. A need for legitimacy, therefore, shadowed his pontificate and reinforced his inclination to muster the attractiveness and power of authentification of art and ceremony (fig. 1). He added a coronet to the papal tiara and had himself portrayed more often than had any of his predecessors, especially favoring sculpted effigies, a taste that provoked his archenemy, Philip the Fair of France, to accuse him of idolatry.

Scope and Approach of the Book

Using as a pretext destinations on the path that a hypothetical pilgrim in the first Jubilee year might have taken, this book presents some of the significant

1

Page from *De Coronatione* by Jacopo Stefaneschi. Written in 1299 by Boniface VIII's nephew, the manuscript describes and illustrates the pope's investiture on 25 January 1295. Stefaneschi himself, who was Cardinal Deacon of Rome's S. Giorgio in Velabro, is shown here replacing Benedict Caetani's bishop's miter (at Stefaneschi's feet) with the papal tiara; the new Pope Boniface wears the papal pallium and red cloak and sits on a *sella curulis*, the lion-headed folding chair that since Roman times symbolized secular power. At the right, Celestine V, who had recently abdicated, begins the journey from St. Peter's, where the enthronement took place, to the Lateran, where his successor would appear before the people (see figs. 27 and 28). Though he is leaving the papacy, Celestine is still honored by the ceremonial umbrella, another ancient emblem of secular authority, and is preceded by the *ferula*, or papal cross-staff. (BAV [Biblioteca Apostolica Vaticana], Cod. Vat. Lat. 4933, fol. 7v.)

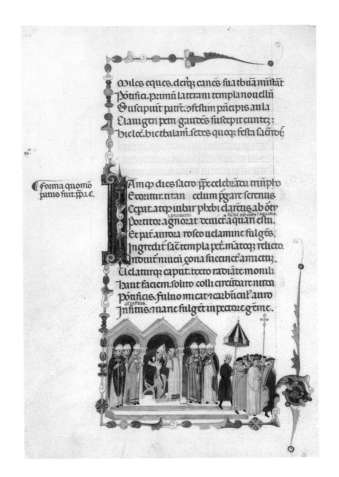

sites of Rome as they appeared at the end of the Middle Ages. For modern pilgrims retracing their forebears' steps through Rome, many of the monuments and much of their dazzling art still survive and make appropriate destinations for travelers in the Holy Year 2000 and thereafter. Others, though damaged or destroyed, can be reconstituted through fragments, copies, and written descriptions. Until now, Rome's medieval masterworks have been treated mostly as markers on art-historical timelines and examined in isolation. In fact, however, the paintings, sculptures, metalwork, icons, saints' relics, and classical remains, as well as the sacred buildings that did and still do house them, worked together in the city's religious life. Even within a single structure, many components were separated from one another by centuries as it were, responding with one another and with the ceremonies conducted nearby. Sacred geography and function, and not chronology, iconography, style, or medium, are therefore the guiding factors in the book's focus and organization.

The text begins at the Lateran (Chapter 1), with the Patriarchium, or principal palace, of the medieval papacy, which functioned as the Vatican does today. It

surveys the emblems of the papacy once arrayed there and sets the stage for the beginning of the papal procession to the basilica of Sta. Maria Maggiore undertaken on the eve of every August 15, the Feast of the Assumption of the Virgin. It then takes the reader into the private chapel of the popes (Chapter 2), the Sancta Sanctorum, a jewel box of resplendent architecture, frescoes, and mosaics that was brand new at the time of the first Jubilee and that has been newly restored for the Holy Year of 2000. Chapter 3 follows the start of the papal procession from the Lateran through the church of S. Clemente, with its twelfth-century mosaics rich in both material splendor and intellectual complexity. And Chapter 4 continues along the route, through the ancient Roman Forum—which in 1300 still played a significant role in Rome's civic life, but now a Christian one—to end with a long pause in the church of Sta. Prassede, a remarkable witness to the revival of Roman art during the age of Charlemagne. In Chapter 5, the annual meeting of the Lateran icon of Christ with the icon of the Virgin at Sta. Maria Maggiore provides the context for describing the fifth-century church on the Esquiline Hill, with its extraordinary Early Christian biblical mosaics and exquisite thirteenth-century depiction of the Coronation of the Virgin, as well as the charming Adoration scene sculpted by Arnolfo di Cambio. The final chapter, Chapter 6, re-creates the culmination of any Holy Year pilgrim's journey, visits to the twin basilicas of St. Paul's Outside the Walls and St. Peter's at the Vatican.

From the standpoint of the student of history, the first Jubilee year by chance offers an ideal perspective from which to look at Rome and its holy sites. Not only was the Christian imprint on Rome deep and all-pervasive in 1300 but a phase of history was also on the brink of ending. Nine years later, the papacy quit Italy altogether, to be established for almost seventy years at Avignon in France (the so-called Babylonian Captivity). Thus, the full evolution of Christianity and the art it stimulated in Rome—from the Early Christian period almost to the very end of the High Middle Ages—is fully summarized in the Rome of the first Jubilee year. What emerged after the reestablishment of the papacy in the city after 1377 was entirely different; what followed was Renaissance Rome.

Authors' premise. The selection of material treated in the book is defined by what pilgrims of the first Jubilee encountered and were prompted to contemplate. Nothing unknown in 1300 is considered, and of course, everything from later falls outside the purview of the book. (With respect to two works—the facade mosaics of Sta. Maria Maggiore and the *Navicella*—the earlier dating has been assumed.) In presenting pictures, the accretion of later fabrications and modern life cannot be entirely avoided or concealed. Indeed, one of the most remarkable and compelling features of Rome is its continuous occupation since Antiquity. At the time of Christ's birth, the city was the capital of a vast empire; as the seat of Roman Catholicism, it retains its central importance to this day. For this reason, as anyone who knows the Eternal City firsthand or has just leafed through a picture book of its sites is aware, each trace from any one period

is embedded in the handiwork of earlier phases and encrusted with what subsequent time has laid over it.

Successive generations of Romans deployed the remnants of the city's past with purpose. If Christians at first shunned the mighty remnants of ancient Rome because of their negative connotations, they soon realized the advantage—both practical and symbolic—of converting the pagan *spolia* (literally "spoils") for Christian purposes. Medieval works, in turn, while sometimes enduring dismissive treatment in the hands of Renaissance and later artists, took on symbolism of their own. In the period following the Protestant Reformation in the sixteenth century, especially, and again during the spiritual revival during the nineteenth, medieval monuments were treated with respect as vestiges of the Church's early dominance. One result of these vacillations in attitudes is that, although many Early Christian and medieval works were destroyed during the Renaissance—most notably Constantine's great basilica of St. Peter—even more are oddly embedded in stylistically ill-fitting settings, products of Counter-Reformation attempts to preserve and reframe the remnants of the Church's glorious past. In turn, historicist attitudes and principles of restoration of works of "art" during the twentieth century often stripped medieval objects of what was imposed on them in later periods and hence of their afterlife. The Sancta Sanctorum (Chapter 2) is a perfect example. Extensively repainted during the sixteenth-century Counter-Reformation and largely intact through the nineteenth, it was deprived of its precious reliquaries a hundred years ago, when its treasury was removed and put on display in the Vatican Museum. The chapel was restored to its thirteenth-century state (to the extent possible) only in the late twentieth century, when its great icon and magnificent frescoes and mosaics were freed of overpainting and centuries of accumulated grime.

Virtually every monument presented in this book, therefore, has a complicated history of creation, use, modification, and restoration. Austere medieval icons today are anomalously clad in Baroque frames atop ornate nineteenth-century altars; what remains of the medieval facade mosaics of Sta. Maria Maggiore, for instance, is obscured behind Ferdinand Fuga's grandiose rococo loggia (Chapter 5). Much of medieval Rome survives today, but to view it, the modern visitor must be able to see through layers of history and past obscuring additions.

About medieval "art." The reader will note that, although this is a book of art history, the word "art" occurs only rarely and "artist" even less. The reason for what some readers may find an idiosyncrasy is that these words, connoting personal originality, imagination, and self-expression, do not apply directly to the medieval period, at least not until the thirteenth century, when a few makers' names and reputations actually do emerge. Before that, most mosaicists, fresco painters, sculptors, and architects worked as craft persons, executing jobs assigned to them by religious and lay patrons. When a handful of artists begins to emerge by name—Jacopo Torriti, Arnolfo di Cambio, and a very few others—

this in itself signals a major shift in the system of art production that marks the end of the Middle Ages and the dawn of the Renaissance. Thus, Giotto di Bondone, who worked in Rome for Boniface VIII and whose *Navicella* in St. Peter's ends this book, can be considered either as a medieval artisan working within craft traditions or as the first Renaissance artist creating entirely new forms and compositions. Moreover, medieval "art" was not intended merely to give pleasure. Rather, it was primarily a device to attract, teach, and confirm belief. And as often as not, the work itself lacks the unity and integrity modern viewers expect in art, combining media, fragments of earlier objects, and texts, and frequently fully understandable only within its original ceremonial context.

Narrative device. Both to propel the discussion from place to place and to give a human, not just scholarly, view of how a devout Christian from far away experienced the Holy City in 1300, we have invented for the text of the book a hypothetical pilgrim. It is by peering over this imagined person's shoulder that we, the authors, and you, the reader, see and, we hope, are affected by Rome of 1300. Because the book deals with art and history, however, and not with human drama, we have given our pilgrim no name. As many women as men made the pilgrimage to Rome in 1300, and we have arbitrarily envisioned our pilgrim to be a woman. (In fact, one of early Christianity's most important pilgrims was a woman; Helena, mother of Constantine, traveled to the Holy Land in search of the True Cross, and many others followed her.) The present of our imagined pilgrim of 1300 is the present of the book's text.

Our imagined traveler comes from someplace south or southeast of Rome, probably by way of the via Appia. Admittedly, this was a far less common approach than by the northern via Francigena; but travelers from southern Italy, Sicily, Spain, and the eastern Mediterranean did indeed approach Rome from the south. We selected this point of entry because it permits the discussion to begin at the Lateran, then Rome's center of religious and administrative power.

Our pilgrim is literate and has therefore studied up a bit on what she has come to Rome to see. We have placed in her hands a guidebook, the *Graphia Aureae Urbis Romae*, an updated version of the twelfth-century classic guidebook known as the *Mirabilia Urbis Romae* (fig. 2). The *Graphia* offers her only a heterogeneous inventory of sights to see in Rome, however, freely mingling points of interest from pagan Antiquity with those of primary concern to the pious Christian traveler.

We have timed our hypothetical pilgrim's journey to place her—like many modern counterparts—in Rome at the height of summer. This allows us, as we follow her, to witness the extraordinary rites celebrated before and on the August feast day of the Assumption of the Virgin. These rites, leading to a symbolic reunion of Son and Mother that takes all the faithful in Rome, the pope included, through the heart of the city, enliven the monuments and reveal how

2

An opening of a manuscript of the *Mirabilia Urbis Romae*. A twelfth-century manuscript of the standard guidebook to Rome, with marginal annotations attesting to centuries of use. (BAV, Cod. Vat. Lat. 3973, fols. 1v–2r.)

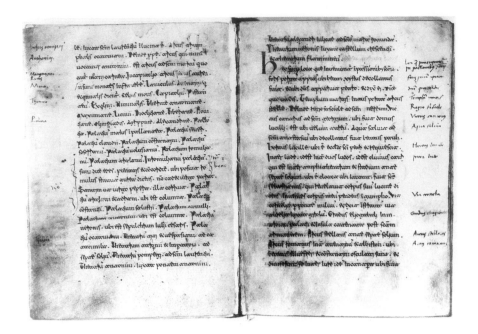

art and ceremony were constructed in the Middle Ages to dramatize that the pope was Christ's vicar on earth and that Rome was an image of the Heavenly Jerusalem.

Our pilgrim does not travel alone but, most likely, in a group that waxes and wanes as it progresses. Solitary travel would have been imprudent; to peddlers, beggars, and petty thieves along the roadside and on the periphery of most church complexes, a wave of pilgrims was in 1300 (as it can be today) a vein of gold ready to be mined. In reality, in a place as crowded as Rome in the first Jubilee year, travel in solitude would actually be impossible. In following our pilgrim, we can see that, like the relationship to God, her experience is appropriately individual and, at times, deeply emotional.

We have based our description of that experience on available written sources as well as on our imagination. Just as we have consulted numerous texts to flesh out aspects of the monuments that are now destroyed, we have informed ourselves wherever possible from contemporary documents about the ceremonies, events, and reactions.

Although our hypothetical pilgrim determines the subject matter and perspective of understanding of the book's narrative, the same strict limits do not apply to the illustration captions. Besides identifying what is pictured, the accompanying text is meant to provide information that fills in the context of the central subject matter. To avoid adding yet a third viewpoint to our text, the book has no notes. The sources on which it depends are, instead, listed in a thorough bibliography with sources for each chapter.

1

THE PAPAL PRECINCT
AT THE LATERAN

For the pilgrim of the first Jubilee approaching Rome from the southeast, the primary seat of the papacy itself at the Lateran makes a compelling destination. This is the site of the cathedral of Rome and of the principal residence of the bishops of Rome. To arrive there, the traveler must follow a course that passes sites of immense importance and antiquity, both pagan and Christian, through which more than a millennium of transformation of religion and rule can be read. During the several decades immediately preceding the first Jubilee, moreover, Rome has been the object of many popes' urges to beautify their city and its holy places. As Rome's governors, the popes bear the responsibility once carried by the pagan emperors for civic functions and edifices. In contrast to their imperial predecessors' patronage of public works, the popes' attention has been intended not merely to earn a place in the hearts of Rome's citizens and histories but to secure entrance into heaven as well.

The southeastern sector of the city, where remnants of pagan imperial grandeur still loom especially large, has benefited particularly from papal ambitions to leave lavish and lasting imprints on Rome. The incumbent pope, Boniface VIII (1294–1303), has already made an architectural mark by constructing, high overhead on a prominent wall of the papal palace, an open balcony from which to present himself before his followers. Thus, the pilgrim who heads first for the papal precinct will hardly have arrived within the walls of Rome before the sacred city begins to satisfy the quest for the historical and the holy.

The guidebook the pilgrim carries, the *Graphia Aureae Urbis Romae,* is gener-

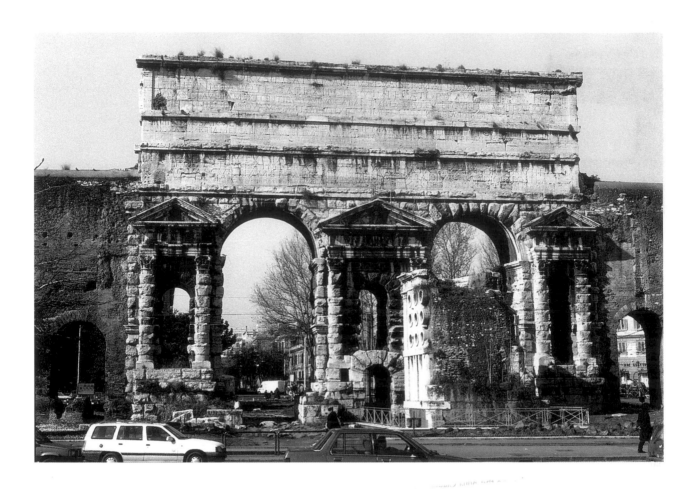

3
Porta Maggiore. Directly in front of one of Rome's principal gateways, here seen from outside the city wall, is the first-century B.C.E. tomb of the baker Marcus Vergilius Eurysacius. Since ancient times, Roman law required that all burials be located outside the city walls.

ous on what to see and why, but it contains no maps or advice on routes. Fortunately, however, in the Jubilee year, the roads to and within Rome are carrying unusually heavy pedestrian traffic, so numerous fellow pilgrims are at hand for consultation. And once the traveler is within the city, Rome itself provides guidance.

Entry into the Eternal City

Entry at the Porta Praenestina, also popularly called the Porta Maggiore (fig. 3) while situating the pilgrim well to reach the Lateran, provides an introduction to Rome that is rewarding in other respects as well. Located at the convergence of the via Praenestina and the via Labicana, two of the ancient thoroughfares that lead to the city, the Porta Maggiore is one of the portals that the *Graphia* lists. This and the other gates that breach the massive wall built by the Emperor Aurelian (215–75) late in the third century give Rome defensible access from all directions. Although the city has numerous portals, the *Graphia* names twelve, which, by no accident, is the number traditionally ascribed to the gates of Jerusalem and, in turn, to the Heavenly Jerusalem, of which Rome has been considered a

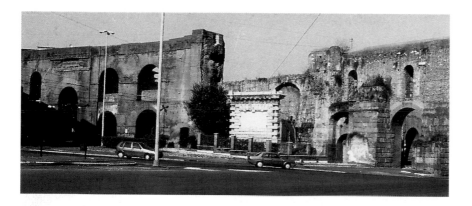

4

Aurelian Wall. From within the city at the Porta Maggiore, various stages of building and maintenance are evident, including the large arches at the right introduced in the twentieth century to allow passage of modern traffic.

replica. Elegantly lettered inscriptions carved into the attic story above the gate's twin-arched opening proclaim the succession of emperors who built and maintained this portal: Claudius (41–54), Vespasian (69–79), and Honorius (395–423).

The Porta Maggiore actually comprises two arches of one of Rome's principal civic works, the aqueduct known as the Aqua Claudia, completed in 52 C.E. to bring water some forty-five miles from the mountains southeast of the city. Two centuries later, Aurelian incorporated the aqueduct into his wall, so that traffic now flows below while water courses along a trough above (fig. 4). At the time of the first Jubilee, the Aqua Claudia is kept up largely to serve the religious and secular needs of the papal complex at the Lateran. Indeed, were it not for the Lateran—which stands quite alone in what has become a mostly vacant part of the city—the aqueduct might have been left to fall into ruins. Still functioning as a water conveyor in 1300, the Aqua Claudia happens also to serve visitors to Rome as an essential navigational guide within the city, where it is again separate from the Aurelian wall. It thus figures prominently in the few, still-rare attempts to map the city (fig. 5).

Even before passing under the Porta Maggiore, our pilgrim has parted ways with the many others who have detoured to pray at the church of St. Lawrence Outside the Walls (San Lorenzo fuori le mura). The bell tower at the Lateran church, which can be seen from inside the Porta Maggiore, serves as a beacon for the traveler who would stay on course for the papal precinct, for there one can witness the start of the Assumption Day procession that will begin this evening (see Chapters 3 and 4). Although she is missing St. Lawrence's, the Lateran-bound pilgrim will have the opportunity to offer a prayer instead at the important church of the Holy Cross in Jerusalem (Sta. Croce in Gerusalemme), which stands virtually midway between the Porta Maggiore and the first major objective within the city, the Lateran.

Legend explains the name of this sacred site. Founded by the Empress Helena (c. 255–c. 330), the church was established to shelter relics of the cross on which Christ was crucified that the empress had brought back from the Holy

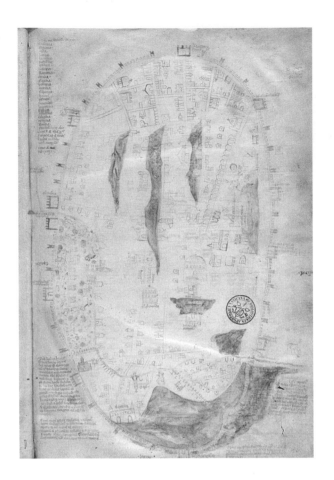

5
Map of Rome inserted into Paolino
Veneto's *Chronologia Magna,* 1330–40.
Made three decades after the pilgrim's
visit, this tinted drawing is one of two
exemplars (the other is a slightly earlier
version in Venice, Biblioteca Nazionale
Marciana, Ms. Lat. Z. 399, fol. 98r) that
reflect an effort to show the city more or
less as it was in 1300. The Porta Maggiore
is at the top of the page, the Vatican at
the left, and the Lateran at the right. Des-
ignated by twenty-two arches, the Aqua
Claudia is shown running from the
church of the Holy Cross (Sta. Croce in
Gerusalemme) to the Colosseum, which
is depicted as standing at the center of the
city. (BAV, Cod. Vat. Lat. 1960, fol. 270v.)

Land to Rome. Tradition holds that Helena herself had unearthed the True
Cross. Although she sought an appropriate memorial for the portions of it that
she kept for Rome, Helena also wished not to offend her still mostly pagan
neighbors with too ostentatious a Christian edifice. She therefore simply con-
verted a large hall in her palace into a church by building an apse onto one end
and introducing an entrance at the other. Indeed, except for a bell tower added
less than two centuries before the first Jubilee, the church of the Holy Cross still
hardly looks from the outside like a church at all (fig. 6). Hordes of pilgrims
have stopped beneath the apse to pray in the chapel of Helena.

From here, the Aqua Claudia guides the way to the Lateran.

Approaching the Papal Precinct

From the doorway of Helena's church, little other than trees and the arches of
the aqueduct interferes with a plain view of the Lateran. The great papal resi-
dence may appear a bit closer than it is, because it stands on high ground.
Although well within the walls of the ancient city, farmland now blankets the

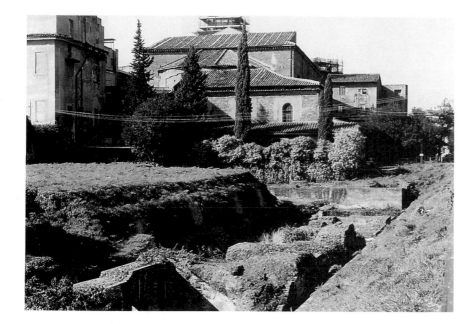

terrain on the way, most of the fields maintained to sustain the pope and the army of clergy and laymen that staffs the palace complex. To avoid treading on cultivated fields, the pilgrim must pass back under the Aqua Claudia and then follow its course toward the Lateran.

Like so much on the pilgrim's path, the Lateran complex has deep, now largely invisible roots in pre-Christian Rome. At one time, a mansion stood here that was the property of a patrician Roman family, the Laterani, whose members were intimates of several emperors and foes of others. By 65 C.E., the Emperor Nero had appropriated the property from Plautus Lateranus, whom he suspected of plotting against him. During the second century, the rich house had given way to barracks of the *equites singulares,* the emperor's mounted bodyguards, and lodgings for the commander. At about the same time, a matriarch called Domitia Lucilla owned a vast property further north. There, her son, who was to become the great emperor Marcus Aurelius (161–80), had spent his youth amid baths and nymphea fed by the aqueduct built by Claudius. By the time of the first Jubilee, however, little remains of the Roman Laterani besides their name, and of their aristocratic neighbors even less survives.

Christianization of the Lateran. For nearly a millennium now, the Lateran has stood at the center of Roman Christianity, for it was here that, overnight, an imperial property was ceded to Rome's Church. Upon his conversion to Christianity in 312, the Emperor Constantine (306–37) deeded the Lateran to the bishop of Rome, Pope Miltiades (311–14). To make space on the site for a grand church to be dedicated to the Savior, Constantine leveled the cavalry barracks—that is, those of the very troops he had routed in 312 in his battle at the Milvian

Bridge against his rival, Maxentius (306–12). The demolished barracks walls provided the church's foundations. What better symbol of Christianity's victory over the old pagan order?

When, in 324, he founded Constantinople—a "new Rome" at the site of the Greek city of Byzantium on the Bosphorus—Constantine left a vacuum of temporal governance in the old city that popes gradually filled. Since the departure of the imperial court, the bishops of Rome have acquired not only the property but also, increasingly, the attributes and responsibilities that had been the prerogatives of the city's pagan rulers. By the sixth century, they had begun to act as chief city administrators. And after shaking off Byzantine control—that is, governance from Constantinople—during the eighth century, they secured the protection of the Frankish kings seated in Gaul. The famous *Donation of Constantine* (*Constitutum Constantini*) dates from that time (752–57), and not from the fourth century as it purports. This fabricated record reports that the Emperor Constantine conferred sovereignty over Rome, all Italy, several Eastern patriarchates, and the empire's Western regions on Pope Miltiades' successor, Sylvester (314–33), who had effected Constantine's deathbed baptism. Though it in fact reflects the aspirations of a much later time, it has long legitimated papal authority over the city and its surrounds. It was in the second half of the eighth century, too, and as a part of the same set of ambitions, that the popes began to reshape the Lateran palace in imitation of imperial palaces. What the pilgrim sees beyond the great ancient aqueduct, then, is nearly one thousand years' building and rebuilding that established and confirmed the papacy as the dominant political power over all Rome.

The public center of the papal court. The Aqua Claudia leading to the Lateran demarcates a courtyard along the church's right (north) flank, the campus Lateranensis. This boisterous meeting place at the convergence of the Celian Hill (Caelimontana), the via Tusculana, and the via Asinaria has evolved as the center of papal court life (fig. 7). The *campus* is a wholly changed place from what it was in the time of Constantine's and Sylvester's Lateran. Over the course of a millennium, the remarkable spiritual and political evolution of Christianity has carved, in stone and bronze, an animated profile into what once was a relatively quiet zone of noble and royal residences.

The church of St. John. The great basilica at the Lateran, which has been visible to the pilgrim from quite some distance, dominates the skyline of the complex. The Lateran church is known variously as the Basilica Constantiniana, Basilica Salvatoris, and San Giovanni in Laterano (St. John Lateran). The names bear witness to the church's history. Founded soon after Constantine's triumph over Maxentius, it may, in fact, have been an ex-voto—an offering of thanks to God for the victory. At the start, the church was dedicated to Christ the Savior, in whose name Constantine carried the battle. By six hundred years later, however, the church had been renamed for St. John; whether for St. John the Bap-

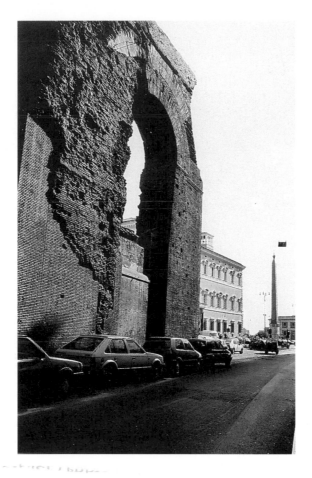

7

Aqua Claudia and campus Lateranensis. During the Middle Ages, the Aqueduct of Claudius (foreground) not only furnished water to the Lateran complex but also formed the precinct's northern boundary. Visible here beyond the aqueduct are the Palace of Pope Sixtus V (1585–90), the Obelisk of Tuthmos III and IV, formerly in the Circus Maximus, and, in the distance, the hospital of the Holy Savior.

tist, St. John the Evangelist, or (as eventually) for both, is uncertain. Relics of the two Johns are housed here.

At the time the church was constructed, Christianity offered no precedent or example for its design. Indeed, the evolution of Christian architecture begins with St. John's. Until Constantine instituted Christianity as the imperial religion and transferred to it the emperor's prestige and property, Christians throughout the empire and even in its capital worshiped in modest "house churches." These were mere domestic buildings adapted for use as places of Christian worship by the introduction of minimal accouterments, such as a pulpit or altar. After 312, however, the empire had need for church buildings of sufficient capacity to hold the swelling ranks of the community and suitable to the status of the official religion. Rejecting pagan temples as inappropriate for both practical and ideological reasons, Constantine's architects, perhaps in consultation with Church authorities, chose a well-established building type as a pattern for Christianity's nuclear church: the basilica. This was a generic structure consisting of a rectangular hall entered on one of the short sides and sometimes focused on an exedra (apse) at the opposite end. In the Basilica Constantiniana, the bishop's throne was

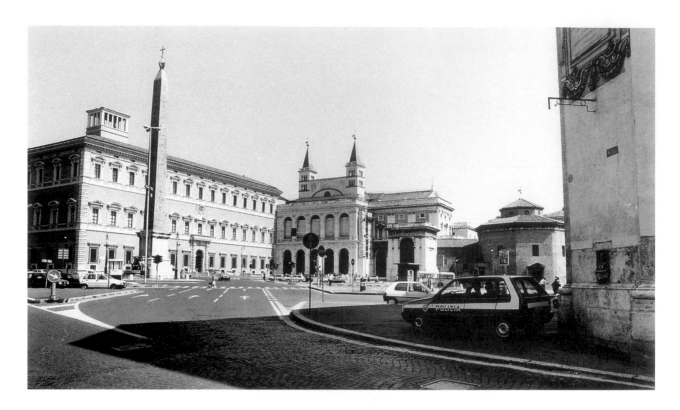

8

Campus Lateranensis. Sixtus V's palace now dominates the Lateran square (far left). The towered end of the medieval transept of St. John's basilica is mostly obscured by Domenico Fontana's benedictional loggia (1586). The Lateran baptistery is to the right.

installed in the semicircular exedra where, in earlier structures, the emperor's official seat had commonly been placed, and an altar was built before it, set off by a theatrical framing arch bearing sculptures of Christ and his apostles. Otherwise, the interior space was simple. A tall central nave, lighted by a row of windows beneath the roofline (clerestory), was flanked by side aisles divided from it by colonnades.

Its size and status notwithstanding, Constantine's basilica of the Savior looks rather plain on the outside—a trait that is characteristic of all the churches Constantine had built for the emergent official faith. This external modesty perhaps reflects the same sort of diffidence on the part of Constantine that his mother, Helena, had manifested when, without architectural fanfare, she had a palace hall transformed into a church by adding an apse and having the hall consecrated as the church of the Holy Cross.

Over the centuries, the increasingly complex needs of the papal liturgy have necessitated major alterations to the Lateran basilica. In fact, to the first Jubilee pilgrim approaching the papal complex, the single feature of the basilica that meets the eye looking across the campus Lateranensis is the most recent of these modifications. Balancing a left (south) counterpart, the right (north) transept opening onto the campus has been built only a few years ago. The transept's facade presents such an imposing aspect (fig. 8) that a naive visitor could mistake it for the church's main entranceway. In fact, though, the basilica's actual

facade is both out of sight and not directly accessible from the Lateran campus; to reach it, one would have to circumvent the entire, grandiose papal palace, or Patriarchium, which has grown up along the basilica's north flank.

The church's actual entranceway, in fact, faces east. When the church was built, the custom of orienting Rome's churches had yet to develop. So here, the architects followed the foundations of the razed barracks and faced the church toward the city wall and the Porta Asinaria. In the course of succeeding centuries, practical considerations overtook the initial planning, however. The major roads from the inhabited parts of the city and, most important, from the Vatican to the north-west, as well as the enclosure described by the aqueduct, elevated the area to the basilica's north into a public space, or *platea,* that was even more important than the piazza before the facade and necessitated changes in the church's very plan.

The Lateran baptistery. Much closer than the Lateran church's own main doorway, the little octagonal baptistery stands just paces away, dwarfed by the basilica's great right transept and apse. The venerable Aqua Claudia has long since come to serve a new purpose here: waters that once supplied a noble fam-ily's baths now fill a baptismal font. It was Constantine who founded the baptis-tery, and local lore has it that Pope Sylvester baptized Rome's first Christian emperor on this very spot. This is unlikely, however, as Constantine had aspired to be baptized in the River Jordan in the Holy Land, and he waited until he lay dying in Constantinople to receive the sacrament. Though founded in the fourth century, the baptistery had already been rebuilt by Pope Sixtus III (432–40), and it is Sixtus's fifth-century building that still serves the faithful.

Especially considering the importance to the history of Christian Rome of the rites carried out here, the baptistery—a simple, central-plan structure—pre-sents a modest external appearance. But in this case, the plain brick exterior, interrupted by simple, rectangular windows, conceals a sumptuously adorned interior. It is here, according to tradition, that Pope Gregory the Great (590–604), inspired directly by the Holy Spirit, had transcribed the Gregorian chant, the sacred music that provides the setting of the divine liturgy.

The main entrance to the baptistery directly faces the apse of the basilica so that the clergy can move easily between the two buildings (fig. 9). Framing the baptistery door and imparting a definite grandeur despite the overall smallness of scale are great porphyry columns and intricately carved marble pilasters and col-umn bases, all purloined from ancient buildings (fig. 10). (The porphyry used here suggests that the source of this spolia was a place where great power was wielded. This rare, hard stone—quarried until the fifth century exclusively in Upper Egypt—has long signified regal status and has maintained its meaning throughout history.) Although in the past architects had sometimes reused older materials for economic reasons, from Constantine's age on, such spolia came to signal continuity with Rome's great past. Indeed, by the time of the Jubilee, the use of spolia had become a pronounced characteristic of most public Roman architecture.

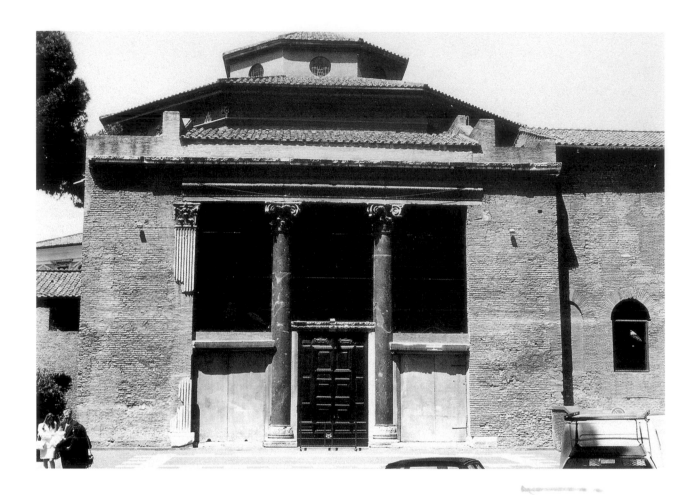

9

Lateran baptistery and St. Venantius Chapel. The imposing main entranceway was constructed with porphyry columns and marble pilasters taken from an earlier building; the reuse of ancient *spolia* and the luxuriant vegetal ornament suit perfectly the idea of rebirth associated with baptism. At the right is the chapel of St. Venantius, constructed under Pope John IV (640–42) from a building belonging to the imperial complex already on the site; its floor was raised to the level of the baptistery, it was fitted out with an apse, and it was decorated with gold mosaics.

The inner portico continues the lavishness established by the baptistery's portal. The walls are reveted in splendid ornaments of *opus sectile* (fine inlay of many-colored marbles), which includes a vine scroll motif that symbolizes the regeneration of baptism. The vine motif dominates apses to the left and right, there rendered in gold and blue mosaics (fig. 11). Branching from either side of a central stalk to fill the conch, the vines reach up to a circle from which gold crosses are suspended and on which stand doves and the Lamb of God. This is the heaven to which the faithful aspire. Below the apses are altars to SS. Rufinus and Seconda, and to Andrew and Luke, respectively. These have been added long after Constantine's day, to transform the portico into an oratory.

The baptistery itself is an octagonal structure featuring a dome above the font supported on a richly carved architrave resting on eight porphyry columns, again, spolia taken from other structures (fig. 12). Even though the columns, capitals, and bases are not perfectly matched, the overall impression is one of classical simplicity. Eight distichs inscribed on the architrave set forth the doctrine that baptism is rebirth. One of them reads:

10
Lateran baptistery, portico. At the main entrance, the baptistery is preceded by a portico richly adorned with porphyry and marble disks and delicately worked cut-inlay marble designs.

11
Lateran baptistery, portico. The apses at either side of the portico were originally covered by mosaic carpets filled with gold spiraling vines against a rich blue ground. (The stucco angels are Baroque additions.)

FONS HIC EST VITAE, QUI TOTUM DILUIT ORBEM
SUMENS DE CHRISTI VULNERE PRINCIPIUM
(This is the fountain of life, which purges the whole world,
Taking its course from the wound of Christ.)

What a perfect concept: Christ's death on the cross brings life to all those who submit to his will and accept the sacrament of baptism.

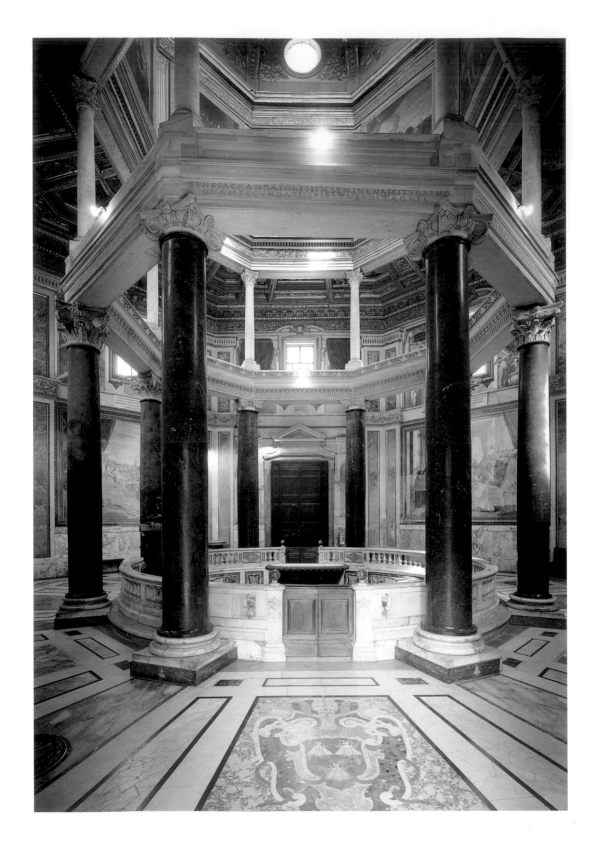

The Imperial Pope

Against the backdrop of the Patriarchium, the campus Lateranensis is, above all else, a showplace for purposeful displays of papal authority, both religious and governmental (fig. 13). Here is where the pope ceremoniously emerges from vast private quarters when he leaves the Lateran to say Mass elsewhere. According to the *Donation of Constantine,* the white horse he rides on such occasions follows a custom begun with Constantine's conferring of imperial power and properties upon Pope Sylvester (although, in fact, it is only a medieval custom introduced to assert the pope's status as secular ruler). It is here, too, that the pope returns, acclaimed by his cardinals singing the *Laudes* (praises), until he pauses on an enormous porphyry disk at the foot of the main portal of the palace and ascends the grand staircase, also in imitation of imperial rite.

Beginning with Pope Hadrian I (772–95), popes have assembled an eclectic collection of ancient artifacts in bronze and stone that the pilgrim of the first Jubilee can see here in the Lateran courtyard, under the portico of the Patriarchium and elsewhere. Most of the works actually predate the Christianization of Rome. Certain pieces are mounted on pedestals and atop columns. The effect gives something of the impression of an array of trophies. Though disparate in subject, scale, and material, everything in this odd array shares two features: all of the objects refer in one way or another to the imperial might of ancient Rome, and none has ever been buried. Reasons to preserve and display these prizes from Rome's patrimony have always been found.

One group bears on the meting out of justice, a papal responsibility, that often takes place outside the Patriarchium. Signs of this function are difficult to overlook—a thief's severed hand is tacked up on a wall, and an executed murderer's charred corpse is visible in a corner of the square. The bronze she-wolf (fig. 14) set in the portico is emblematic of the pope's juridical authority. In ancient times, the sculpture was revered as representing *Lupa,* who nurtured the legendary founders of Rome, the brothers Romulus and Remus. The figure's feral aspect and stylized features speak of Rome's primitive, unevolved origins. At the same time, *Lupa, mater Romanorum* (mother of the Romans), long represented on coins, symbolized the protective Roman Empire. The figure was brought to the Lateran late in the eighth century and was later converted into a kind of fountain, the water symbolizing a judge's washing his hands. Its connotations remained even when it was transferred to near the main entrance to the papal palace. With the same set of references intended, the main staircase just beyond has come to be called the scalae Pilati (stairs of Pilate), an allusion to the stairs that Jesus is said to have ascended to his trial in the tribunal of the Roman governor Pontius Pilate (fig. 15). Pope Boniface has only recently had another ancient bronze removed from its place in the portico, where for centuries it has served as a sign of papal authority to minister justice, and has had it embedded in an altar. Perhaps the *Lex Vespasiani* (law of the Emperor Vespasian [69–79]), a

Opposite:

12

Lateran baptistery, interior. Only the plan and first story, with its eight porphyry columns supporting a spoliate architrave, date from the fifth century; the second level and dome were redesigned and constructed in 1637.

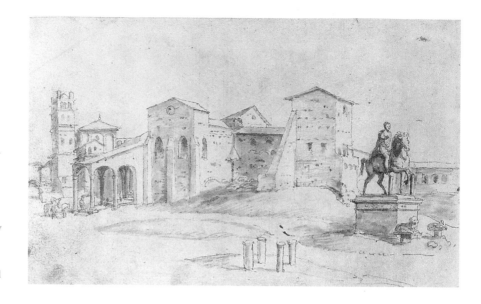

13

Campus Lateranensis. Drawing by
Marten van Heemskerck. The Patri-
archium is visible behind the equestrian
statue of Marcus Aurelius, notably the
main portico with its long flight of steps.
(Berlin, Kupferstichkabinett, 79 D 2, fol.
71v.)

14

Lupa. (Capitoline Museums.) Most likely
an Etruscan work of c. 500 B.C.E., the
bronze sculpture of the she-wolf who
suckled Romulus and Remus symbolized
Roman justice during the Middle Ages.
The figures of the twin brothers are
Renaissance additions.

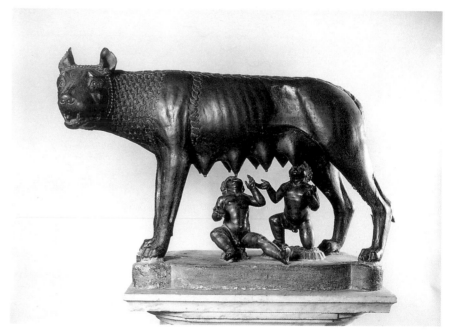

legal document of the sort promulgated by the Roman emperors, offended the
pope because it verified the secular ruler's entitlement to imperial power in 69
C.E. (fig. 16).

The most conspicuous of the antique works at the Lateran (certainly the
one that has lodged in the memory of all who recorded their impressions of the
campus) is the great statue, in gilt bronze, of a mounted rider (fig. 17). The statue
is several times life-size and stands on a marble base (fig. 18). The rider, dressed in

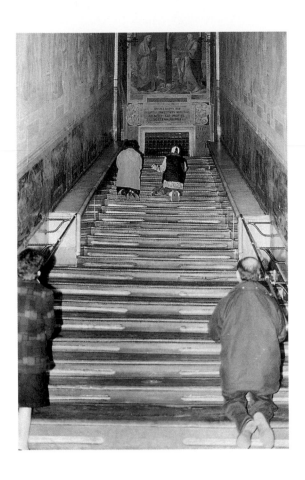

15

Scala Santa (Holy Stairway). Taken to be the steps Christ ascended to face Pilate's judgment, the stairway (now encased in wood) leading to the Sancta Sanctorum (beyond the grate at the top) is today one of Rome's most important pilgrimage destinations. During the Middle Ages, it was the stairway to the pope's nearby palace (see fig. 13).

16

Tablet of law. (Capitoline Museums.) Like many Roman spolia, such tablets of ancient law were of interest more for their pedigree than for their specific contents. The magnificent script of rustic capitals and fine technique were also admired during the Middle Ages.

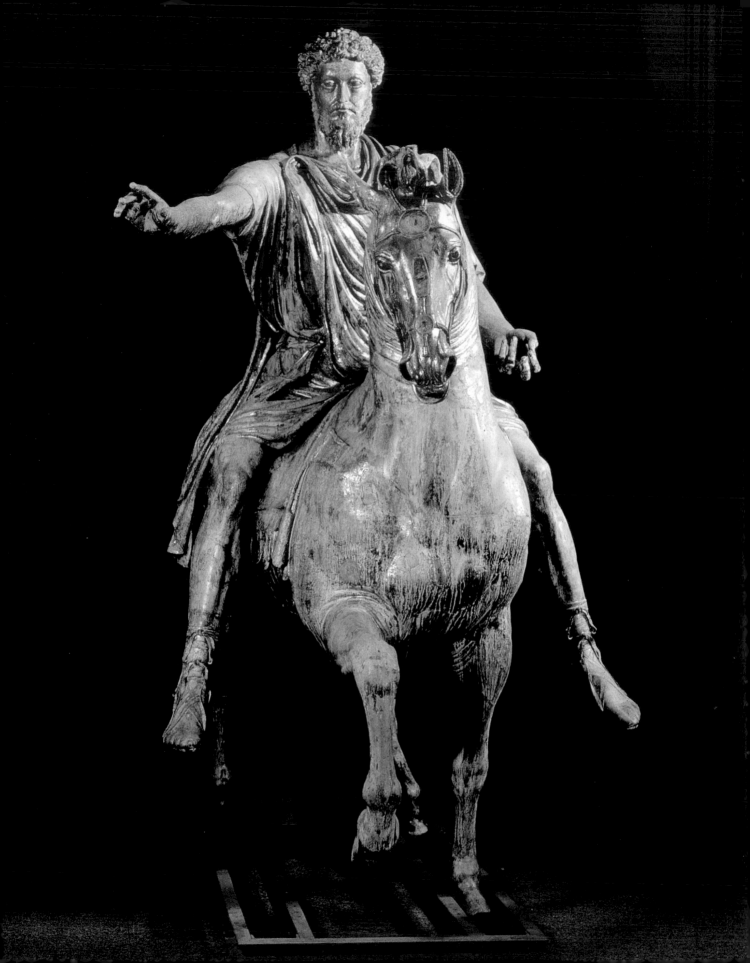

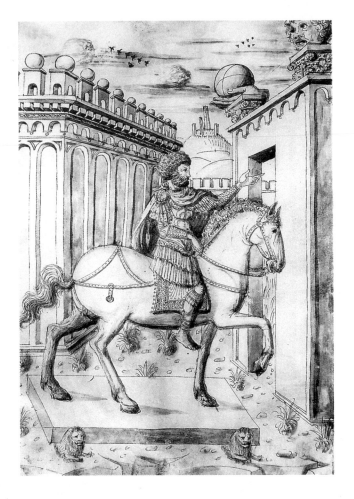

simple, civilian garb and a patrician's soft leather sandals, extends his right hand in a gesture that some find ambiguous. Is it pacification or admonition? Stone lions, carted from Egypt by Roman soldiers, accompany the statue as feline guardians (fig. 19). Dozens of equestrian monuments of this sort once adorned the ancient city as senatorial tributes commemorating important victories; this is the only one to have survived to the year 1300. It has been preserved because it represents the founder of Christian Rome.

Or does it? Many Romans believe the subject to be Constantine. But those pilgrims who have come from Germany insist that the rider is their "compatriot," Theodoric (475–526), the Ostrogothic king who ruled over Italy for thirty years. In fact, however, the later Frankish king Charlemagne had installed an equestrian monument of Theodoric, taken from the palace in Ravenna, before his own "Lateran" in Aachen; the Germans may have been thinking of that. And the *Graphia* offers still another identification, claiming Rome's equestrian to be a depiction of the knight Quintus Quirinus, who, according to legend, had sacrificed himself and his horse to save Rome from the plague. But a look at the awe-

19

Egyptian lions. The figures associated with the *Marcus Aurelius* are difficult to identify with certainty, but most likely they are the paired sculptures that, in modern copies, serve as fountains at the base of the Capitoline steps.

some mounted soldier before the pope's palace leaves many pilgrims certain that the rider is Rome's first Christian emperor.

Surely, the statue was thought to be Constantine when it was brought here centuries ago, at the time when the popes were constructing the Lateran as an imitation of—and in competition with—the imperial palace in Constantinople, which was adorned with a similar monument of the Emperor Justinian. Setting up the ancient bronze in front of the Patriarchium was the archaeological counterpart to writing the *Donation of Constantine:* it established the ancient, imperial roots of the pope's sovereignty over the Western empire. The figure beneath the horse's raised right hoof, moreover, has long been identified as a conquered enemy and, hence, as the sign of Constantine's victory over evil forces and protection of Roman. No wonder, then, that the equestrian is seen, together with the she-wolf nearby, as an emblem of the justice dispensed around it. The *Liber Pontificalis,* the chronicle of papal activities, reports, for instance, that in 966 a Roman prefect named Peter, charged with having plotted against Pope John XIII (965–72), was executed by being hanged by his hair from Constantine's horse.

Although the equestrian statue may not, in fact, portray Constantine, a gigantic gilt bronze head, hand, and orb (figs. 20, 21) displayed in the campus may indeed have depicted him. These mammoth fragments, too, have been identified variously. That they come from a great bronze "Samson" has been posited, for instance; but the *Graphia* tells that the remnants come from the colossal "God of the Sun" figure that once stood in the stadium to which it gave the name Colosseum. "With his feet on the earth," the *Graphia* reports, "he reached heaven with his head and held in his hand an orb that signified that Rome ruled over the whole world." Whether or not the enormous fragments exalt the might

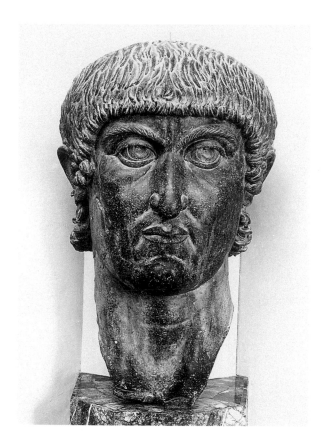

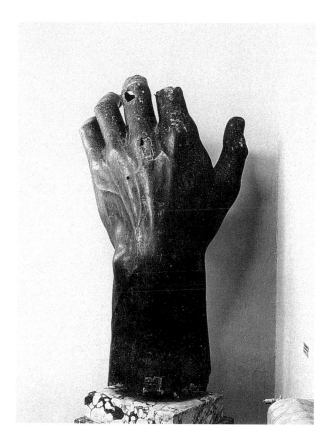

of a pagan deity, they deliver a clear and important secondary message: the popes residing in the Lateran and the God they represent now rule in his stead.

Among the various antiquities assembled in the campus Lateranensis, the appealing *Spinario* (thorn puller, fig. 22) seems to have been here since the time of Pope Gregory II (715–31). Its presence, too, has given rise to diverse interpretations. One of several replicas of a popular ancient Greek statue depicting a youth pulling a thorn from his foot, it has sometimes been taken as representing the licentious Priapus. The presumed true meaning, however, makes the figure more appropriate to the stage in front of the papal palace: in depictions of Christ riding into Jerusalem at the start of his Passion, a boy picking thorns from his foot is often included to evoke the Lord's pain that will follow his entry into the city. Such a depiction may have suggested the placement of the ancient statue among the other emblems of papal power in the place where the pope, riding his white horse, enters his palace on return from his journeys, especially during Holy Week.

Although most of the antiquities installed at the Lateran have been here since the eighth century, others were added later, especially at moments when other popes were asserting the claim of their right to rule Rome. Thus, Pope Innocent II (1130–43) had himself buried in the Emperor Hadrian's sarcopha-

20
Bronze figure, head. (Capitoline Museums.) Only three fragments of a colossal bronze portrait, perhaps of Constantine, survive. In Zoppo's drawing (see fig. 19), all three fragments are mounted above the gate.

21
Bronze figure, hand. (Capitoline Museums.)

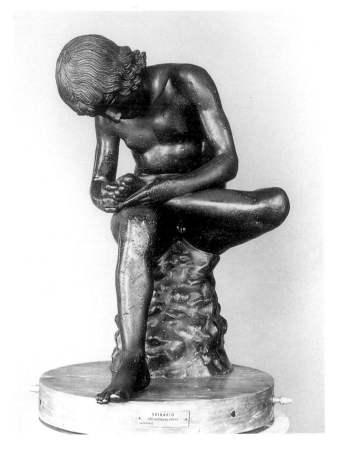

Spinario. (Capitoline Museums.) One of the most famous of all works of ancient art, the Thorn-puller is, in fact, a first-century Roman confection in the Greek manner. The head is in the classical style, the body hellenistic.

23

Fragment of the Emperor Hadrian's sarcophagus. (Lateran cloister.) Medieval sources noted the remarkable fact that Pope Innocent II had had the emperor's porphyry sarcophagus transported from the Castel Sant'Angelo all the way to the Lateran, where it would serve as his own tomb; they interpreted it correctly as a sign of papal imperial pretension. All that remains today is this fragment of a headless bust.

gus, carried all the way from the Castel Sant'Angelo (fig. 23). The most explicit emblems of temporal authority are the three papal thrones. Two of these—the second-century imperial thrones made of porphyry that are installed before the chapel of St. Sylvester within the Patriarchium—are not in public view, but a more modest, though still impressive, ancient white marble throne is to be seen in front of the basilica (fig. 24). Used during papal coronations, the inherited seats symbolize the new pontiff's worldly power.

Boniface's benedictional loggia. As attentive as any of his predecessors to the awesome significance of his position, Boniface VIII has had erected, for the occasion of his elevation to the papacy six years ago, a loggia from which to address and bless throngs of his followers (fig. 25). The benedictional loggia, attached to the Patriarchium at the end of the Council Hall of Pope Leo III (795–816), provides a new, open face onto the campus Lateranensis. Three great, ancient columns support a protruding balcony, which in turn is framed by Gothic arches that rest on another four slender columns. These form a baldachin of the type that shelters the altar in many a Roman church—not accidentally adding to the aura of sanctity surrounding the pope's person. The balcony is adorned with the coat of arms of Boniface's family, the aristocratic Caetani, and is capped by a

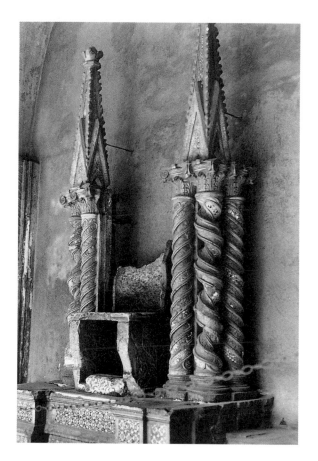

24

Throne. (Lateran cloister.) Called the *sedes stercorata*, or chair of excrement, this papal coronation throne alludes to a biblical passage: He lifts the weak out of the dust and raises the poor from the dunghill (de stercore); to give them a place among the great, to set them in seats of honor (1 Sam. 2.8).

25

Campus Lateranensis. Drawing by Marten van Heemskerck. The right transept of St. John's is all that remains of the complex recorded in this drawing (see fig. 8). Boniface VIII's benedictional loggia dominates at the left; directly to the right, one of the ten lateral apses of Leo III's Council Hall is visible (see fig. 29). (Berlin, Kupferstichkabinett, 79 D 2, fol. 12r.)

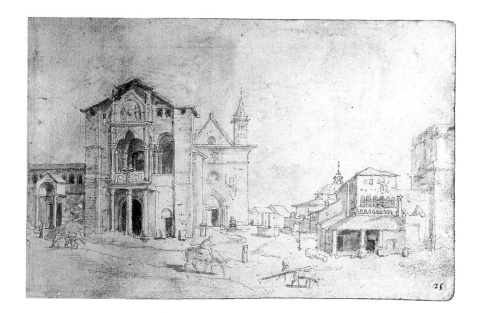

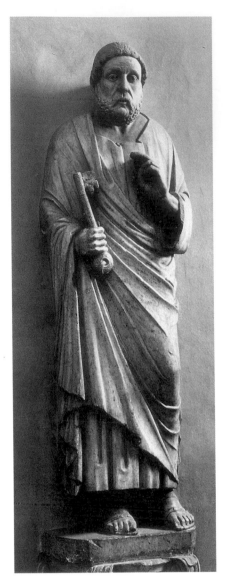

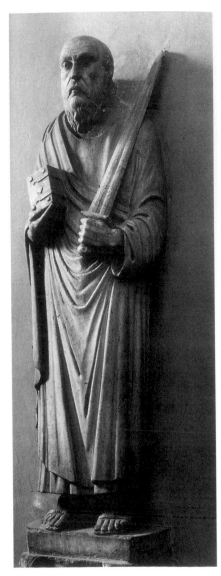

Saints Peter and Paul. (Lateran Museum.)
These two statues are almost certainly the
figures of the apostles that flanked the
Caetani coat of arms in the arched pedi-
ment of Boniface's benedictional loggia
(see fig. 25).

Opposite:

27

Boniface VIII Addressing the People of Rome.
(St. John Lateran.) All that remains of the
series of frescoes that once adorned Boni-
face's benedictional loggia is this fragment
of the central portrait. It was carefully pre-
served during the eighteenth century, a
period in which the early history of the
papacy was of special interest. Tradition-
ally attributed to the painter Giotto, the
fresco is of uncertain authorship.

gable decorated with statues of Peter and Paul (fig. 26) flanking the Caetani
arms, effectively affirming papal legitimacy: Constantine had deeded the Lateran
palace and with it temporal power to "Sylvester and all his successors in the line
of Peter and Paul." The balcony leads off a loggia opened by arches into the
palace complex.

Even when the pope is not physically present in the loggia, his persona is
suggested here in a fresco portraying him as he appeared on the day of his elec-
tion in 1295, when he was crowned at St. Peter's and then proceeded to the Lat-
eran to take possession of the papal palace (figs. 27, 28). The setting depicted in
the fresco is remarkably faithful to Boniface's new structure, down to the detail

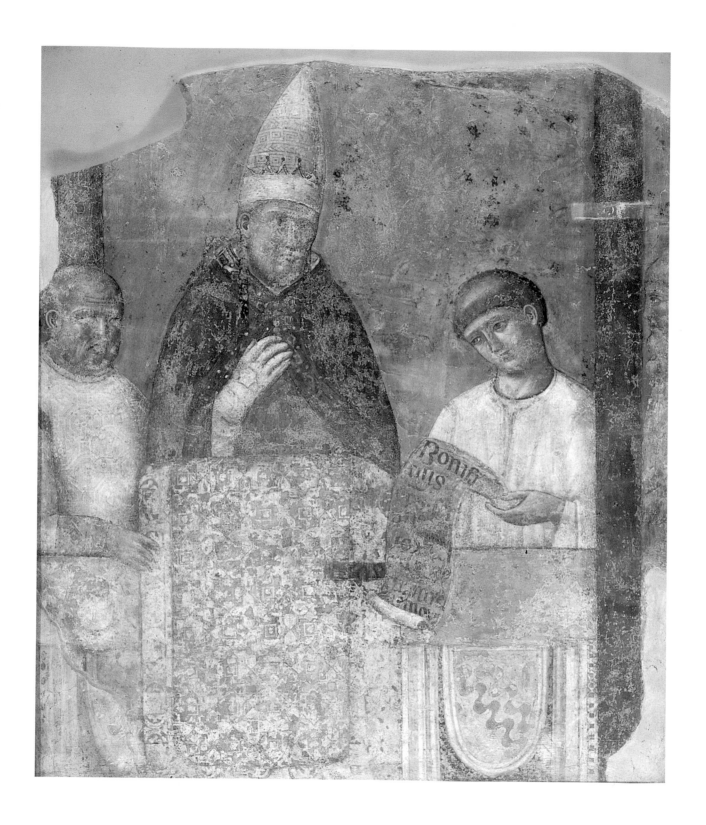

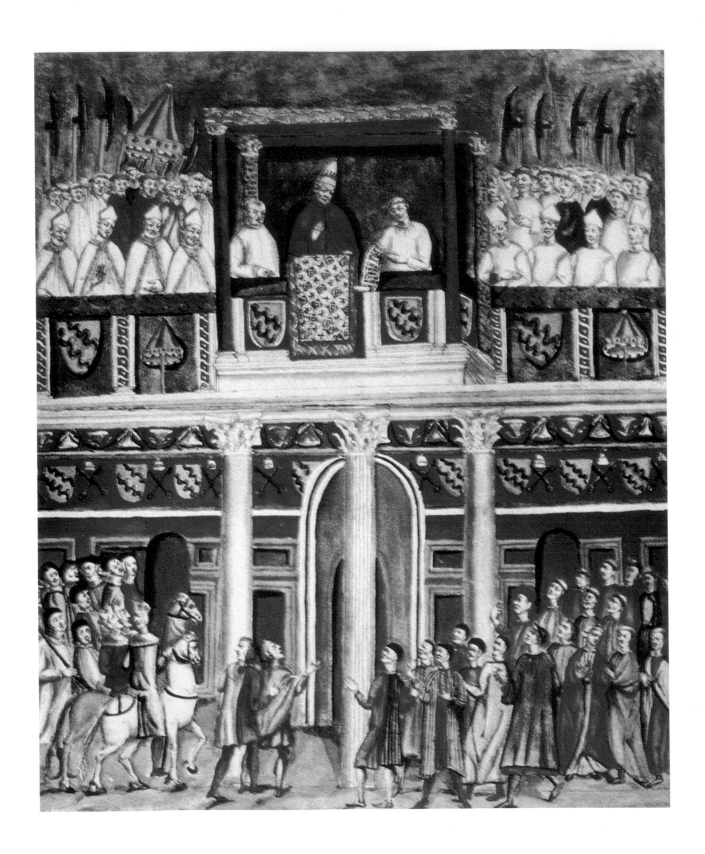

of the three spolia columns and the large, arched portal into the palace, firmly asserting the scene's historicity. But the painting modifies one important detail: the papal canopy is rendered as a flat awning supported by two porphyry and two green serpentine marble columns. This form was taken not from the actual cusped structure in which the pope appears but from ancient images of the emperor appearing in public, surrounded by court officials. As such, it is intended to signal Boniface's earthly sovereignty.

Boniface's own court, the curia of cardinals, is also pictured with full regalia and accouterments: cardinals wearing miters, a cleric holding a taper, a processional cross, and a striped parasol, which is another borrowing from imperial emblems and the ultimate sign of Boniface's temporal authority. According to legends incorporated into the *Donation of Constantine,* Constantine had given Pope Sylvester, along with the red cape, *phrygium* (tiara), and white horse, a symbolic umbrella. The connotation of papal power is reinforced by ranks of guards at the rear bearing halberds, and especially, by the citizens of Rome below, mounted and on foot, who acclaim the new pope. The ancient authority vested in Boniface is reinforced by scenes on either side, one showing the Baptism of Constantine and the other the Founding of the Lateran Church. These establish a further connection to Pope Sylvester and his imperial patron.

The frescoes also advance another, quite particular claim. Boniface is portrayed in the company of his immediate predecessor, Pope Celestine V (1294), the saintly hermit who had ruled for a mere six months before retiring, and by Cardinal Matteo Rosso Orsini, a nephew of Pope Nicholas III (1277–80), another recent predecessor. Thus, the representation of Boniface carries an explicit message of political entitlement for Benedetto Caetani, who was elected pope only after a period of vitriolic feuding over power among Rome's aristocratic families. The portrait's Boniface is quite the opposite of the servile figure he is proclaimed to be in the scroll held by the deacon at his side, "Bonifacius, Episcopus servus servorum dei" (Bishop Boniface, servant of the servants of God). Whenever one of Boniface's successors appears in the loggia, the frescoes will proclaim, furthermore, that the controversial Caetani pope was legitimately elevated to the chair of St. Peter and thus is a link in the chain of succession back to the apostle.

Sacred Interiors for the Imperial Pope

Beyond Pope Boniface's loggia sprawls the papal palace itself. Like the rest of the Lateran precinct, the Patriarchium encountered in the first Jubilee year reveals nothing of the structures that the Church inherited upon Constantine's conversion. At the time of Constantine's momentous gift to the bishop of Rome, the papal quarters consisted merely of the buildings already standing on the Lateran property. Over the centuries since 312, however, the complex—mirroring

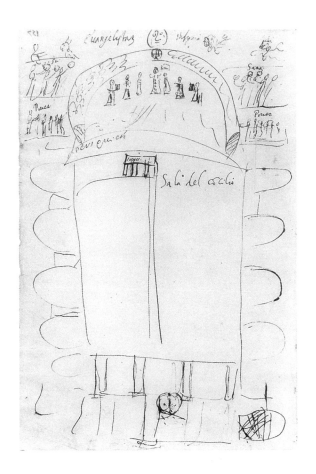

29

Council Hall of Leo III at the Lateran. The only visual record to the eighth-century hall in the papal palace is this late sixteenth-century sketch by Pompeo Ugonius. At first, the drawing seems hopelessly crude, but in fact, it contains most of the essential information about the room: the main apse and ten flanking niches, the pope's banqueting table, and the portico. The mosaic on the apsidal arch featured the face of Christ at the top, with the four evangelist symbols, the twenty-four elders bearing crowns, and others hailing the Lord with palms. The apse portrayed Christ at the center, Peter and Paul at either side, and other saints. (BAV, Cod. Lat. 2160, fol. 209v.)

the steady growth of papal power and ambition—has evolved into a jumble of towers, chanceries, libraries, baths, courtyards, and chapels. Only some of this imperial warren is visible to the visitor, and then, just from the outside. Most of the papal palace is sequestered from everyone but the pope himself and his highest-ranking ministers, the cardinals of the Curia.

Within the palace complex, long corridors connect the banquet halls built at the time of Charlemagne to one another and to other parts of the Patriarchium, including the portico of Pope Zacharias (741–52), and to buildings added later, especially during the twelfth century, to meet the needs of a growing papal bureaucracy. These include a chapel constructed by Pope Callixtus II (1119–24) dedicated to St. Nicholas and additional audience halls built by Callixtus's successor, Pope Honorius II (1124–30).

Near the end of the right transept of the Lateran basilica and jutting into the campus stands the large, anomalous council chamber built for Pope Leo III to serve as a large audience hall, its long sides bulging with ranks of apses sheltering banquet tables (fig. 29). It is to this structure, which still serves as a venue for formal dinners such as those at which the pope dines with cardinals and other

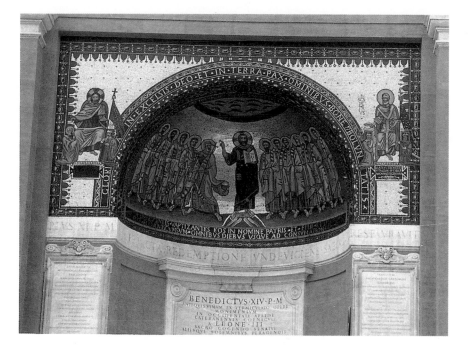

ranking Church functionaries after he returns to the Lateran from visits to other churches, that Boniface had his loggia attached. The very design of this council hall expresses, in architecture, the shift in power from the emperor in Constantinople to the pope in Rome when it was built during the eighth century. Rome was still a Byzantine protectorate until shortly before Pope Leo III conceived the structure, and the hall's unusual shape copies a banquet hall constructed with many apses, the *decanneacubita* (hall of the nineteen niches), in the imperial palace in Constantinople. In fact, this is just one of three grand refectories erected for Leo; another was built at the Vatican palace across the Tiber, and the third is the Triclinium, slightly to the south within the Lateran palace.

In directing the construction of this distinctive edifice, Leo, like his immediate predecessors, was providing for the new status of the papacy following the gradual rupture with Byzantium. During the century before 752, many popes were Greeks who, for obvious reason, fashioned the Lateran court after the imperial court in Constantinople. Eventually, the papacy shifted allegiance from the Eastern empire and allied itself, instead, with Western rulers. Leo III's coronation of Charlemagne in 800 marked the definitive break.

A mosaic in the other banqueting hall in the Lateran built by Leo, the Triclinium (fig. 30), represents the new alliance by showing Peter, enthroned on the right apsidal arch, conferring the papal pallium (a ceremonial band of wool) on the living pope, as a sign of supreme authority, and the vexillum, or ancient military standard, on Charlemagne. Moreover, in the depiction of Christ among the apostles in the apse conch below, Peter alone turns from the ranks of his

31

Triclinium of Leo III, head of an apostle. Although rather crude, the laying of tesserae in this fragment of the mosaic attests to the revival of the ancient technique early in the Carolingian period.

32

The so-called mensura Christi from the Council Hall of Leo III. (St. John Lateran, cloister.) The tall table (*mensa*) from the Council Hall came to be taken as the measure (*mensura*) of Christ—that is, a record of the Lord's great height. It is visible beneath the apse in Ugonio's drawing (see fig. 29).

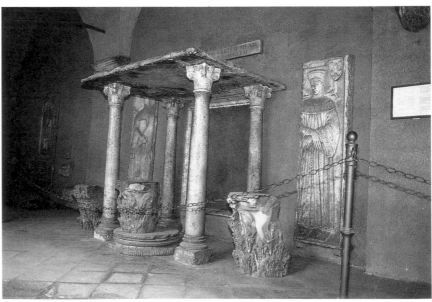

saintly brethren to carry Christ's mission into the world; this is the model for the role of Peter's successors in Rome, the popes, as they rule the Church (fig. 31). Something of the same idea is conveyed, too, in the decorations of the Council Hall. There, the apse features Christ flanked by the Roman patrons, Peter and Paul, while the subsidiary apses depict the mission of the ten other apostles. When the pope dines below at a great marble table (fig. 32), in the presence of cardinals and other Church officials, the message is clear: Rome is heir to the legacy of the chief apostles, and its bishop, the pope, is superior to all others. Moreover, the depiction of the twenty-four elders and four beasts of the Apocalypse, together with other martyrs and saints adoring Christ on the apsidal arch above, confer an aspect of sacredness on the banqueting pope below. The imagery symbolizes the heavenly Church, with Christ as its leader, of which the Roman Church is a replica.

2

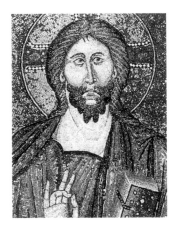

THE SANCTA SANCTORUM, RELIQUARY OF RELIQUARIES

On the eve of the all-important Feast of the Assumption, Pope Boniface is in the Sancta Sanctorum (Holy of Holies), the private papal chapel near the southwest corner of the Patriarchium. A throng of impassioned pilgrims and local citizens is gathering outside the chapel in preparation for the rite carried out each year throughout the night of August 14–15. But none of the laity and precious few of the ordained in the crowd will ever see more of the Sancta Sanctorum than a bit of its deceptively blank exterior—an austerity that reflects the reality that the Sancta Sanctorum in fact has no outward function (fig. 33).

A simple cube in plan, the chapel is so small that anyone in the corps of exalted clergymen privileged to pray here can pace off one side in just a few strides. Indeed, the Sancta Sanctorum's apparent insignificance seems directly to contradict its central importance to the papacy. But only the pope himself when he privately says Mass, and the cardinals and canons who attend him and administer the Lateran, will ever see with their own eyes how precedent, allusion, and dexterity have shaped and colored the interior of the Sancta Sanctorum.

The crowd now waits, not to enter the Sancta Sanctorum, but to see the emergence of the chapel's most precious relic, the icon of Christ known as the *Acheropita*.

The New Tabernacle

Like Boniface's benedictional loggia, the chapel building is a recent addition among the venerable structures that make up the Patriarchium. At the time of

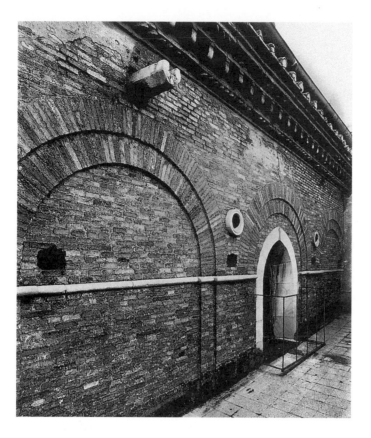

33

Sancta Sanctorum, windows. Except for
the pointed windows dressed in traver-
tine, the exterior of Nicholas III's papal
chapel is completely hidden today by
housing over the Scala Santa built by
Pope Sixtus V in 1589.

the first Jubilee, it has been in place for scarcely more than two decades. Pope
Nicholas III (1277–80) had it built after an earthquake that occurred early in his
reign destroyed an ancient chapel erected on this spot to honor the local Roman
saint Lawrence. Its structure, treatment, and contents establish the Sancta Sanc-
torum's paramount importance. In 1300, Nicholas's chapel is a recent addition to
a long line of palace reliquary chapels built in emulation of the most sacred pro-
totype, the desert Tabernacle, and its later replacement, Solomon's Temple in
Jerusalem described in Scripture.

 In that Tabernacle or Temple, only the high priest could enter the innermost
chamber, which the Bible calls the *sancta sanctorum*. There were kept Judaism's
most precious objects, notably, the altar of expiation and Ark of the Covenant
containing the tablets of the law. The idea of constructing a Holy of Holies at
the Lateran was particularly appropriate because the Lateran church of St. John
had long been compared to Sinai, where Moses received the laws, or, despair-
ingly, to the synagogue. This comparison originated in part because the basil-
ica's altar enshrined not only relics of Christ and the two saints John but also
the Temple implements captured by Vespasian and Titus in 70 C.E.: Aaron's rod,
the seven-branched candlestick, the altar of incense, the jar of manna, and the
shew-bread table. Moreover, in a very real sense, the pope has replaced the Jew-

ish high priest; like his prototype, he, alone with his "Levites," enters the holiest precinct, where he mediates with God on behalf of a new Chosen People.

Whereas the Jerusalem Temple was the ideological model for Nicholas III's chapel, the Sancta Sanctorum's immediate sources are hardly remote in either time or distance, and they are more visibly influential. Even in the chapel's outward plainness, the pointed arches of its windows signal the influence of *opus francigenum* (work in the French style), the new mode of architecture that has been evolving in France for more than a century. As such, the Sancta Sanctorum marks a turning point in Roman church architecture, in which the traditional round arches, which have long been the hallmarks of the local architectural tradition, have been replaced by an imported style.

The ultimate inspiration of this opus francigenum may have been Ste.-Chapelle in Paris, the palatine chapel of King Louis IX ("St. Louis," 1214–70) completed in 1248. Thirty years before dedicating the Sancta Sanctorum, when Pope Nicholas was still Giovanni Gaetani Orsini, the young cardinal had resided in France, at the very time when Ste.-Chapelle was dedicated. King Louis's palatine chapel was also a sancta sanctorum, housing a treasury of relics of Christ acquired during the crusade to the Holy Land and Constantinople: the crown of thorns, part of the cross on which Christ died, one of the nails that fixed him to it, a piece of the lance that pierced his side, and the image of his face miraculously transferred to a cloth.

Yet another source of inspiration for Pope Nicholas's chapel concept, if not its form, was the Pharos Chapel in Constantinople, the palatine chapel of the Byzantine emperors. It, too, was considered a sancta sanctorum, and it derived its special sanctity from housing the most precious of all relics, the tablets of the law handed by God to Moses and the *Mandylion* and *Keramion,* cloth and clay "tablets" bearing Christ's miraculously imprinted likeness. Clearly, Nicholas III had wanted a chapel for the most precious papal treasures that was on a plane with those of his two rival counterparts in France and Byzantium.

The Decorated Interior of Nicholas's Gift

The clerical elite who serve the chapel enter directly via internal passageways within the Patriarchium, through an enormous bronze door (fig. 34) bolted with massive locks to protect the treasure inside. On a wall within the low, barrel-vaulted entranceway, an inventory written in hexameters records some of the sacred relics preserved here. It is an eclectic array, to say the least. The inscription lists a fragment of the True Cross, Christ's umbilicus and foreskin as well as his sandals, Mary's hair, some of her milk, and her veil. (Because both Christ and his mother had ascended bodily into heaven, they left only dispensable remains behind.) There is also a bit of the bread from the Last Supper, John the Baptist's coat, St. Matthew's shoulder, and Bartholomew's chin. And most impressive,

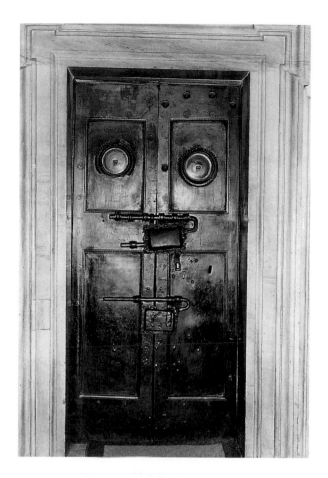

34
Sancta Sanctorum, bronze portal. Even though the chapel opened onto the papal palace, it was still secured by enormous ancient bronze doors and heavy bolts, a sign of the value of its treasures.

the Sancta Sanctorum preserves the heads of SS. Peter, Paul, Agnes, and Euphemia. The greatest of all the chapel's treasures and the focus of its interior, however, is not one of these body relics but an image, the portrait of Christ called the *Acheropita*.

When the clerics take their places on the marble benches lining the chapel's walls, they address God from one of the most visually satisfying and spiritually uplifting interiors in all Rome (fig. 35). An inscribed plaque (fig. 36) alongside the inventory of relics reminds them that the place owes its splendor not only to God himself and his appointed regents but also to a craftsman: MAGISTER COSMATUS FECIT HOC OPUS (Master Cosmatus made this work) proclaims a stone wall plaque. This is an unusually explicit and conspicuous assertion of authorship. But the Jewish Tabernacle, one may recall, also had a divinely inspired maker, the great artisan Bezalel (Ex. 31.1–6); even in this assertion of authorship, then, there is scriptural precedent.

The handiwork of Master Cosmatus belongs to a type of craft long associated with his Roman family and called after the favored name "Cosmatesque." The technique, called *opus sectile,* entails the fine fitting-together of both large and small cut

pieces of marble of many colors to form intricate, symmetrical, geometric designs
that cover floors, lower walls, pulpits, altars, candlesticks, and other surfaces. Cos-
matesque work is to be found not only in Rome's churches but also in buildings
outside Rome that are associated with the papal court. In this way, Cosmatesque
work harmonizes liturgical furnishings with the buildings that serve the liturgy
and endows them with physical richness. At the same time, it has also come to
symbolize papal presence, because the pope and Curia have been the principal
patrons of the Cosmati workshop. It is no surprise, therefore, that the pope's
chapel features one of the most outstanding examples of Cosmatesque work: the
Sancta Sanctorum's pavement is a particularly magnificent example of the tech-
nique (fig. 37). A geometry comprising twelve enormous porphyry and serpentine
discs—slices cut from ancient column drums—marks a pathway toward the altar;
the snaking bands of white marble and various fields of mosaic seem to compel

movement. Framed by white marble and more porphyry, the bands also indicate places for participants in the liturgy. The rectangular apse beyond deploys the same materials to different effect. Two porphyry columns, supporting a lintel filled with Cosmatesque mosaic, mark off the holiest area within (fig. 38).

Painted evocations of the temporal and eternal realms. Above the benches where the clerics sit, tapestries suspended on iron hooks cover the plain marble slabs that make up the chapel's lower walls; the tapestries are changed in the course of the year according to the liturgical calendar. Above these are portraits in fresco of the saints—the unchanging pillars of the Church—enclosed within pointed trilobe arches arrayed along all four walls. The arches rest on alternating braided and twisted spiral colonettes of snowy white marble, hallmark features of Cosmatesque work. As with the windows, the miniature blind arcades reflect the influence of opus francigenum; here, in fact, the source is quite specific and the allusion explicit. The band of arches has been copied from the transept of the church of St. Francis in Assisi, one of the great pilgrimage shrines on the south-bound route from France to Rome. The introduction of these arcades is certainly

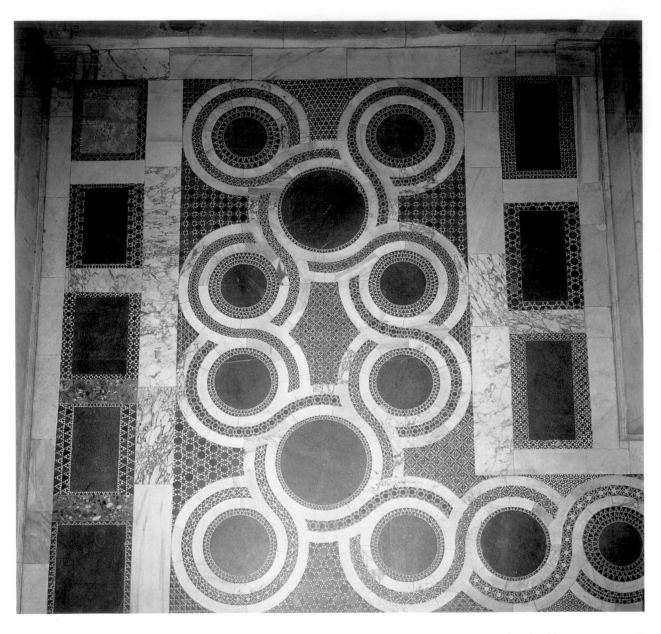

37
Sancta Sanctorum, floor. The rich materials and intricate design of the "Cosmatesque" pavement served as more than mere decoration. The reuse of ancient porphyry and serpentine symbolized Christianity's triumph over the pagan Roman empire and the usurpation of its power; the patterns functioned as place markers for participants in the liturgy; and the style, in itself, indicated papal patronage.

personal and intentional: before becoming pope, Nicholas had been "protector" of the Franciscan order. In two places in one of the arcades, deep cupboards covered over with iron grills interrupt the row of saints. These contain saints' relics, the actual remains of the holy men and women who sanctify the chapel.

Tall, slender columns in the four corners of the room support a vault in the pointed opus francigenum style. Their effect is to transform the space into a kind of tent—again, in reference to the desert Tabernacle that is the chapel's ideological model. This canopy, painted a deep sky blue and filled with stars, symbolizes the firmament, which marks the boundary between earth, perceivable by the

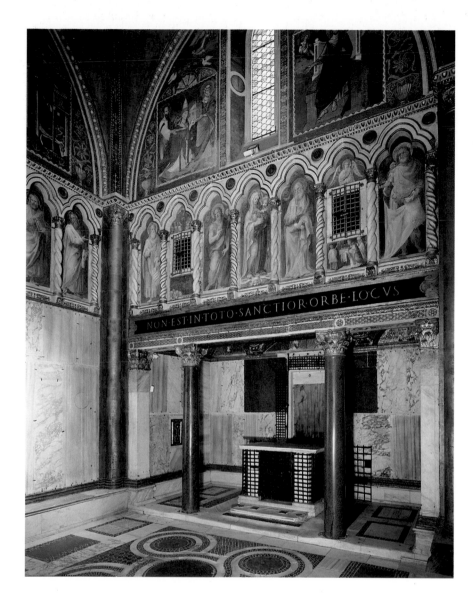

Sancta Sanctorum, altar precinct. Beyond
two porphyry columns is the squat, rec-
tangular apse housing a massive marble
altar containing a cypress chest (see fig.
45) full of relics. The iron grate encasing
the altar and the bronze doors are evi-
dence of the need to protect the treasure
within the altar. Although the inscription
above the apse, NON EST IN TOTO SANC-
TIOR ORBE LOCUS (There is no holier
place in all the world), was introduced
only during the sixteenth-century renova-
tions, it expresses the medieval belief, as
well, that the Sancta Sanctorum was
Christianity's most sacred building. The
saints pictured between the arches are
also sixteenth-century impositions; pre-
sumably, they replaced thirteenth-century
counterparts, although recent restora-
tions uncovered no medieval frescoes
beneath them.

senses, and the invisible realm of heaven above. Hovering in the celestial space,
the ox, eagle, lion, and man envisioned by Ezekiel and John and traditionally
understood as symbols of the four Evangelists hold open books. Each open
book, in turn, carries a quotation from the appropriate Gospel: the ox's hooves
hold words from Luke, the eagle's talons words from John, the Lion's paws
words from Mark, and the angel-like man's hands words from Matthew. Float-
ing above the four windows that admit both real and symbolic light into the
chapel, these figures create the perfect transition between the realm occupied by
God and that served by his minions.

The relation of heaven to earth is figured in other ways as well. At the cor-
ners of the upper story are painted classical vases flanked by black birds with

folded wings; plants spiral upward from the jars, leading the eye toward—but never quite reaching—paired white birds. With wings spread for flight, the birds direct attention heavenward, to where coupled angels float. The black birds stand for the souls of earthbound humans; the plants symbolize the eternal life offered by Christ and his church of saints; the white birds portray human spirits freed from earthly confinement. The same distinction is subtly marked, too, by the classical egg-and-dart molding that frames each arched wall. Along the bottom, it is real carved stone; as it arcs upward, it is a near-perfect painted imitation. In this way the lower part of the Sancta Sanctorum is made heavy and distinctly physical, while the upper areas are more dematerialized. A similar relation is conveyed by the painting, in imitation of Cosmatesque work, of the window embrasures, which are physical recollections of the structure below.

This same spiritualization of the terrestrial world governs the figural representations on either side of three of the Sancta Sanctorum's four windows. Five scenes within the lunettes beneath the ceiling vault recount the martyrdoms of the saints whose relics are preserved here—Peter and Paul, Agnes, Stephen, and Lawrence (fig. 39). In each martyrdom scene, the painters have taken care to place in the foreground the elements venerated here: Stephen's stones, Lawrence's grate, the apostles' heads. In effect, the narrative depictions complete and authenticate the fragmentary remains treasured within the sanctuary. And even though these depict actual events, they are separated from this world by the odd conceit of rendering each episode as an individual picture that is framed in a manner that goes back to Antiquity. In this way, the historical past is visible to anyone present while also remaining distant and elevated. The fictive panels convey the belief that the saints' sacrifices were rewarded by spiritual ascent, an ascent symbolized by the fans above each picture; here, as in the fourth-century Lateran Baptistery (see fig. 11), the fans symbolize the firmament.

Nearest to the entrance, on the west wall, Stephen, Christianity's first martyr, is pictured being stoned. The raging citizens spilling out of Jerusalem to hurl rocks at the saint contrast poignantly with the pious clergymen who enter the Sancta Sanctorum directly below to worship in the presence of the sacred blood of St. Stephen kept here. In a field to the right, Lawrence meekly gestures to his tormentor, Decius, while accepting an excruciating death on the grate; a relic of this martyrdom, a coal from the fire that killed St. Lawrence, is also preserved in the Sancta Sanctorum. Again, a lesson can be drawn: Decius, the third-century emperor who oversaw Lawrence's execution, has been superseded by the pope as governor of Rome.

In the scenes on the south wall depicting the martyrdoms of the apostles Peter and Paul, the local Roman element has taken on greater prominence. Both executions—Peter's by crucifixion upside down to deny him the glory of dying as Christ had died, and Paul's by beheading—are explicitly presented as taking place in Rome (figs. 40, 41). (For that very reason, Rome is made sacred by the mar-

39

Sancta Sanctorum, vault. The groin vault of the main space suggests a tent opened to the firmament. There are the four creatures that, according to Scripture, sing a perpetual liturgy to God. From the second century on, the biblical beasts were equated with the four evangelists. Although the identifications varied, the standard was: man–Matthew, lion–Mark, ox–Luke, eagle–John.

tyrdoms here of the chief apostles.) In the background behind Peter, one sees two of Rome's hallmark monuments near the Vatican: the pyramid of Romulus and the Castel Sant'Angelo, with its characteristic massive wall encircling a tower (see also fig. 186). The two soldiers with haloes are Saints Processus and Martianus, who guarded the apostle when he was jailed in the Marmertine prison, were converted, and then met death for embracing Christianity; Processus and Martianus are venerated in St. Peter's basilica. In the scene depicting the martyrdom of Paul, the basilica consecrated to him, St. Paul's Outside the Walls (see also fig. 153), appears behind a heavily armed Roman soldier; moreover, the river beneath the slain apostle's severed head refers to a local legend memorialized in the abbey of the Three Fountains, which in fact stands not far from St. Paul's. The tale tells that streams flowed forth at the three spots where the apostle's head bounced on the ground before it came to rest.

The north wall presents the martyrdom of another Roman saint, Agnes. The governor of the city, a scepter on his shoulder, has tried various methods to break the young virgin's faith—torture by fire and worse, the threat of desecration by lustful men pictured in the fresco. Having withstood both, Agnes is dis-

40

Sancta Sanctorum, crucifixion of Peter. Even though no medieval viewer would ever have mistaken the central figure, the apostle is nonetheless labeled on either side of his haloed head: S[ANCTUS] PETRUS. This titulus helps to transform the narrative image into a holy icon. The painter, like the author of the *Mirabilia*, represented the "pyramid of Romulus" (tower immediately to the left of Peter) as "no less high than the Castle of Hadrian" (to the right) (see fig. 186).

41

Sancta Sanctorum, beheading of Paul. The Sancta Sanctorum frescoes exhibit a precocious naturalism and some of the earliest experiments in the kind of spatial representation that led, ultimately, to the Renaissance. The painter was careful to show that Paul's martyrdom took place outside the city's walls; and the rendering of the soldier's armor betrays an almost archaeological interest in ancient costume. Nonetheless, in medieval fashion, the painter still used caricature to indicate evil and deployed the landscape to frame each of the main figures.

patched by a particularly venomous-looking soldier, who stabs her in the neck; but she is rewarded by an angel, who descends to carry her soul to heaven.

To the right of the scene of Agnes is a depiction of St. Nicholas; a special and personal reason has again motivated the choice of subject. To be sure, the papacy had long venerated Nicholas of Bari (in fact, indeed, the Patriarchium has long included an oratory dedicated to him). But the saint is surely pictured in the Sancta Sanctorum because he was the namesake of the pope who commissioned the chapel's paintings. And it was for that reason, too, that what is represented here is not St. Nicholas's death but, rather, the best-known episode of his life. As the story goes, a nobleman of the city fell onto such hard times that he considered giving up his three daughters to prostitution. During the night, Nicholas—here with his head ringed by a halo of gold—appeared at the nobleman's window to give a sack of money for the girls' dowries. Thus he rescued the daughters from lives of impurity. In the end, the nobleman recognized who had saved his family, and therefore he venerated Nicholas.

On the chapel's east wall, perpendicular to the telling of Nicholas of Bari's saintly deed, the new Nicholas appears. Here Pope Nicholas, like his namesake, proffers a dowry, but one of another sort (fig. 42). Attired in the papal red cope, pallium, and tiara, he presents the Sancta Sanctorum—this very chapel—to Christ. Just as the Castel Sant'Angelo and St. Paul's are carefully depicted, so, too, the popes' palatine chapel is rendered accurately; its plain exterior pierced by tall lancet windows is easily identified. But here, held in the pope's hands, the

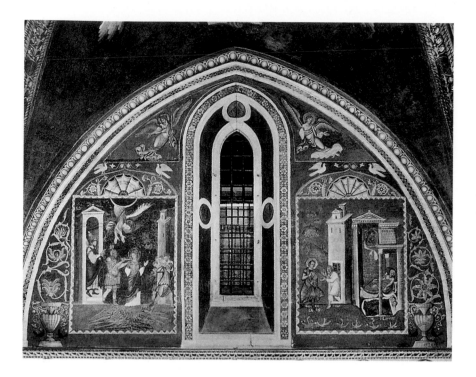

building is on the scale of a large reliquary—which, in a sense, the chapel actually is. Paul ushers the kneeling pope forward, and Peter helps to support the Sancta Sanctorum.

Peter turns toward Christ, who, in a continuation of the same scene, appears in the panel to the right of the east window (fig. 43). (In this way, the composition is twice as large and hence more important than the others.) The Savior sits on his throne (which makes him by far the largest figure in the chapel) and extends his right hand toward Nicholas and his offering. Two angels emerge from behind the throne, making clear that a great gap separates Christ from his faithful servant—the gap between heaven and earth; the window between the two halves of the scene thus symbolizes that separation. The hope of Pope Nicholas is that, by dedicating the new chapel, he will bridge that gap, gaining a place for himself among the celestial servants of God.

Sacred remnants. Curtained off even from the clerics who may enter the pope's private chapel, the shallow, rectangular apse of the Sancta Sanctorum houses many of the relics figured in the outer chamber and other sacred remnants as well. This is the actual sancta sanctorum, the Holy of Holies proper, a reference to the inner chamber that, in the Jerusalem Temple, the high priest alone could enter. It is here that the pope says Mass. A stout altar takes the place of the ancient "altar of expiation." Ancient spolia pillars carved with vegetal designs support the great marble slab that is the altar's top. Heavy bronze doors (fig. 44), locked with a sturdy bolt and decorated with portraits in relief of Paul

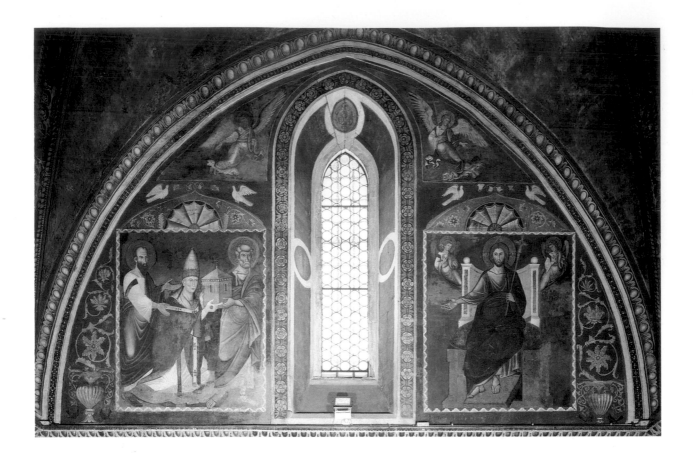

43

Sancta Sanctorum, dedication picture.
Pope Nicholas III, assisted by St. Paul
and St. Peter, presents the papal chapel to
Christ. The model of the Sancta Sancto-
rum is an accurate rendering of the actual
structure (see fig. 33), although it appears
to be the size of a large reliquary. The
fresco painter has broken with custom in
these adjacent but separate panels. There
is a logical link between the two: though
the enthroned Christ and flanking angels
make a complete picture, Christ is in fact
the recipient of the donation being made
by Nicholas in the left-hand panel. His
extended hand leads the viewer's eye
directly—across a separating window—to
the chapel and its donor. At the same
time, Christ is conceived to be both part
of the action and above this world.

and Peter, close off the space between the piers. The doors, too, are reused mate-
rials, though from a more recent monument; an inscription beneath the portrait
of Paul declares that the doors are the work of Pope Innocent III (1198–1216). A
similar inscription beneath the portrait of Peter informs the viewer that Nicholas
III made use of it for his new altar.

Behind the doors is the chapel's "ark of the covenant," a cypress chest made
five centuries ago (fig. 45); it bears the inscription: LEO INDIGNUS TERTIUS
EPISCOPUS DEI FAMULUS FECIT (God's unworthy servant Bishop Leo III
made this). In time of Leo III (795–816), the chest alone was considered the
sancta sanctorum and was so labeled; it remains the heart of Nicholas's new
building. Inside, the Sancta Sanctorum's treasury of special relics is protected.
Many of the objects have been brought from Palestine; their relocation to the
cypress chest inside the altar of the Sancta Sanctorum effects a transferal from
the Holy Land of the Jews to the new Christian land of Rome, the destination of
today's pilgrims. After all, the Jubilee year traveler who makes the arduous jour-
ney to Rome to be in the holy places and to touch sacred objects associated with
Christ and his saints is merely recapitulating a rite that is nearly as old as Chris-

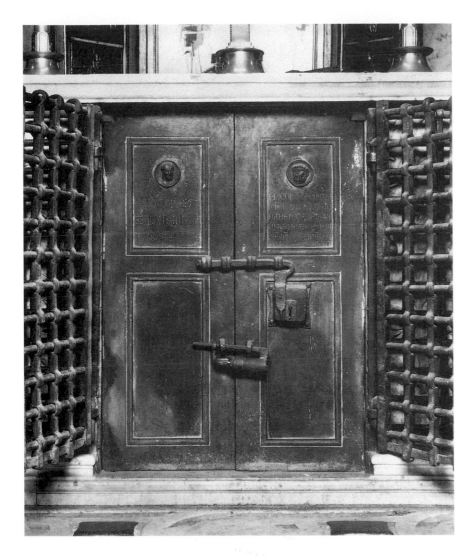

Sancta Sanctorum, altar doors. Like so many other works of art in Rome, the bronze doors of the altar have been reclaimed from an earlier object. The inscription beneath the portrait of Paul on the left valve identifies Innocent III as the first patron; the one beneath Peter gives Nicholas III credit for having "renewed" the altar. Here, as elsewhere, the tradition of reuse inserted each pope in the line of descent going back to the Prince of the Apostles.

tianity itself; even when Christianity was new, the faithful journeyed to the Holy Land to worship at the places where Christ had lived and died.

In one reliquary are actual bits of the Holy Land itself, piously garnered by a sixth-century pilgrim at the most important sites of his or her spiritual journey (fig. 46): a wood box painted a brilliant vermilion containing stones from Bethlehem, the Jordan River, Golgotha, the Mount of Olives, Zion, and elsewhere. Each is carefully labeled as to place of origin—ΑΠ' ΒΗθΛΕΕΜ ("from Bethlehem"), for instance. The outside of the lid is painted with an abstract representation to convey the significance of Christ's death. The cross on Golgotha is encapsulated in a radiant aureole, the lance and sponge pole, instruments of Jesus' Crucifixion, crossed at its base. Flanking it are the Greek letters $\overline{\text{IC}}$ $\overline{\text{XC}}$, the monograms for Jesus Christ, and A and Ω, the first and last letters of the

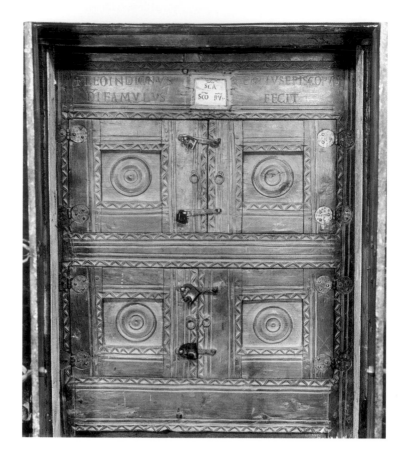

45

Sancta Sanctorum, altar, cypress chest. The inscription on vellum at the top proclaiming this to be the "s[AN]c[T]A s[AN]c[T]ORU[M]" was added in the later Middle Ages, but it may well replace an original, early ninth-century label.

Greek alphabet, which stand for the passage in Revelation 22.13: "I am the Alpha and the Omega, the first and the last, the beginning and the end."

In striking contrast, the inside of the box is painted with scenes that narrate the stories that give significance to some of the stones: the Nativity, Baptism, Crucifixion, Resurrection, and Ascension of Christ (fig. 47). In effect, these scenes are the early pilgrim's pictorial mementos from the Holy Land. The naive style in which the scenes are rendered is as humble as the corresponding souvenirs themselves. Nonetheless, the depictions give form and meaning to the pieces of stone inside the box and, in so doing, elevate them. And like much Christian art, including the newly painted frescoes of the Sancta Sanctorum itself, they blend history, reality, and doctrine. The Nativity scene, for instance, does more than merely re-create Christ's birth as the Gospels recount it; the tiny painting also pictures the altar set up within the grotto in Bethlehem—complete with a niche for a relic—where sixth-century pilgrims had worshiped. Likewise, the tomb at which the three Marys grieve is not only fitted with an altar but also enclosed by a gated precinct beneath a great dome; this is the church of the Holy Sepulcher that Constantine built three centuries after Christ's death at the spot where the Savior had been buried. The Crucifixion scene, in turn, includes rec-

Sancta Sanctorum, reliquary box. This collection of pebbles and earth from Palestine attests to the continuous desire for physical contact with saints and holy places, of which the Jubilee year itself was a culmination.

ognizable topography: two hills, Gareb and Agra, stand at Golgotha. The Ascension, by contrast, in which two angels support an aureole encircling Christ, includes an element added not for literal accuracy but for theological fidelity. Although Scripture does not record Christ's mother as having been present at her son's ascent to heaven, the Virgin appears here because she symbolizes the Church established at the moment Christ left this world.

The inner sanctum of Pope Nicholas's chapel is particularly rich in relics of the True Cross, preserved in various reliquaries. This is not surprising, because the Lateran is a station for the Good Friday liturgy—that is, a place where the pope says Mass on the anniversary of the day Christ was crucified. One is a simple wooden box inscribed with the Greek words ΘΩΣ (light) and ΖΩΗ (life), which intersect to form a cross. Another is a magnificent tenth-century box from Constantinople (fig. 48), probably a gift to the pope from a Byzantine emissary. Painted and gilt to recall reliquaries of precious metal and enamel, it pictures on the outside the crucified Christ; once again, depiction provides the context and realization for the fragment inside. Christ is still alive here, and blood spurts from his chest and hands; his mother bends to embrace the cross and kiss his feet. Darkness veils the sun and moon overhead. John, Christ's evangelist, looks back in sorrow. The passion of the Crucifixion is transmuted within by St. John

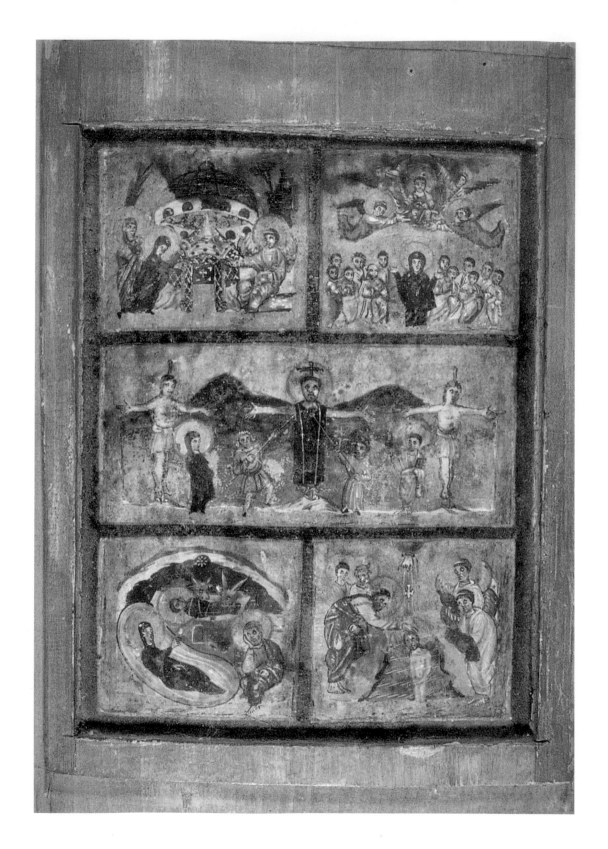

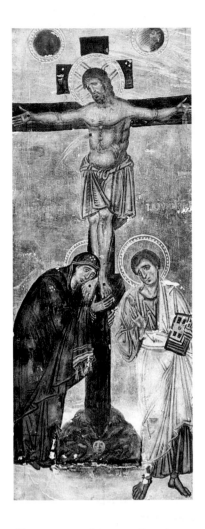

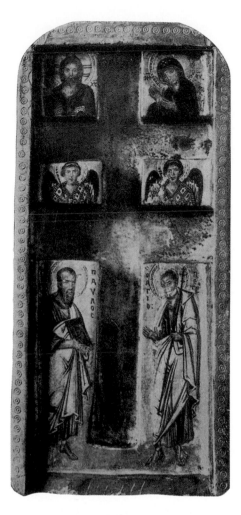

Chrysostom, the great fourth-century doctor of the Church, who displays some of Christ's most compassionate words: "This is my commandment: Love one another, as I have loved you. [There is no greater love than this, that a man should lay down his life for his friends]." Carved out in the shape of a double cross to receive the holy wood fragment, the reliquary box is itself like Mary on the cover, depicted embracing the timber on which Christ died (fig. 49). The Roman apostles, Peter and Paul, stand on either side, representatives of the terrestrial realm where Christ once dwelled and that now is governed by his Church. Above them are two angels, inhabitants of the firmament, the boundary that divides this world from heaven. And at the top are the cosmic ruler, Christ himself, and his mother, in the posture of the intercessor on humankind's behalf, the *Madonna avvocata* with one hand at her chest and the other, palm-forward, raised toward her son.

Quite different in style and material is yet another cross reliquary (fig. 50), a cruciform box decorated in enamel with scenes from Christ's early life: the

50

Sancta Sanctorum, enamel reliquary.
While allowing for complicated figural
compositions, the enamel technique also
suggested the brilliance and richness of
precious stones. The figures are shaped
with gold wires on a gold plate, forming
cells that are filled with powdered glass of
different colors; the glass fuses when the
plaque is heated, fixing the design. When
light, passing back through the glass, is
reflected off the lower gold surface,
something of the luminousness of gems
is effected.

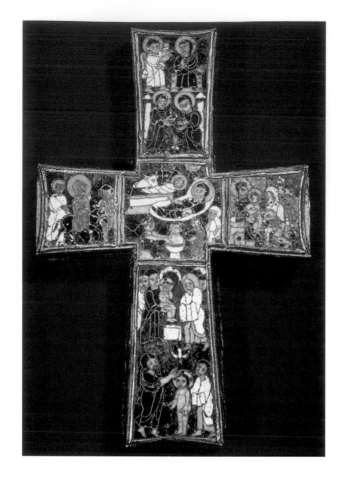

Annunciation to the Virgin, the Visitation of Mary and Elizabeth, the Journey to
Bethlehem, the Nativity, the Adoration of the Magi, the Presentation of Christ in
the Temple, and the Baptism. Like the relic inside, the technique of cloisonné
enamel was imported from the East. If the workmanship of the reliquary seems a
bit crude, it is because, at the time when it was made for Pope Paschal I (817–24),
this piece was the most ambitious application of the imported technique ever
attempted in Rome. In the seven scenes depicted, the emphasis is less on Christ,
whose cross the reliquary held, than on the Virgin Mary; the Virgin appears six
times, her son only four. As on the Byzantine reliquary, it is Mary, then, who
serves as intercessor between humankind and Christ, sacrificed on its behalf.

The enamel cross, in turn, rests in a heavy silver box, also a gift of Pope
Paschal, adorned on all sides with figures in gilt repoussé (fig. 51). Its lid can be
slid out and made to stand upright as a kind of altar back, and indeed, the images
recall subjects commonly seen in Roman church apses. Beneath two angels,
shown bust-length to indicate that they are in heaven, Christ is flanked by
Rome's two apostles, Peter and Paul, the one clutching the keys to heaven, the
other, his Epistles. The Lord is enthroned on a hillock from which four rivers

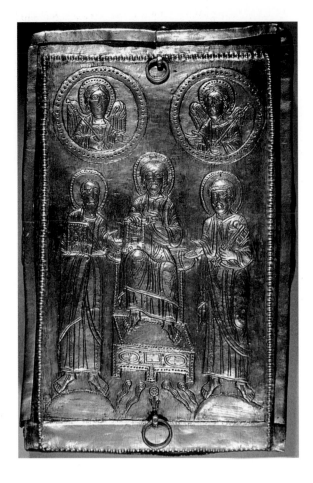

51
Sancta Sanctorum, silver-gilt box. The lid
and decorated base were meant to func-
tion together when the reliquary was
used in the service.

flow, a reference to the rivers of Eden generated by a single fountain to water
the earth (Gen. 2:10–14); these had come to stand for Christ, the source of life
and of the four Gospels, which Christ holds. When the lid is in place atop the
opened box, it forms a single composition with the depiction, on the base, of
the Lamb, flanked by the evangelists' beast symbols, each grasping his Gospel,
hence completing the allegory. On the three other sides of the box's base, narra-
tive scenes in repoussé repeat the same sequence depicted on the enamel cross
inside. Again, attention focuses on Mary. Here, however, a handmaiden is intro-
duced into each of the scenes, a reminder to the pious that everyone of the faith
is a servant of God.

Pope Paschal had also provided a second reliquary box, and it, too, is pre-
served among the Sancta Sanctorum's treasures within the cypress box inside the
altar (fig. 52). This one was made to hold a still older cross reliquary of heavy
gold and set with sixty-eight pearls and seventeen semiprecious stones (fig. 53).
Within a capsule at the intersection of the cross are the two most precious relics
of Christ, his umbilicus and foreskin, the only bodily remains left on earth when
he ascended to heaven. In the inventory of the Lateran treasury compiled in the

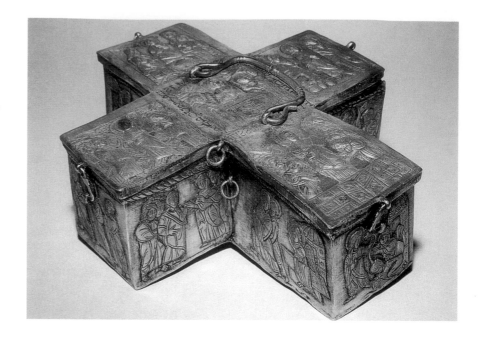

Sancta Sanctorum, cross reliquary. Although the handle and clasps are modern additions, the rings on the reliquary are original, suggesting that, from the start, the silver-gilt container containing the gemmed reliquary was carried in papal ceremonies, such as the procession on the Feast of the Exaltation of the Cross.

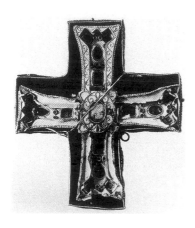

53
Sancta Sanctorum, gemmed reliquary. Precious stones set in gold were deemed appropriate to adorn the actual body relics of Christ. The reliquary disappeared during World War II, most likely because of its material value, not its spiritual significance. (After Grislar)

twelfth century by John the Deacon, this cross is given pride of place. On the annual Feast of the Exaltation of the Cross (September 14), the pope carries this gem-encrusted relic from his chapel to the nearby basilica of St. John, anoints it, and says Mass before it on the main altar. The lid of the box in which it rests during most of the year is divided into five panels, each adorned with a scene formed of raised silver detailed in gold: Christ teaching in the synagogue, the Miracle at Cana, the parable of the vine, Christ instituting the Eucharist, and Christ taking leave of the apostles. In other words, the reliquary's decorations summarize Christ's life and death with a scene of his childhood, a miracle, a parable, an act of ministry, and an appearance after his death. Lacking is a depiction of the Crucifixion, but this, too, is present in the cruciform shape of the reliquary box itself and in its contents. Most important, the Crucifix is alluded to through the Eucharist (the sacrificial blood and body) depicted at the center. There, Christ is pictured blessing the wine and bread from behind an altar, marked by a cross, that is nearly identical to the one represented at the tomb in the painted reliquary box. Mary and Peter look on, personifications of the Roman Church, which now ministers in Christ's stead. Appropriately, it was around this scene that Pope Paschal has had his name inscribed, with the epithet EPISCOPUS PLEBI DEI (Bishop of the People of God).

The most extensive sequence of pictures runs along the box's sides, twelve episodes from Christ's life on earth after the Crucifixion; these provide unusually rich verification of the orthodox tenet of faith, which holds that Christ was resurrected after the Crucifixion and continued his mission until he ascended to heaven. The lowest scene on the lid is the last of these post-Resurrection episodes

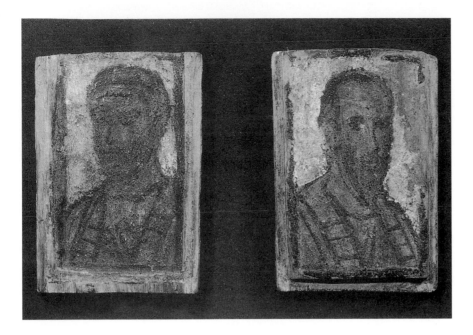

and hence completes the series. It shows Christ blessing the apostles and con-
ferring authority on them: "Go forth therefore and make all nations my disci-
ples and teach them to observe all that I have commanded you" (Matt. 28.20).
This is the foundation of the terrestrial Church, a point underscored by Mary's
presence here, too.

Near the relics of Christ, other sacred remains repose in diverse housings.
The head of St. Agnes, for instance, reposes in a plain silver box, a gift of Pope
Honorius III (1216–27). In sharp contrast, the head of another Roman saint,
Praxedes, is enshrined in a magnificent Byzantine silver chest, decorated on top
with delicately crafted enamel. A central rectangular panel shows Christ
enthroned between Mary and John in the traditional composition of advocacy
known as the Deesis; surrounding the center are medallions with portraits of
the twelve apostles.

In addition to the skulls of Peter and Paul in reliquaries, the Sancta Sancto-
rum houses tiny portraits of the apostolic princes (fig. 54). These are painted in
the recesses intended for wax on two ancient writing tablets, grooved to fit
together. According to the story of Constantine's conversion reported in the
Donation of Constantine, Pope Sylvester verified the emperor's dream in which
Peter and Paul had appeared by showing him these very effigies; Constantine
was converted forthwith (see fig. 199). The minuscule portraits, then, are not
merely images but, like the other objects, sacred relics.

The terrestrial becomes celestial. The entire apse area of the Sancta Sanctorum
is transformed by its wall and ceiling decorations into a facsimile of the celestial
realm and hence suitable for its contents. Only here is gold mosaic deployed,

Sancta Sanctorum, St. Agnes. Portrayals of the principal saints venerated in the Sancta Sanctorum are portrayed around the main altar, there elevated by the mosaic technique and more iconic bust format.

effectively setting the sanctuary apart from the outer chamber with its beautiful but far less precious fresco and marble. And here, only icons of the saints venerated in the Sancta Sanctorum, not their earthly stories, are arranged for meditation in crescent lunettes: Agnes, Lawrence, Stephen, Nicholas, and, of course, Peter and Paul (fig. 55). On the ceiling directly above the altar, moreover, four angels carry a wreathed portrait of Christ to heaven (fig. 56), demonstrating in the imagery itself the transition from this world to the next. It is an old convention—one found on the earliest Christian sarcophagi and ivories—to represent Christ's ascent; indeed, it appears on the painted box of the Sancta Sanctorum itself. Here on the sanctuary ceiling's, however, the two angels at the back stand almost on the cornice; the other two are already in flight. Thus, from the perspective of the pope celebrating Mass, the disk bearing Christ seems to float away. The effect is only heightened by the play of light from suspended lamps on the shimmering gold ground. Christ, whose life as a man is enshrined below, is returning to his Father.

St. Luke's icon. When the pope says Mass in the Sancta Sanctorum, Christ is present here. Like God, who in the Old Testament was enthroned on the mercy seat within the sancta sanctorum, Christ is enthroned above the altar in Rome's Sancta Sanctorum by means of the greatest of all the chapel's relics, the full-length portrait of Christ, *Acheropita* (fig. 57). This name, from the Greek word *acheiropoietos,* meaning "not made by hand," refers to the legend that the Evangelist Luke had begun painting the image but an angel had had to finish it. The Emperor Titus (79–81), it is said, brought the *Acheropita,* along with other spoils,

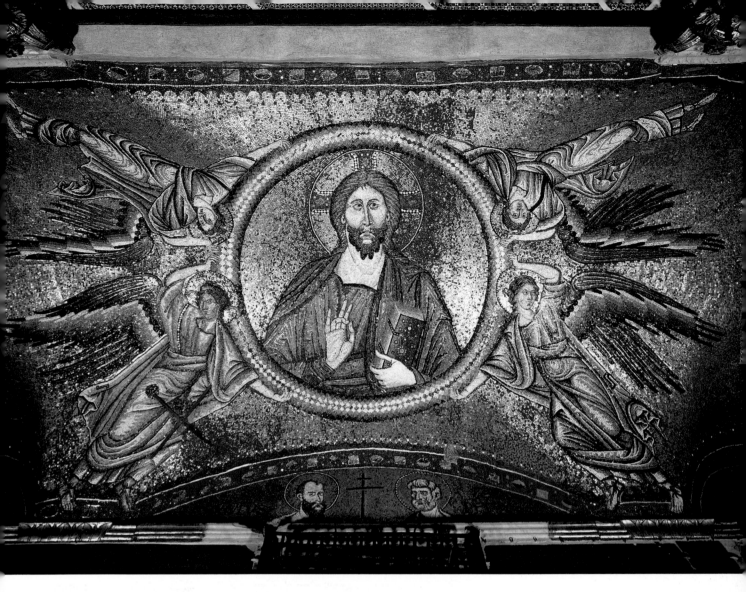

out of Jerusalem when he conquered the sacred city. Thus, like so many of the Sancta Sanctorum's treasures, the *Acheropita* was intended to transfer to Rome the sanctity of the Holy Land. It is a venerated relic, locked in a cupboard in the back wall, framed by porphyry slabs, and secured behind heavy iron grates. In this arrangement, Christ rests his feet in the physical world, specifically in the Holy Land, where he had lived his earthly life (made present through the box of stones and soil), but his head, repeated in mosaic overhead, penetrates the material heaven and enters the spiritual world above.

In fact, the *Acheropita* depicts Christ seated on a cushioned, jeweled throne with a footstool. The Lord holds a *rotulus* (book roll) in his left hand; he blesses with his right. An inscription on the starry blue sky behind his head identifies him as Emmanuel ("God is with us"; Matt. 1.23). The image itself has long since faded, and over the years, it has required several repairs. Already in the tenth

56

Sancta Sanctorum, ceiling above altar. The wreathed portrait, *imago clipeata,* like so many other devices of Christian art, was rooted in ancient tradition. In general, it signified a protagonist not present in the main action; in this case, it suggests that Christ is no longer really of this world. The altar, *Acheropita,* and mosaic together effected a transition from the material world—represented by the marble casing and physical relics—through the miraculously made image to the icon borne to heaven by angels.

57
Sancta Sanctorum, *Acheropita*. A recent cleaning has revealed that the painting is on cloth and probably dates from the late seventh or early eighth century. Almost all the pigment has been lost, and the area near the feet is particularly degraded because of the continuous washing mandated in the liturgy.

century, a new face, painted on cloth, was applied (fig. 58). Later, the entire body was covered with a bejeweled silver coat of armor, leaving only the new face visible; the abstract, cosmological patterning of the new silver covering further dematerializes the *Acheropita*. The icon is familiar to most Christians, however, through such copies as one in the cathedral in nearby Tivoli, which, like the original, is set into a secured wall shrine above an altar. It also was the source of the enthroned Christ painted high above in the Sancta Sanctorum; one image of God proves that another is authentic and present.

Entering the apse of the Sancta Sanctorum, the pope thus fulfills the duties of the Old Testament high priest, offering prayers of expiation on behalf of the

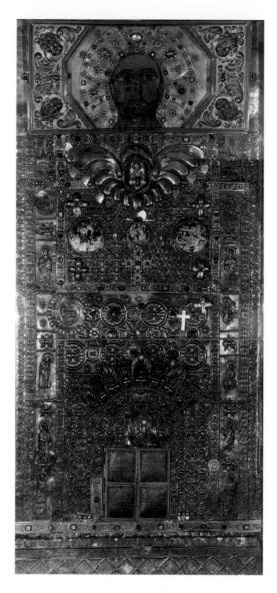

58

Sancta Sanctorum. The case of the
Acheropita is an agglomeration of addi-
tions. The face on cloth (*vellum*) was
probably added in the tenth century. The
gilt silver cover seems to have been a gift
of Pope Innocent III (1198–1216). The
four reliefs on the small doors at Christ's
feet were added in the fourteenth century
to enable the ceremony of washing.

Chosen People to God enthroned on the mercy seat. Following the ancient cer-
emony of parading a portrait of the Roman emperor through the city, however,
the *Acheropita* has, throughout its existence, also been removed from the pope's
inner sanctum once a year and carried in procession through the streets of Rome
on the eve of the Feast of the Assumption of the Virgin. That will happen
tonight, and those who can catch a glimpse of it may perhaps partake directly
of its redemptive powers.

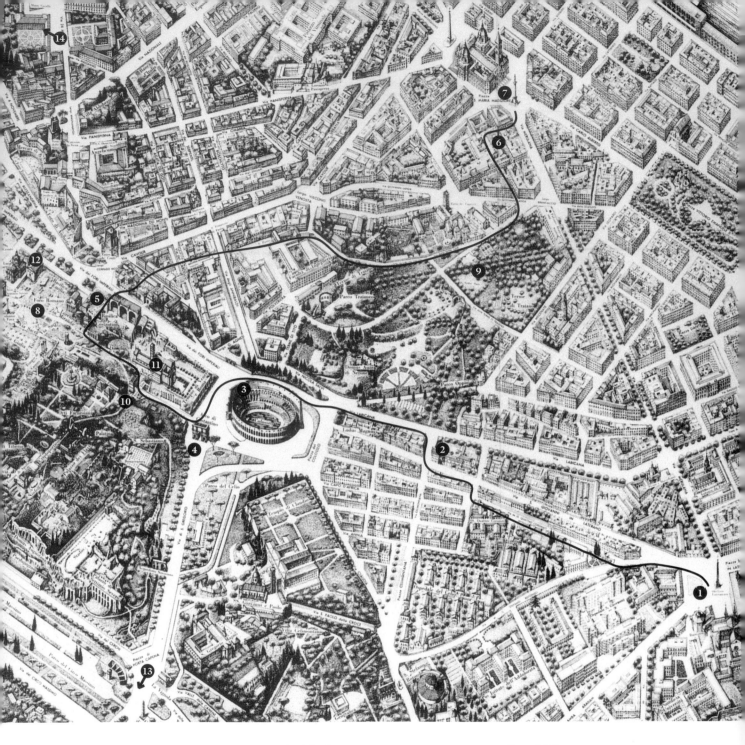

59
The pilgrim's path, superimposed
on bird's-eye map of Rome
©1972 by Armando Ravaglioli

1 St. John Lateran
2 S. Clemente
3 Colosseum
4 Arch of Constantine
5 SS. Cosmas and Damian
6 Sta. Prassede
7 Sta. Maria Maggiore

8 Imperial Forum
9 Esquiline Hill
10 Arch of Titus
11 Sta. Maria Nova
12 S. Hadrian's (now Curia)
13 To St. Paul's Outside the Walls
14 To St. Peter's and Vatican City

THE JOURNEY OF
THE *ACHEROPITA* COMMENCES

It is a solemn moment when the *Acheropita,* the Christ icon residing in the Sancta Sanctorum, is carried into the campus Lateranensis to the throng of pilgrims waiting there. Borne before the *Lupa,* the great bronze equestrian, and the other trophies of the ancient empire assembled at the papal palace, the *Acheropita* vividly reminds the faithful that Christ is now ruler of Rome and that his vicar, the pope, governs a capital city made sacred by the Savior's presence.

The heat of August 14 dissipates as night settles over the increasingly crowded square. The evening seems less dark than normal: most of the myriad faithful converging here carry lighted candles. These will illuminate tonight's long ritual walk from the Lateran to the basilica of Sta. Maria Maggiore for the annual celebration of Christ's reunion with his mother. The complex path of tonight's procession will traverse sections of Rome that are densely populous and others that are all but abandoned. It will follow some normally busy roads and others—especially those near the Lateran—that see little traffic besides comings and goings motivated by the central stronghold of the papacy. Tonight, however, even the roads of the uninhabited district surrounding the Lateran are alive with Romans and pilgrims from afar. Following the prescribed route of the all-important Assumption Day eve procession will give the pilgrims who have traveled to the Eternal City the opportunity to stop at many of Rome's most significant sites.

Although the New Testament makes no mention of the death of Mary, theologians agree that Christ himself took his mother, body and soul, into heaven.

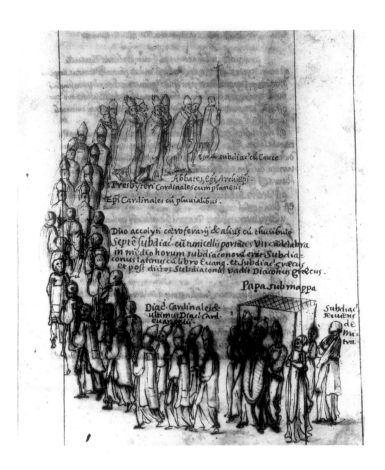

60

Procession of Pope Gregory X. Known only in Giacomo Grimaldi's seventeenth-century copy, the illumination from a liturgical manuscript made for Pope Gregory X (1271–76) offers an idea of what the Jubilee year procession must have looked like. At the head of the file of clergymen, the bare-headed subdeacon carries a crucifix, followed by abbots, bishops, archbishops, cardinals, and, finally, the pope. Among the dignitaries are acolytes carrying candles and censers. (BAV, Cod. Lat. 2733, fol. 51r.)

Marking this miracle, the Feast of the Assumption has been observed in Rome on August 15 since late in the seventh century. From an early date, certainly since the reign of Pope Stephen II (752–57), the rite has centered on a solemn procession of the *Acheropita* through the heart of Rome. Icons have always been carried in processions on other feast days, and the *Acheropita* has at times been taken from the papal chapel to fend off a grave threat, such as pestilence or armed attack, but this is the only annual occasion when the *Acheropita* leaves the sacred precinct. Tonight, Christ, in the person of the *Acheropita,* leaves the residence of his earthly representative to meet his mother in the church dedicated to her.

The Procession Begins

At last, a blaze of light signals the end of the wait. The radiance emanates from near the Sancta Sanctorum; out of the sanctuary proceeds a corps of canons, the clergymen attached to the Lateran basilica and palace (fig. 60). Twelve of the canons carry torches. As every Christian has been taught since childhood, everything has meaning, especially numbers. The number twelve, in particular, is replete with significance. The Bible tells of twelve major prophets and twelve

sons of Jacob. And, of course, there are twelve apostles. Twelve is also the number of Rome's portals and its districts; the latter are represented in tonight's procession by the *duodecimviri* (body of twelve men), which is led by the city prefect.

The Lateran cross. At the head of the procession, a subdeacon carries a great silver-gilt cross (figs. 61 and 62). Next come cardinals marching in pairs, then torch-bearing deacons, then bishops, and finally another torch bearer. The procession of holy men moves out into the campus and across it with a stately gait that is neither swift nor slow.

The cross borne by the young deacon at the head of the clerical avant garde is itself almost as tall again as the men. It glitters in the fire of the candles. The gleam from the surface suggests that this artifact is brand new, and indeed it is. In all likelihood, it is one of the myriad votives made to the Church. For the first Jubilee year, these offerings have been particularly numerous and grand.

As the enormous standard comes into view, the fortunate few who are close enough can "read" that it is covered front and back with biblical scenes of sin and redemption. Rendered in delicate relief, these begin, at the top of the cross's front, by recounting the origins of humanity, the creation of the world, and the formation of Adam and Eve. The emphasis here is on the fall from grace. Thus, the large roundel at the crossing of horizontal and vertical arms pictures the first humans as they eat the fruit of the forbidden tree—the sin that, according to Genesis, brought death into the world. The scenes that follow trace God's rebuke, the expulsion from Eden, and, at the bottom, Noah and his children as they are saved from God's vengeful inundation of the sinful world. As the cross passes, one can discern in the reliefs on its back the more sanguine prospect promised to the saintly patriarchs: Abraham, who was willing to offer his own son as God was to do; Jacob, who at Bethel built an altar and enjoyed a vision of God's angels; and Joseph, who, blessed with a prophetic gift, saved Israel.

But why these scenes from the Old Testament on a cross? They are there to remind the faithful that only Christ's sacrifice redeemed the sin of Adam and Eve. The point is made, not only by the fact that the scenes are arrayed on a cross, but also by the large medallion on the back. The central roundel pictures the Crucifixion, the only scene drawn from the Gospels and the counterpart to the Fall depicted on the obverse. According to a widely held belief, the cross on which Christ died was made of wood from the very tree that bore that the fruit Adam and Eve ate. The cross is thus a new Tree of Life, a point reinforced visually by the narratives and by spiraling leaves embossed on the sides of the enormous standard.

Guardians of the Christ icon. As the churchmen bearing the great cross press ahead, attention turns to another group carrying a still more sacred burden, the *Acheropita.* Just as it does when it resides on the altar in the Sancta Sanctorum, the miraculously made icon remains concealed tonight in its silver case. To enable the *Acheropita,* housed in its weighty case, to be moved safely through

61

Processional cross. (Lateran Museum.)
Made around 1300, this great silver-gilt
cross, more than five feet high, was still
used in church ceremonies through the
1950s; it now resides all the time in the
treasury of St. John Lateran. The front
pictures: (upper vertical arm) *Creation of
the Universe, Creation of Eve, Creation of
Adam;* (cross arms from left) *Denial of
Blame, God Chasing Adam and Eve
Through Eden, the Fall, Expulsion, Work
After Expulsion;* (lower vertical arm) *Esau
Bringing Venison to Isaac, Jacob Before
Isaac, Calling of Noah, Noah and Family in
the Ark.*

the city, a strong wood carrying frame has been made expressly for the Assumption Day eve procession.

Notwithstanding the awesome sanctity of their charge, the bearers of the divinely wrought icon are not men of the cloth. Rather, they belong to a special class of laymen recognized only within the decade before 1300 as entitled to undertake certain religious responsibilities. The Confraternity of the Savior, one

62

Processional cross. (Lateran Museum.)
The back of the cross pictures: (upper
vertical arm) *Joseph's Dream, Sacrifice of
Isaac, Isaac Sending Esau;* (cross arm from
the left) *Jacob Wresting the Angel, Joseph
Interpreting Pharaoh's Dream, Crucifixion,
Joseph on the Way to Dothan, Joseph Taken
from Well, Joseph at Dothan;* (lower arm)
*Cain Killing Abel and God Rebuking Cain,
Sacrifice of Cain and Abel, Jacob's Dream of
Angels, Jacob Anointing Altar at Bethel.*

of Rome's three brotherhoods privileged to serve the Church, includes priests,
but it is principally an organization of local lay aristocrats. Its founder was Car-
dinal Pietro Colonna, scion of one of Rome's most powerful noble families and
a dynasty with particularly close ties to the Church. The brotherhood's missions
are to serve pilgrims, administer charity, tend to the hospital of St. John adja-
cent to the Lateran campus, and take care of the *Acheropita*. The brothers' great-

63
Hospital portico. Situated on a road that follows the Aqua Claudia, this twelfth-century portico, supported on reclaimed spolia columns, gave onto one of the several hospitals in the area of St. John Lateran. The modern hospital of S. Giovanni, rising behind its medieval predecessor, attests to Rome's remarkable continuity.

est honor, of course, is to lift the precious icon from its shrine in the Sancta Sanctorum and, surrounded by the pope and his Curia, to bear it in the Assumption Day eve procession.

Toward the Heart of Ancient Rome

The crowd, which splits to make way for the cross and icon and their bearers, soon closes again to proceed in their wake as they exit the campus. The procession is now headed toward what was once the ceremonial center of imperial Rome. The clerics in the lead disappear through the Arch of Basile, a triumphal gateway at the northwesternmost point of the campus formed by openings in the Aqua Claudia. Surging through the arch, the crowd spills into the upper branch of the via Maior, a quite long, straight street that forks as it ascends the Caelian to the plain between that hill and the Palatine.

An unidentified but noteworthy portico (fig. 63) of particularly harmonious proportions to the left just outside the Arch of Basile catches the pilgrim's eye. Its scale and certain elements of its construction, notably its well-shaped though unmatched spolia columns, give the portico the appearance of a church entrance. In fact, however, it is a hospital. The Lateran is famous for its facilities for treating the sick; earlier in the century, in fact, Francis of Assisi stayed awhile at the nearby hospital of St. Anthony, a hospice served by the same community of monks that attends the pope on all his peregrinations. Like the Lateran baptistery, the hospitals have been situated here to take advantage of the water supplied by the Aqua Claudia. Moreover, proximity to the Lateran offers hospitals

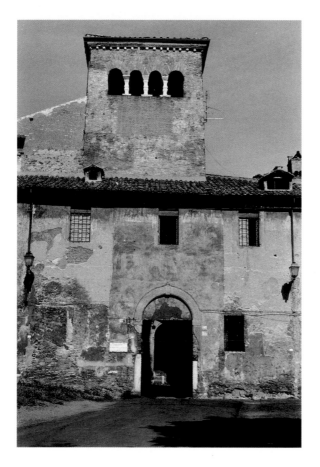

64

Santi Quattro Coronati. At the end of a street the procession followed out of the Lateran is the church dedicated to four Roman martyrs. Erected on a high spot on the Celian Hill, SS. Quattro Coronati offered better refuge for the popes and their entourages than did the Lateran, which lies on low ground nearer the city walls. At the peak of the papal conflict with the Hohenstaufen emperors, Pope Innocent IV (1243–54) fortified the diverse earlier structures on the spot. Sometimes identified as the oldest bell tower in Rome, the imposing structure over the atrium seems actually to have been built as part of fortifications provided still earlier by Pope Leo IV (847–55) and only later equipped with bells. To this day, nuns sequestered in the adjacent convent dispense charity here to the destitute.

the asset of an interested and well-fixed lay community. Members of Pietro Colonna's Confraternity of the Savior maintain this one.

Beyond the structure with the fine portico, however, the via Maior offers little to divert the traveler. Although this sector is the center of papal power, the road out of the Lateran presents mostly ordinary dwellings and establishments set up to feed, house, and hawk memorabilia to pilgrims. Yet if one looks a bit ahead, the partly vacant street affords a view of a most impressive, if unholy, sight. The Colosseum—the Temple of the Sun—looms in the middle distance; long neglected and partly in ruin, it still exerts a magnetic force.

Partway along the route, as the procession passes the fortresslike church and monastery of SS. Quattro Coronati (Four Holy Crowned Ones, fig. 64), the marchers take an abrupt right onto a narrow road that runs north and then west. The purpose of the sharp turn is to avoid what is referred to as the *vicus Papisse* (Lane of the "Popess"), so-called for one Pope Joan. In the middle of the ninth century, it seems, an English woman who had disguised herself as a man rose through the clerical ranks, ultimately to be elected pope. Pope John VIII was the name she took. Made pregnant during a misguided alliance, Pope Joan gave

65
Oratory of Pope Joan. The shrine on the spot shelters a painting of the Virgin and Child. Partway along the road back to the Lateran is the right transept of SS. Quattro Coronati (see fig. 64).

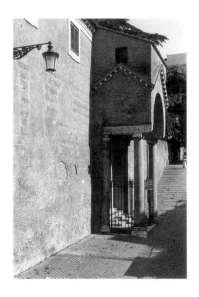

66
San Clemente, protyry. Continuous building, destruction, and rebuilding has gradually raised Rome's ground level; as a result, the entrance to the eleventh-century atrium is well below the modern street.

birth to a child while returning to the Lateran from the Vatican. She died on the spot where the infant was born and was buried there. Although the story is officially discounted as impious rumor, few can help gawking a bit to catch a glimpse of the little oratory that marks the spot as the procession detours to avoid the embarrassing site (fig. 65). Just across the small street from Pope Joan's edicule is the deceptively modest *protyry,* or porch (fig. 66), of the extraordinarily beautiful church of S. Clemente, into which some members of the procession have strayed.

The Church of San Clemente

Although dedicated to a first-century pope (Clement, 88–97), the basilica of S. Clemente now standing dates only to the early twelfth century. In appearance, however, it purposely reflects an Early Christian spirit; indeed, within its foundation lies the wreckage of a building of the fourth century. The predecessor church had stood more than six centuries until Robert Guiscard, the Norman leader and scourge of South Italy, invaded Rome in 1084 to rescue Pope Gregory VII (1073–85) from incarceration by Henry IV of Germany (1056–1106) in Castel Sant'Angelo. Not surprisingly, the crisis had been a struggle for power between rival camps, one imperial and the other papal. To assert the Church's independence from secular authority, Pope Gregory had denied the secular ruler's right to make appointments to ecclesiastical posts. This sparked the battle that culminated, in 1077, in the famous showdown with Henry IV and in the pope's arrest and imprisonment.

The same spirit of reform that incited armed conflict also accounts for the architectural character of S. Clemente. The church's appearance—its basilical plan, atrium, and use of spolia—is the result of conscious efforts by the so-called Gregorian popes to reinstate the primitive aspect of the Church. These three popes were Victor III (1086–87), who, as Abbot Desiderius of Montecassino before his elevation to the papacy, had rebuilt the monastery according to Early Christian models; Urban II (1088–99); and Paschal II (1099–1118), the reigning pope when S. Clemente was built. All three sought to create physical witnesses to their reforms by returning to Early Christian sources for their buildings and artistic enterprises. Many of the churches of Rome reflect their initiatives, including parts of nearby SS. Quattro Coronati (dedicated in 1116) as well as S. Crisogono and Sta. Maria, both in Trastevere.

In plan and external aspect, S. Clemente reflects this spirit of reform perfectly. The basilica is entered through a protyry set into a two-storied gatehouse. With its upper story supported on four spolia columns of differing stone and with unmatched bases and capitals, the porch conveys from the outset the church's aura of ancient austerity. Beyond the protyry, an atrium (fig. 67)—a courtyard surrounded on all four sides by a covered portico—buffers the church

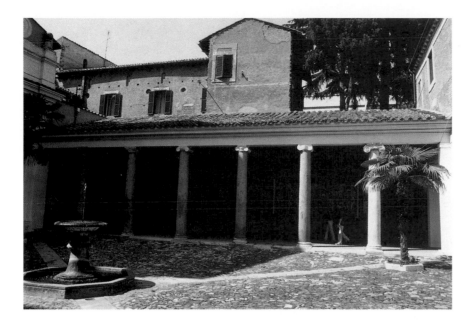

proper from the street. It is a colonnaded, rectangular courtyard familiar from classical Roman houses and communal spaces (already in the time of Constantine, architects had appropriated atriums and used them as spaces for instruction, ablution, and preparation). San Clemente's atrium also separates the church from the canons' residence at the right, where clergymen work, eat, and sleep. The wall of the atrium abutting the church provides a portico for the church, which one enters through a central doorway.

The pure Early Christian spirit has shaped the internal space of S. Clemente (fig. 68). Within, the basilica consists of a simple nave, single side aisles, and an apse. The basilica and its furnishings serve a single purpose: to articulate the sacred services they were constructed to adorn. Beginning at the entranceway— that is, at the world outside—they lead the faithful, step by step, toward a holy realm occupied by men who have dedicated their lives to God's work led by his surrogate on earth, the bishop.

Except for the basilica's basic design, however, S. Clemente's austerity stops at the door; and, in this respect, too, the church presents an Early Christian aspect. A variety of ancient spolia, graceful arches, and, most of all, abundant exquisite ornamentation offer more than mere relief from the starkness of the exterior and simple elegance of the plan. Granite columns are mixed with marble, fluted shafts with smooth, all with diverse capitals and bases. Amid such variety in the structural elements, however, order is maintained by the matching of columns in pairs flanking the nave to mark off the side aisles. The floor, moreover, is covered in a rich, symmetrical, many-colored Cosmatesque pavement that begins at the door and carpets the nave, the side aisles, the raised

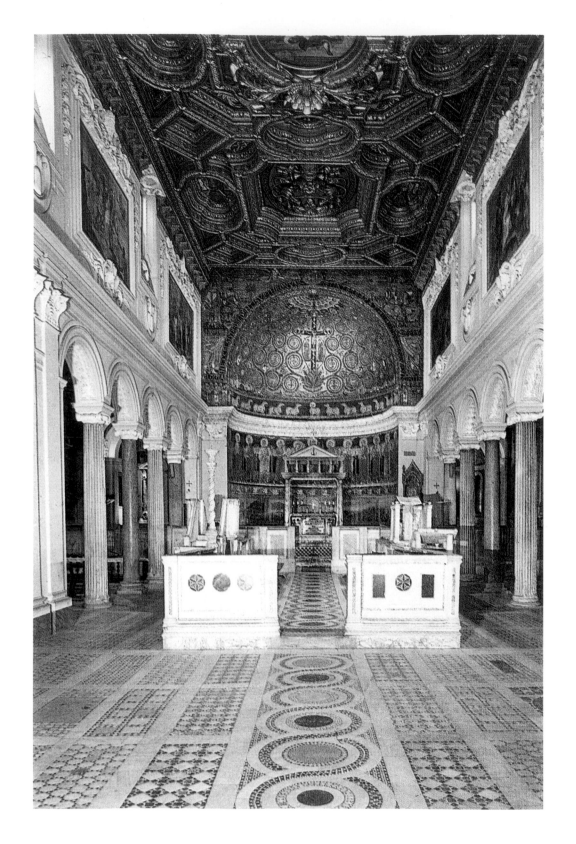

69

San Clemente, nave floor. When seen
from above, the functional aspect of the
Cosmatesque floor is particularly clear.
The porphyry disks wrapped with marble
links provide a pathway through the
schola cantorum to the sanctuary.

precinct in which the clergy sit during services, the presbytery, and the apse (fig. 69). The kaleidoscopic marble floor forms a majestic path from the church's entrance to the altar, permanently designating the route of ecclesiastic ceremonies and the marking of the cross that priests trace in ashes and holy water within the sanctuary.

The processional way in S. Clemente passes through the clerical enclosure known as the *schola cantorum*, a term that reflects the fact that Popes Urban II and Paschal II had both made choral chanting of the canonical hours mandatory in Rome's churches. Walled by polished white marble slabs, the schola cantorum was actually salvaged from the much earlier building, damaged in Robert Guiscard's rescue mission, that was taken down and now forms the present church's foundations below. That part of the ancient furnishing was refitted for the new nave is entirely consistent with the spirit of Early Christian revival that governs the structure. Several slabs bear the monogram of Pope John II (533–35), the presbyter of S. Clemente before his elevation to the throne of St. Peter. Hence, although it has been adjusted to the new nave, the schola cantorum actu-

Opposite:
68

San Clemente, nave. Extensively rebuilt
during the Baroque period, the church
still preserves much of its early twelfth-
century character. The arches, clerestory,
and ceiling date from the eighteenth cen-
tury, but the pavement, columns, schola
cantorum, ciborium, and magnificent
apse mosaic are all medieval.

San Clemente, pulpit. During the
twelfth-century remodeling, a candlestick
for the Easter liturgy was added at the
end of the old ambo.

ally dates to a time when the generally unfurnished spaces of Early Christian
basilicas were first being articulated for the developing liturgy. The two plaques
facing the door, moreover, were reworked by the Cosmati workshop; wreaths
ringing the monograms have been fitted with colored stones, and the frames
have been filled with mosaic designs. Thus, although the sculptors admired the
work of their predecessors, they also seem to have felt able to improve the
ancient pieces with their own inlaid marble ornamentation. Viewed from the
church's entranceway, the colorful added ornament has the effect of integrating
the severe, classical, Late Antique schola cantorum with the basilica's highly col-
oristic twelfth-century floor.

Within the schola cantorum, a pulpit at one side and an ambo at the other
provide for the reading of the Epistles and the Gospels (fig. 70). When the dea-
con (preceded by candle- and censor-bearing assistants) mounts the steps of the
ambo bearing the Gospels, epiphanic prayers accompany him as though he were
Christ himself entering the congregation, who was the Word made flesh. At one
end of the ambo, a twisted column decorated with delicate, brilliantly colorful
Cosmatesque work has been added to the ancient liturgical furniture. It stands
ready to hold the paschal candle for a ceremony that dates only to the eleventh-
century reform. On the night before Easter, an enormous candle, symbolic of
the column of fire that preceded the Israelites during the Exodus from Egypt,
is lighted to mark the victory of light over darkness and life over death (fig. 71).

Beyond the schola cantorum but directly accessible from it, a much higher
barrier of similar marble slabs separates the nave and aisles from the sacred
nucleus of the church; the basket-weave pattern carved in reused marble (fig. 72)
is a particularly fine example of sixth-century stonework. Just within the sanc-

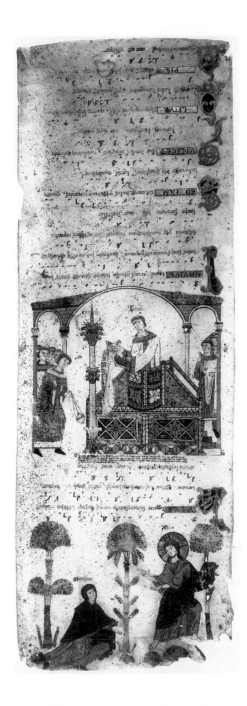

71

Portion of Exultet Roll. This liturgical manuscript was produced in the monastery of Montecassino at about the same time the present, twelfth-century S. Clemente was being built. The form and arrangement of the S. Clemente pulpit and candlestick are quite like those in this picture, showing clerics, within the nave of a three-aisle basilica, blessing and censing the paschal candle. During the service, the officiating priest draped the parchment roll over the pulpit (as appears here); for that reason, the text, read by the cleric, is written in one direction, and the picture, seen by those below, is oriented in the other. (BAV, Cod. Barb. Lat. 592, sect. 3.)

tuary is the altar, sheltered by a large but simple *ciborium* (canopy). This focuses attention on the place where Christ's sacrifice is enacted in the church during Mass, while it also allows the bishop's throne (cathedra), elevated four steps higher at the head of the apse, to remain visible to the congregation (fig. 73). The back of the throne, carved to form a kind of halo behind the sitter, is a reused slab from the buried lower church. It bears a single word of the old

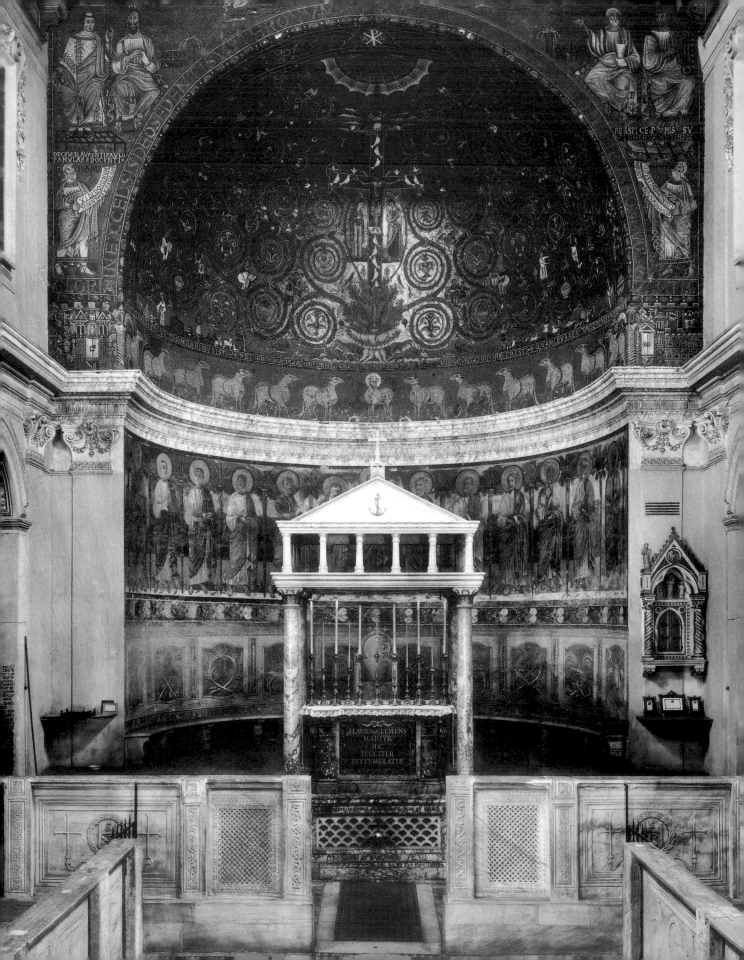

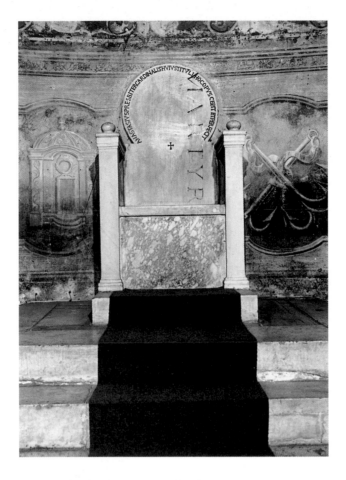

inscription, MARTYR; it also carries a new inscription written around the edge in
a circular pattern, recording the patronage of Anastasius, S. Clemente's cardinal
presbyter between 1102 and 1125. Forming an arc around the cathedra, a bench
for lesser clergymen lines the curve of the apse.

 To the right of the apse, a small marble tabernacle is set into the wall nearly
six feet above the presbytery floor, where it is in full view of all who come to
pray in S. Clemente (fig. 74). This is where the sacraments repose, "out of reach
of profane hands," as a Church council convened at the Lateran in 1215 has pro-
claimed they must be. Commissioned only in 1299 by the cardinal of S.
Clemente, Giacomo Tommasini (a nephew of Pope Boniface), the new taberna-
cle reflects the thirteenth century's growing devotion to the Eucharist. At the
start of the century, the Synod of Paris decreed that, during the Mass, the priest
should elevate the Host to demonstrate the real presence. Then, in 1263, a mira-
cle occurred in Bolsena that confirmed the veracity of the doctrine of Transub-
stantiation: at the moment of consecration, the Host began to bleed. A year
later, the Feast of Corpus Christi was instituted, commemorating God's gift to
humankind of the sacred sacraments.

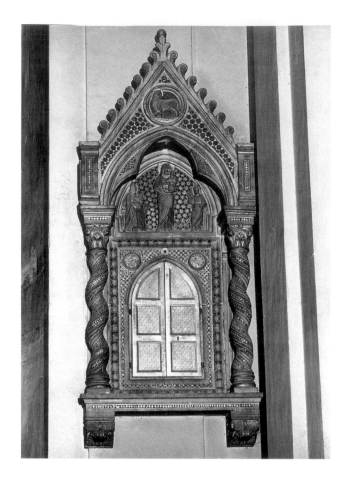

74

San Clemente, tabernacle. The pointed and cusped arches reveal the influence of French Gothic (*opus francigenum*), which had taken full hold in Italy by the end of the thirteenth century. The twisting columns inlaid with mosaic, by contrast, are typical of Cosmatesque art.

From some distance, the little tabernacle is visually consonant with S. Clemente's presbytery, ornamented with Cosmatesque inlay quite like that of the paschal candlestick. The worshiper must come near it to discern the small, sculpted figures on the tabernacle's front. Angels fashioned in the workshop of Arnolfo di Cambio (c. 1245–c. 1310), who has become Rome's preeminent sculptor, flank the canopy, which is appropriately adorned with a medallion picturing the *Agnus Dei* against a blue background. This, of course, is the Lamb of God in heaven, whose sacrifice for humanity is reenacted on earth with the recitation of the prayer *Agnus Dei* each time Mass is celebrated. And in the tympanum inside the shrine, Christ appears, in the arms of his mother—God made flesh so that he could expiate humanity's sin. The tabernacle's patron, Cardinal Tommasini, has had himself depicted here, kneeling before the Virgin and Child, expressly to record in perpetuity his hope for redemption. He is directed toward the divine presence by his namesake, the Apostle James, and is sponsored by Pope Clement, the first century pope and saint honored in the basilica (who looks for all the world like Boniface VIII as yet another device to establish the living pope's lineage).

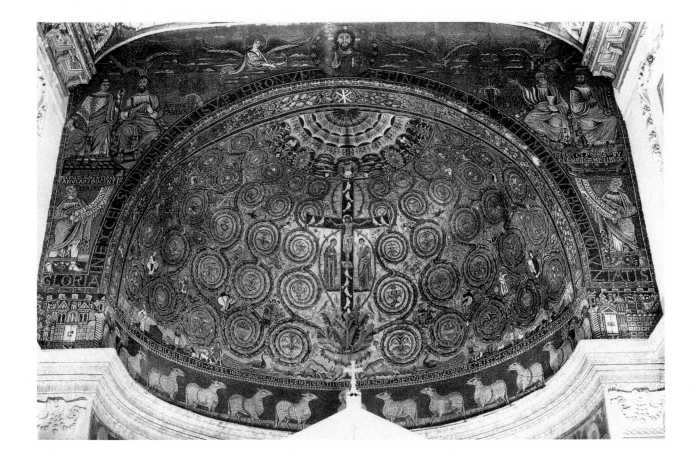

San Clemente's furnishings and decorations construct a hierarchical world. The focus on the altar and bishop's throne from the entranceway ascends vertically from there to the pictorial decorations in the church's apse, the semicircular exedra that includes the cathedra and crescent bench, where the earthly hierarchy intersects with the celestial. There, Mary and the twelve apostles appear, in fresco, on either side of Christ, who is seen in the familiar position of holding a book in his left hand and blessing with his right. Standing on the banks of a river that is alive with fish and planted with flowers and palm trees, the saintly founders of God's Church inhabit paradise, setting the pattern for the earthly Church governed by their ordained successors.

The apse mosaics. Crossing the heavy cornice into the vault of the apse (fig. 75), the faithful gaze on and enter a shimmering world wrought in mosaic, the threshold separating the earthly and heavenly realms. The shift in medium makes this ascent explicit. Patterned marble and fresco cede to brilliantly colored pieces of stone and glass (tesserae) set against a gold ground to create a fitting spiritual atmosphere (fig. 76). Completing the work in 1118 or 1119, S. Clemente's mosaicist revived a technique that had not been used in Rome for two centuries; the sump-

75

San Clemente, apse mosaic. Christ's Crucifixion is presented here as the bridge that links the earthly and spiritual realms and the source of everlasting life. Lambs symbolizing the twelve apostles emerge from Bethlehem to approach the lamb at the center symbolizing Christ. A gemmed border and an abundant vine framing the main conch indicate that the Church, indeed, this very church, is an image of the living church in heaven above. (This photograph predates restoration of the mosaic.)

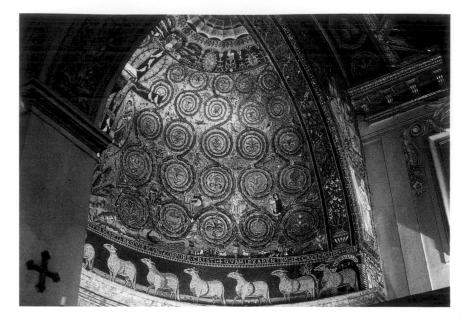

San Clemente, apse mosaic. While the vine, animals, and human figures hint at the earthly paradise, the gold ground elevates the mosaic to the spiritual realm.

tuous patterns and colors transfix the visitor's eye with material splendor, while the preciousness and intellectual complexity elevate the mind to higher things.

At the extreme left and right corners of the vault, twelve lambs process out of the cities of Bethlehem and Jerusalem. Shown in profile, the two files of lambs converge on the nimbed lamb at the center. The gentle creatures figure the apostle-martyrs and Christ directly beneath. At the same time, though, they translate the imagery into a more symbolic, hence higher, mode of representation.

Above the parade of lambs, an inscription declares the intent of the mosaic's main field:

ECCLESIAM CRISTI VITI SIMILABIMUS ISTI

DE LIGNO CRUCIS JACOBI DENS IGNATIIQ[UE]:

IN SUPRASCRIPTI REQUIESCUNT CORPORE CRISTI

QUAM LEX ARENTEM SET CRUS FACIT E[SS]E VIRENTE[M]

The second and third lines refer to three relics preserved within the body of Christ depicted above in the mosaic itself, a piece of the True Cross and teeth of St. James the Apostle and St. Ignatius: "The remains of the Cross of wood [and of] James and Ignatius / rest above this inscription [in] the body of Christ." The first and last lines, read together, give meaning to the profusion of motifs and figures in the apse mosaic as a whole: "This vine shall be a symbol to the Church of Christ, which the Law makes wither but which the cross brings to life" (trans. E. Kane). The apse mosaic introduces the central mystery of Christianity: Christ's death on the cross redeemed humankind's sin, providing eternal life to those who enter his Church.

The figures depicted in the tier just above the inscription make this message explicit. Stags, birds, a snail, a lizard, and two peacocks (the traditional birds of paradise), advance toward a river, which issues forth in four streams. As on the base of one of the ninth-century reliquaries in the Sancta Sanctorum, the allusion here is to Genesis (2.9–10): "And in the middle of the garden [of Eden] he set the tree of life and the tree of the knowledge of good and evil. There was a river flowering from Eden to water the garden, and when it left the garden it branched into four streams." The profusion of life and nourishment visualized here refers also to the recapitulation at the end of the New Testament: "He showed me the river of the water of life, sparkling like crystal, flowing from the throne of God and of the Lamb down the middle of the city's street. On either side of the river stood a tree of life, which yields twelve crops of fruit, one for each month of the year; the leaves of the trees serve for the healing of the nations" (Rev. 22.1–2). A further reference to Psalm 42.1 may also be intended: "As a hind longs for the running streams, so do I long for thee, O God." A particular fascination with such art is the way it merges many different scriptural references and, in so doing, demonstrates the essential unity of all Christian doctrine.

Above the stags, two pairs of tendrils sprout from an enormous acanthus, making explicit the belief that the wood on which Christ was killed came from the tree of life in Eden (this conceit repeats a message that the Assumption Day eve marchers have already seen on the Lateran processional cross). The lower, heavier tendrils of the vine divide, twisting and spiraling to form no fewer than fifty circular compartments. All frame images of flora of many kinds and creatures of the land, sea, and air the profusion of life that, before the Fall, had inhabited the earthly paradise. The higher two tendrils are withered and form two schematic ovals, which enclose the verticals of the cross that dominates the center of the apse. Mary and John the Evangelist, also enclosed within these ovals, mourn the dead Christ. The sin of Adam and Eve is redeemed.

The stag and serpent within the acanthus symbolize this triumph over sin and death (fig. 77). The serpent, of course, recalls the tempter in Eden; the stag, according to the widely read collection of anecdotes known as the *Physiologus*, is Christ. Quoting Psalm 42, the *Physiologus* notes that the stag, the serpent's natural enemy, "spits water into the cracks [where the serpent has slithered], draws him out and stamps on him and kills him. Thus did our Lord kill the devil with heavenly waters of indescribable wisdom. The serpent cannot bear water, and the devil cannot bear heavenly words." In this way, the cross that rises from the marvelous acanthus not only recalls the tree of life but is also a trophy, a sign of Christ's victory over sin.

As the inscription indicates, the idea is realized quite literally here by the placement in the S. Clemente mosaic of an actual piece of the True Cross: DE LIGNO CRUCIS . . . REQUIESCUNT CORPORE CRISTI (fig. 78). The mosaic cross itself is explicitly understood not as a naturalistic representation of Christ's

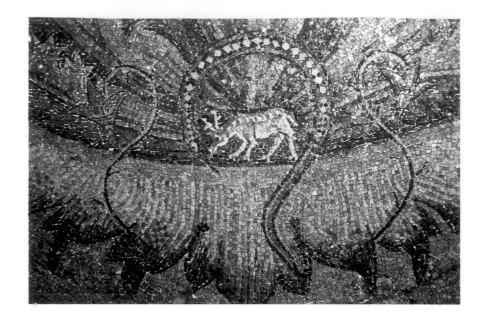

Crucifixion but as a decorated container for sacred remains, a reliquary. It may be
no mere coincidence that S. Clemente's present mosaic Crucifix replaces the
gemmed cross donated by Pope Leo IV (847–55) that had hung above the altar of
the now-interred earlier church. Thus, amid the mosaic's profusion of nature
closely observed and then embellished upon, the cross is purposefully mechanical
and inanimate. Its regular shape, smooth surface, and color elements of deep
blue edged in white and vermilion recall enamel reliquaries (see fig. 51). As Leo
IV's cross once did, then, the mosaic containing a fragment of the True Cross
now connects the apse with the altar below, where Christ's sacrifice is reenacted
during the Mass. The image does more than mark the theological watershed of
Christ's death; it also makes real the inscription's allusion to the Church of
Christ, the source of redemption in the here and now.

In fact, the S. Clemente mosaic is rife with references to the Church. The
doves within the cross—twelve in number—stand for the prophets or the apos-
tles (or both). The farm figures along the lower edge feeding fowl and tending
goats and sheep stand for the community of the faithful within the Church (fig.
79). The four churchmen in spaces above the first tier of acanthus spirals are the
Church Fathers Ambrose, Augustine, Jerome, and Gregory. And higher still, the
winged, naked figures blowing on horns and riding sea and land creatures help
to propel the ascent from the earthly to the heavenly realm. As in the Sancta
Sanctorum, these and the birds above them symbolize souls soaring toward
heaven (in contrast to the earthbound chickens, which still need tending by the
Church). And the great swags that frame the apse are the abundance of life that
the Church nourishes. The very decoration of the space in which the faithful

78
San Clemente, apse mosaic, detail. The disruption of the mosaic in Christ's chest is a repair of the place where, originally, a relic of the True Cross was embedded.

79
San Clemente, apse mosaic, detail. Unable to fly, chickens must be tended; just as humans must be cared for by the Church if they are to reach heaven.

stand, then, with its profusion of grapes and figs and flowers, asserts that S. Clemente is part of the Christian paradise.

In its construction, too, the mosaic symbolizes the unified Church, deploying individual elements that can be traced to various earlier churches of Rome. Like its architecture, S. Clemente's mosaic betrays a particular nostalgia for art associated with Christian Rome's first golden age. Thus, the large, central cross has parallels in the apse of the nearby Lateran basilica; the acanthus scrolls dividing and subdividing the apse and the celestial fan that radiates from the peak of the vault recall nothing so much as the fourth-century mosaic in the Lateran baptistery (see fig. 11), an association confirmed by the shepherds and a woman feeding fowl depicted in the apse on the opposite side of the baptistery's portico. These quotations not only tie S. Clemente to the Church's ancient past but also integrate the twelfth-century manifestation within a single and eternal ecclesiastical polity: the Church of Rome.

The complex overlaying of diverse themes is highly original, however, and just as the formation of the S. Clemente vine scroll is far more schematic than its Early Christian source, so, too, the theological message is more abstract. Thus, though it is also borrowed from the Lateran baptistery, the great canopy of heaven at the crest of the apse again displays the mosaicist's characteristic way of elaborating and refining the model. Here a broad blue band marks the boundary separating earth perceptible by the senses from heaven. Only the Hand of God proffering a crown of victory to his crucified Son penetrates the fiery clouds, which, like the lambs on either side, symbolize the Incarnation, which bridged the two worlds. Above is the fanlike tent or veil—the firmament that no human eye can penetrate.

Nonetheless, if the worshiper looks upward still more, the mosaic of the apsidal arch offers a glimpse of heaven, at least as far as humans can imagine it. A medallion with the XP (Chi Rho), the ancient symbol of Christ's appearance in heaven, makes the transition, with its suspended alpha (A) and omega (Ω) reminding the viewer that Christ is the beginning and the end. Then, at the apex of the arch, an enormous, static, bust-length portrait of Christ framed by a blue star-filled ring, attests that God is alive in heaven. Holding the Gospel book, he is the Logos, the source of Scripture read in the church below.

At Christ's sides are the celestial beasts of the evangelists that Ezekiel and John envisioned, the lion, man, eagle, and ox. Again, a reference to earlier Roman church decoration may well have been intended; the apsidal arch in the Council Hall of Leo III in the Lateran Patriarchium displays similar imagery. Here, however, the reference is more particular, as the crowns proffered by the winged man and eagle (symbolizing Matthew and John) suggest. Both the Prophet Isaiah and the Apostle John tell us that, in heaven, the creatures perpetually sing God's praises in a hymn from Isaiah that begins "Sanctus, sanctus, sanctus" and is repeated in Revelation (4.8): "Holy, holy, holy is God the sovereign Lord of all, who was, and

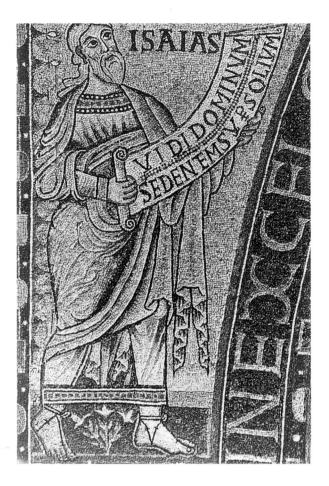

80

San Clemente, apsidal arch, detail. Isa-
iah's vision of God enthroned was taken
as proof that Old Testament prophecies
had been fulfilled by Christ.

is, and is to come." A worthy expression of the timeless vision on the arch, this refrain is also a regular part of the liturgy enacted in the space it frames: the *Sanctus* concludes the epilogue to the preface to the Mass.

In S. Clemente, there is no mistaking the allusion: the Prophet Isaiah, pictured just above the walls of Bethlehem, gazes up toward Christ as he unrolls a scroll inscribed with the words from chapter 6.1 of his prophecy that introduce the chant (fig. 80): VIDI DOMINUM SEDENTEM SUP[ER] SOLIUM (I saw the Lord seated on a throne). The brief excerpt evokes in the faithful the continuation of the text, especially when it is repeated in the Mass, "high and exalted, and the skirt of his robe filled the temple. About him were attendant seraphim . . . calling ceaselessly to one another, Holy, Holy, Holy is the Lord of Hosts: The whole earth is full of his glory." The concept is perfect: Isaiah introduces the appropriate scripture, the mosaic visualizes it, and the congregation completes it when reciting the prayer.

Depicted opposite Isaiah on the right wall of the apsidal arch, Jeremiah, too, affirms that Christ has fulfilled the Jewish prophecy. Also looking up toward the central bust portrait, he bears witness with a quotation from the book of his sec-

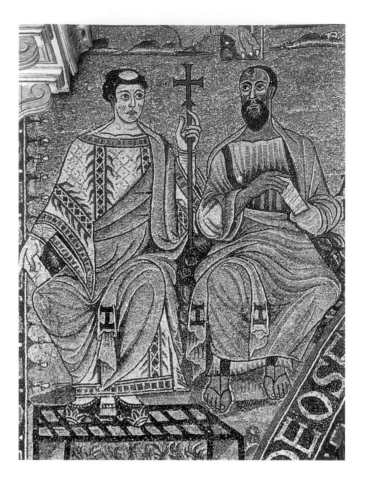

81

San Clemente, apsidal arch, detail.
Lawrence, an early Roman martyr, is
shown with the instrument of his death
(the grill) as he receives instruction from
one of the city's two apostolic founders.

retary, Baruch (3.35): HIC EST D[EU]S N[OSTE]R ET N[ON] ESTIMABIT[UR] ALIUS ABSQ[UE] ILLO (This is our God; there is none to compare with him).

Joining these Old Testament visionaries to the image of Christ's heavenly court are four enthroned saints of special importance to Rome (fig. 81). As the inscription tells, Paul, identified by a transliteration of his Greek epithet, AGIOS (saint), to suggest his Eastern origins, is portrayed at the left instructing Lawrence in the doctrine of the cross: DE CRUCE LAURENTI PAULO FAMU-LARE DOCENTI (The servant Lawrence being taught by Paul about the cross). Seated at Paul's side, Lawrence holds a cross-staff in his left hand, his slippered feet on the grill of his martyrdom. At the right, AGIOS PETRUS sits with his suc-cessor-to-be, Clement, to whom the church is dedicated. Like Jeremiah, the first bishop of Rome, Peter simply declares Christ's presence, RESPICE P[RO]MISSU[M] CLEMENS A ME TIBI CH[RIST]UM (Clement, behold Christ as he was promised to you by me). Clement, who was thrown into the Black Sea, here holds in his left hand the anchor used to weigh him down. In a parallel to the depiction of Lawrence, a boat—the instrument of Clement's death—is pictured beneath this martyr's feet. This completes the hierarchy: those venerat-

ing in Clement's church acknowledge his succession from Peter and, in turn, from Christ.

Running along the rim of the arch, the largest and the best known of the inscriptions ties the imagery together: GLORIA IN EXCELSIS DEO SEDENTI SUP[ER] THRONUM ET IN TERRA PAX HOMINIBUS BONAE VOLUNTATIS (Glory to God, seated on the throne, in the highest heaven, and on earth his peace for men on whom his favor rests). A paraphrase of the Gospel of Luke (2.14), the text had already been introduced in the same location within Leo III's banqueting hall within the Patriarchium; it is therefore yet another tie between S. Clemente and Rome's earlier churches. The *Gloria*, like the *Sanctus,* is a biblical hymn of praise that has long since been incorporated into the Mass.

Looking up at the altar's mosaic backdrop to participate in the Holy Mass, the pilgrim is overwhelmed by the pure harmony underlying Christian doctrine. Christ instituted the Church and its sacraments when he died on the Cross, offering salvation to those who believe in him. Alive in heaven, where he is adored in an eternal liturgy, he awaits the end of time, when he will gather the blessed to his actual presence. Although the pilgrim understands that what she sees and hears are but a facsimile of that experience, the mosaic is intellectually so harmonious and, with the celebration of the sacred service, so emotionally uplifting, that she and every Christian feels privy to a bit of that eschatological event.

4

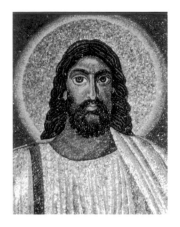

THE *ACHEROPITA* APPROACHES ITS DESTINATION

Opposite top:

82

Colosseum and, in the distance, medieval campanile of Sta. Maria Nova (now Sta. Francesca Romana), and columns of the ancient Temple of Venus and Rome. Begun by Vespasian in 72 C.E. and completed by his son Titus in 80, the great amphitheater could hold some seventy-five thousand spectators at gladiatorial games. During the Middle Ages, it became identified as the Temple of the Sun, where, according to the *Mirabilia,* "Phoebus dwelled; with his feet on the earth, he reached to heaven with his head and held in his hand an orb that signified that Rome ruled over the whole world." Fragments of a statue of an emperor, identified as the sun god, were displayed in the Lateran campus (see figs. 20, 21).

Leaving S. Clemente, the pilgrim turns left (north) to rejoin the procession, which is now streaming down the venerable via Labicana. This ancient artery is leading the marchers directly toward the godless Colosseum (fig. 82), which they skirt counterclockwise. As they round the great, abandoned amphitheater, the light of thousands of candles brings into view the massive Arch of Constantine (fig. 83). Dedicated in 315 to herald the emperor's victory over Maxentius three years before, the arch commemorates the triumph of Christianity over the pagan empire.

Rome's first Christian emperor seems to have wanted, in his arch, a monument that would associate him in the eyes of the people with the merits and might of his illustrious predecessors. This was to be accomplished literally by the appropriation of pieces from his imperial forebears' memorials. Thus, alongside reliefs from Constantine's age, parts of monuments erected in the days of Trajan (98–117), Hadrian (117–38), and Marcus Aurelius (161–80) are embedded in the imposing fourth-century structure. The result is a showy pastiche of sculptural styles that impart diversity and color to the great arch's impressiveness.

In the Heart of Ancient Rome

The pilgrim can see that something not far ahead has slowed the progress of the procession. Word travels back that the bottleneck is the procession's mandatory movement through a much older and much smaller arch that commemorates the deeds of the Emperor Titus (79–81). Passage through the narrow opening

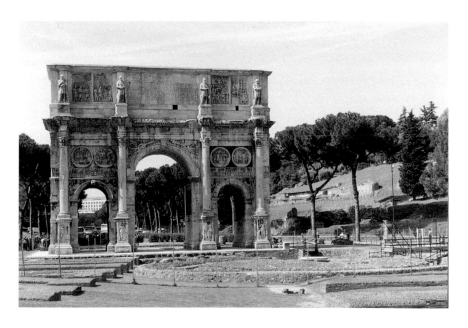

83
Arch of Constantine. As they processed by the Colosseum toward the Forum, pilgrims would certainly have detoured to examine the monument to Christianity's triumph in Rome. The Palatine Hill, largely abandoned in the Middle Ages, is visible to the right. (A building of the United Nations is seen through the left opening.)

84
Arch of Titus. The magnificent ancient pavement of the via Sacra, which led to the Arch of Titus, was buried during the Middle Ages, but the road into the Forum remained a major passageway for pontiffs and their attendants.

of the Arch of Titus (fig. 84) marks a fundamental point in tonight's procession; first, the *Acheropita* must be paraded through the arch, and then every participant in the procession follows.

High reliefs hewn into the walls of the arch's passageway after the death of Titus suggest the significance of this rite (fig. 85). The reliefs on the right side depict Titus entering Rome in a triumphal chariot; those on the left represent the parade of spoils celebrated on this spot a decade earlier, after the conquest of Jerusalem—the seven-branched candelabrum and other objects from the Temple in Jerusalem. Most of this Jewish booty is now kept at the Lateran beneath the altar in the basilica of St. John. Legend has it that the *Acheropita* was originally among these spoils; moreover, when brought to Rome, the icon is said to have cured Vespasian, Titus's father, of a grave illness. The procession tonight thus recapitulates the original event but inverts its meaning: God's Chosen People are now the victors. And they bear a different palladium.

The New Testament justifies the conquest of the Jewish Temple. In his Gospel, the Evangelist Mark reports that Christ vowed to "pull down this temple, made with human hands, and in three days [to] build another, not made with hand" (in Greek, *acheiropoieton;* 14.58). And Mark introduces the dramatic

image of "the curtain of the temple torn in two from top to bottom" at the moment of Christ's death (15.38). When the *Acheropita* passes beneath the arch depicting Titus's victory each year, it thus states the message that Christ had fulfilled the prophecy recorded in Mark's Gospel. In so doing, it also recalls the supersession of the temple cult of the Jews by Christ's sacrifice and reminds the citizens of the "New Jerusalem" that pagan Rome, too, had a preordained role in God's sacred plan.

As the marchers emerge from beneath the Arch of Titus in the wake of the *Acheropita,* the ancient imperial Forum sprawls before them. Once a bustling hub of commerce and government at the heart of the pagan city, the Forum has been allowed to deteriorate into a great basin filled largely with half-buried pagan ruins and haphazard later dwellings. One can discern, amid the disorder, many edifices dedicated to Christian worship, most appropriated pagan buildings, a very few erected expressly for Christian practice. Prominent to the right, the great, gloom-filled Temple of Peace dominates the view in the northeast corner of the Forum (fig. 86). This massive structure has long since been abandoned and let fall fall into ruin; when built by Maxentius and remodeled by Constantine, it served as a court of law. In the distance, the old Curia, where the Roman Senate once sat, presents a barely discernible profile; now the Curia is a church dedicated to St. Hadrian, and it is the procession's ultimate goal within the Forum.

Directly before the hulk of Maxentius's courthouse, though dwarfed by it, stands the oratory of SS. Peter and Paul. Pope Sergius I (687–701) established the oratory on this spot on the via Sacra (holy road) to mark the place where, according to numerous apocryphal texts, Peter and Paul confounded Simon Magus, a magician in the court of the malevolent emperor Nero. The feat of the

86

Basilica of Maxentius and Constantine (Temple of Peace). All that remains of the imposing early fourth-century law courts are the massive vaulted chambers that originally formed one of the aisles.

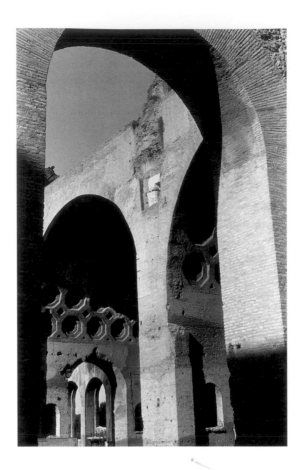

guileful Simon was to impress the emperor by managing to fly. To reveal Simon's feint as mere trickery and not the result of God's intervention, the apostles brought him down with appeals to Christ. In retaliation, Nero had Peter and Paul taken away to their deaths. Depressions left in stone by Peter's knees as he called to God for help can still be seen in the little chapel (fig. 87).

The first meeting of Mother and Son. Adjacent to the oratory and clearly marked by a sturdy bell tower stands the church of Sta. Maria Nova (New St. Mary's), built on a platform once occupied by the great Temple of Venus and Rome (fig. 88). As the name suggests, Sta. Maria Nova is a relative latecomer among the Christian edifices in the Forum. Pope Leo IV (847–55) had it built to replace the much older church of Sta. Maria Antiqua (Old St. Mary's), which stood at the foot of the Palatine Hill, where it had been devastated by an earthquake. Even Leo's "new" church has suffered; after it was consumed by a fire, it had to be reconstructed at the time of the elevation of Pope Honorius III (1216–27).

All the crowd stops here to catch what for most of the marchers is a first glimpse of Pope Boniface and to witness a first reenactment of Christ's meeting with his mother. The brothers of the Confraternity of the Savior, who have been carrying the *Acheropita* through the night, have set up the icon, in its jeweled

87

Knee prints of St. Peter in Sta. Francesca Romana (Sta. Maria Nova). The oratory that once marked the spot in the Forum where the two apostles exposed Simon Magus's trickery has long since vanished, but the imprints of Peter's knees, left in stone and venerated there, are preserved in a nearby church.

88

Arch of Titus and Sta. Francesca Romana. The relief of the emperor's victorious entry into the Forum offered an ancient parallel for the pope's triumphal procession.

Santa Francesca Romana, icon. The enormous depiction of the Virgin and Child (Mary's head alone is twenty-one inches high) was constructed in the thirteenth century to incorporate, and thus preserve, fragments of a sixth- or seventh-century encaustic painting, which had first been venerated in the church of Sta. Maria Antiqua in the Forum and then moved to higher ground in Sta. Maria Nova.

protective case, on the columned portico of Sta. Maria Nova. Alongside the *Acheropita* has been placed the ancient image of the Virgin and Child (fig. 89), which has been brought outside from its place on the altar of Sta. Maria Nova. The pope, surrounded by cardinals and attendants, bows down at the base of the *Acheropita*'s case (see fig. 59). He opens two little doors that give access to the icon's feet. In homage, the prelate pours water infused with basil onto the feet, with this gesture reenacting the episode, recounted in the Gospels, in which Christ washes the feet of Peter and the other apostles.

Overwhelmed, every man, woman, and child in the crowd falls to his and her knees, and the chant of *Kyrie eleison*—Praise the Lord—fills the night air. Then, slowly, they rise to resume their ritual walk.

The church of Saints Cosmas and Damian. Bypassing an impressive portico to the right of the via Sacra, the marchers reach their next goal in mere minutes. This is the church of SS. Cosmas and Damian. Like most of the sanctuaries here, it, too, began as something else—in fact, not as one but as two ancient structures. Specifically, a Roman library provided a foundation for the church (in fact, the interior is still revetted with the original geometrical marble *opus sectile*), and

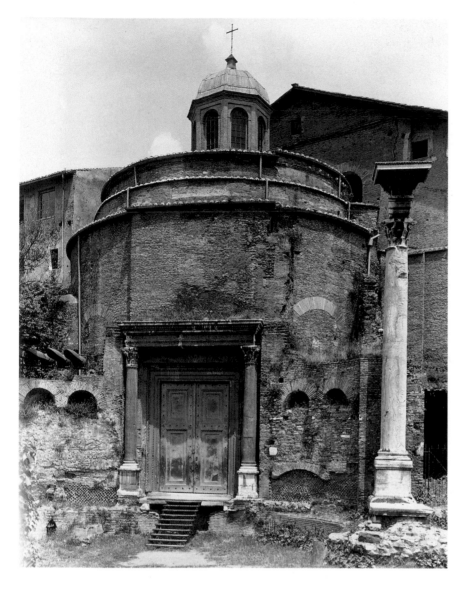

90

Saints Cosmas and Damian. The church was constructed during the sixth century of existing imperial buildings, the so-called Temple of Romulus (foreground) and a library structure (behind). Today the two are again separated. The rotunda belongs to the Forum; the church is entered from outside the Forum from the viale dei Fori Imperiali.

a temple once dedicated to the Emperor Maxentius's son Romulus now serves as an antechamber. The handsome entrance to the cylindrical vestibule, comprising porphyry columns supporting a spoliate architrave (fig. 90), recalls nothing so much as the portal of the Lateran baptistery (see fig. 9); a dedicatory inscription, referring to Constantine, seems to confirm the affiliation. In fact, like the nearby Temple of Peace, the central-planned structure on the Forum's via Sacra was probably begun by Maxentius, perhaps as a monument to himself and his co-emperors, and, again like the Temple of Peace, it was completed by Constantine. Since the pontificate of Felix IV (526–30), however, the imperial monument has served as the vestibule to a church dedicated to two sainted Syrian brothers, both doctors, who performed many miracles and were martyred for Christ.

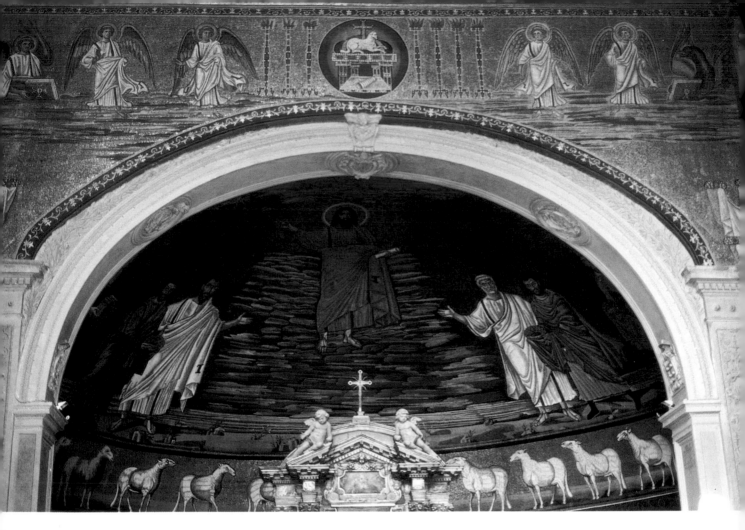

91

Saints Cosmas and Damian. Apse and apsidal arch. The conversion of ancient buildings into Christian churches was not only economical but also symbolic of Christ's victory. Christians preferred religiously neutral edifices, such as libraries, over pagan temples because they best suited the liturgy. In this instance, the earlier structure even provided a suitable apse. Like many medieval churches, Sts. Cosmas and Damian was radically rebuilt during the period of papal triumph following the Reformation, when side chapels were added and the floor was raised. As a result, neither the ancient nor the medieval aspect is visible today; but the dazzling mosaic can now be viewed close-up, as nowhere else.

The interior of SS. Cosmas and Damian reveals the extensive handiwork executed for Pope Felix, who had the existing exedra fitted with an altar and filled with an extraordinary mosaic (fig. 91). Utterly different in scale, style, and mood from the mosaics of the church of S. Clemente, the mosaic here is as absorbing, yet for entirely different reasons. It has none of the bucolic other-worldliness or theological intricacy that overwhelm the faithful in S. Clemente. On the contrary, immediacy and human dignity are its most striking traits.

As elsewhere, an inscription explains the imagery:

AULA DEI CLARIS RADIAT SPECIOSA METALLIS
IN QUA PLUS FIDEI LUX PRETIOSA MICAT
MARTYRIBUS MEDICIS POPULO SPES CERTA SALUTIS
VENIT ET EX SACRO CREVIT HONORE LOCUS
OBTULIT HOC DOMINO FELIX ANTISTITE DIGNUM
MINUS UT AETHERIA VIVAT IN ARCE POLI
(God's residence radiates brilliantly in shining materials; the precious light

of the faith in it glows even more. The secure hope of salvation comes to the people from the martyred doctors, and from the sanctity this place derives honor. Felix offers this worthy gift to God, so that he might live in the heavenly abode.)

In other words, the brilliant mosaic establishes this ancient, once-pagan structure as God's dwelling. By providing this beautifully adorned church, Pope Felix hoped that he would deserve a place in the true Paradise with the two sainted doctors.

Looking up into the apse vault, a worshiper may well feel the urge to speak to the figures of Cosmas and Damian and their sponsors, Peter and Paul, who introduce them to Christ, while St. Theodore and Pope Felix watch from the right and left. Rendered in such lifelike detail and modeling that they seem actually present, the two doctors bear a resemblance that identifies them as brothers. The pilgrim feels sure that she and the men depicted here more than eight centuries ago inhabit the same world. Moreover, the light and shadow that contribute to this vividness seem to come from the candles burning around the altar, an effect enhanced by the shadows depicted on the ground on which the saints stand.

This is sacred ground, however. And if it lacks the supernatural aura evoked by the stylized vines and gold field of the S. Clemente mosaic, the narrow foreground band in the SS. Cosmas and Damian apse is nonetheless meant to signify Paradise, too, filled with flora and separated from heaven by the River Jordan (prominently labeled IORDANES). A phoenix perched in the palm at the left confirms the identification. According to legend, of all the animals in Eden, only the phoenix refused to eat of the forbidden fruit and was, therefore, allowed a form of immortality; after death, it rose from its ashes and lived again. The radiant bird thus symbolizes Paradise and resurrection, an apposite sign for the world trod by saints and by a pope who hoped to gain eternal life.

Beyond the river, Christ appears against a bank of fiery clouds, while the assembled saints direct all viewers' attention to him. Although his appearance is intended to remind the faithful of the promised Second Coming, Christ seems already present (fig. 92). Attired in the toga of an ancient philosopher, his right arm raised in a gesture of teaching, Christ is made divine by the light that radiates from his golden robes. Only if they emulate the virtuous ways of his saints, all worshipers are reminded, will they be accepted into his presence when he returns to earth at the end of time. While Cosmas, Damian, and Theodore proffer diadems to him from below, the hand of God the Father descends with a corona to signify Christ's divinity.

Directly beneath Christ's feet and the River Jordan, the savior appears again, there as in S. Clemente, in the form of a lamb standing on a little hill from which four streams flow. And in the now-familiar iconography, two files of six lambs emerge from Jerusalem and Bethlehem, the followers of Christ from among the Jews and Gentiles.

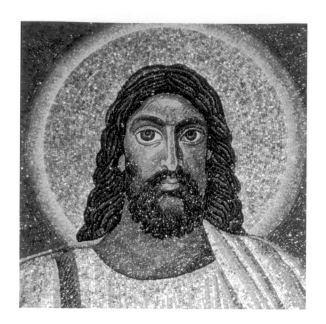

92

Saints Cosmas and Damian, apse, detail of Christ. Christianity brought about neither a decline in the artistic techniques perfected by the ancient Romans, as is often stated, nor an abandonment of pagan imagery. Here the face of Christ is modeled in light and dark tesserae with great subtlety, and his majesty is conveyed through the incorporation of features previously associated with Jupiter and deified philosophers.

The pilgrim also recognizes the core of the imagery on the surface of the arch above the apse, which translocates the subject in the conch to heaven itself. Drawing on Revelation (4–5.10), it pictures the Lamb and cross on a jeweled altar, the books sealed with seven seals beneath:

After this I looked, and there before my eyes was a door opened in heaven; there in heaven stood a throne and in a circle about this throne were twenty-four other thrones and on them sat twenty-four elders, robed in white. Burning before the throne were seven flaming torches, the seven spirits of God. In the center, around the throne itself, were four living creatures, covered with eyes, in front and behind. The first creature was like a lion, the second like an ox, the third had a human face, the fourth was like an eagle in flight. And by day and by night without a pause they sang: "Holy, holy, holy is God the sovereign Lord of all, who was and is, and is to come!" And I saw a mighty angel proclaiming in a loud voice, "Who is worthy to open the scroll and to break its seals?" Then I saw standing in the very middle of the throne, inside the circle of living creatures and the circle of elders, a Lamb with the marks of slaughter upon him. When he took it, the four living creatures and the twenty-four elders fell down before the Lamb. Each of the elders had a harp, and they held golden bowls full of incense, the prayers of God's people, and they were singing a new song: "Thou art worthy to take the scroll and to break its seals, for thou wast slain and by thy blood didst purchase for God men of every tribe and language, people and nation; thou hast made of them a royal house, to serve our God as priests; and they shall reign upon the earth."

93
San Lorenzo in Miranda. Following Pope Felix IV's concession, to the Church, of imperial property in the Forum, which established Sts. Cosmas and Damian, many other ancient structures were gradually ceded to Christian usage. The great temple that Antoninus Pius built in 141 C.E. as a shrine to his wife, Faustina, is documented as a church from the eleventh century onward. The ancient Curia (the medieval church of St. Hadrian's) is visible beyond.

94
St. Hadrian's. During the course of the Middle Ages, the Roman Curia served as a church dedicated to St. Hadrian. It was a principal destination of the Assumption Eve procession.

John's vision made visible in the mosaic is much the same as that in S. Clemente, offering the faithful a glimpse of the perpetual liturgy conducted in heaven that serves as the model for the one in which they participate here below, with its altar, book, candlesticks, and sacrifice.

Ceremonial departure from the Forum. Returning to the via Sacra, the pilgrim discovers that the bearers of the *Acheropita* and most of the throng have bypassed this church and, having in fact traversed most of the length of the Forum, have already reached the church of St. Hadrian. She hurries past the church of S. Lorenzo in Miranda built into the second-century Temple of Antoninus and Faustina (fig. 93) and dedicated to the much-venerated Roman saint Lawrence. And skirting the rebuilt basilica Aemilia, she rejoins the crowd gathered before St. Hadrian's (fig. 94). This church marks the starting point of most Marian observations, and it is an obligatory way station on tonight's trek to Sta. Maria Maggiore, Rome's primary site of the Virgin's cult. For the *Acheropita,* it is the midpoint of the Assumption Day eve journey and the only church so far that the Lateran Christ icon actually enters.

Of the ancient buildings in the Forum that have been transformed into churches, St. Hadrian's bears the greatest significance. Erected as the seat of the

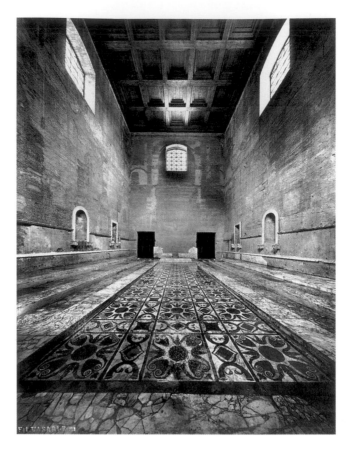

95

St. Hadrian's, interior. Following the ebb and flow of cultural preferences, almost all the medieval interventions were obliterated early in the twentieth century to restore the Curia's ancient aspect, the apse for instance. Only fresco fragments in the lateral niches, depicting St. Hadrian's life, remain from the Middle Ages.

Roman Senate by the Emperor Diocletian (287–305), that legendary persecutor of Christians, it was dedicated by Pope Honorius I (625–38) to a martyred third-century saint. Although it has been Christianized, the building retains to this day the banked platform (fig. 95) that once provided seating for the aristocratic governors of the pagan empire. Also surviving is much of the original opus sectile decoration. Honorius introduced an apse into the northwest wall and constructed an altar and presbytery before it; over the centuries, the building has increasingly taken on the character of a standard church. It now has a nave and side aisles, frescoes depicting St. Hadrian's life and death, and outside, a campanile. The building's original function has never been forgotten, however, and when the cardinals who accompany the pope enter it, they become quite literally what the great eleventh-century Church reformer Peter Damian (1007–72) once called "the spiritual senators of the universal church."

The canon who heads the Assumption Day eve procession has set on the altar of St. Hadrian's the great silver cross that he has carried from the Lateran (see figs. 61–62), positioning it in such a way that the Crucifixion at the center of its back provides a backdrop for the Eucharist. When, during the Mass, a priest raises over his head the sacramental bread, the Eucharist's archetype—the body

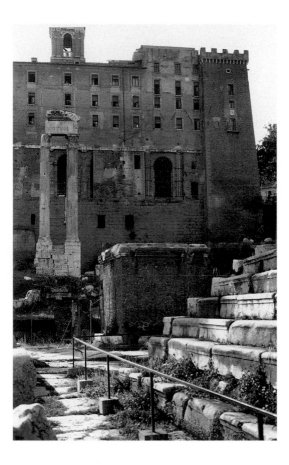

Capitoline Hill. A medieval defense tower is still conspicuous at the far right of the Capitoline palace.

of Christ—appears behind it. And certain other scenes on the great cross take on new meaning when they are seen behind the altar: Isaac bound atop the altar, Cain and Abel making offerings of grain and meat, and Joseph anointing the altar at Bethel—all in line with the Crucifixion—become meaningful Old Testament precedents and, hence, prophecies of the celebration of the Mass. In this way, sacred history enters the present and becomes real.

As the procession leaves St. Hadrian's, it describes an almost closed loop. Instead of proceeding to the Capitol, which rises nearby over the west end of the Forum, it returns almost to its earlier stopping place at Sta. Maria Nova. (By following this course, the marchers turn their back on the ancient center of Rome's government on the Capitoline Hill, which today presents a recently built senatorial palace and the new Franciscan basilica of Sta. Maria in Aracoeli, fig. 96.) The procession stops short of Sta. Maria Nova, turning into a narrow passageway just beyond SS. Cosmas and Damian beneath the abandoned ruin of the Temple of Peace (fig. 97).

To adhere to tonight's course, each marcher must now pass by the Arch of Latona, a cavelike mouth that opens in the foundation of the great, gloomy ruin (fig. 98). It is here that, according to legend, the dragon still lives that Pope

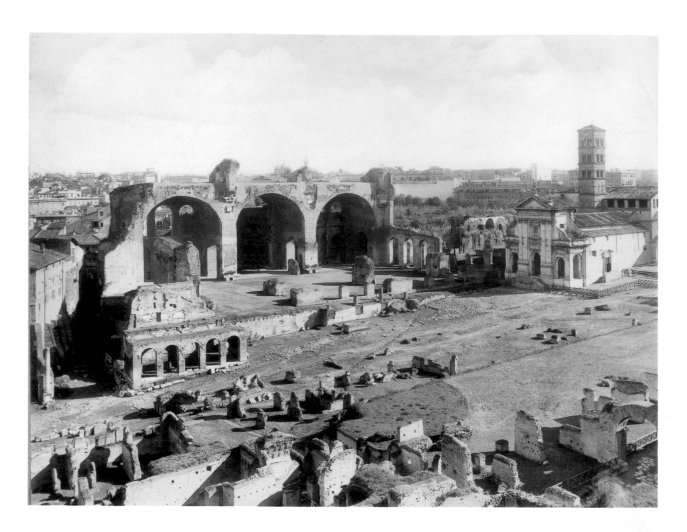

97

Basilica of Constantine and Maxentius and church of Sta. Francesca Romana. Well into the nineteenth century, before the changes brought about by modern excavations and systematization, the Forum preserved much more of its medieval character. The level of the via Sacra and adjacent space before Sta. Francesca Romana was essentially that of the Middle Ages. Much clearer in this century-old photograph than it is today is the passageway through which the Assumption Day procession passed, at the far left between SS. Cosmas and Damian and the basilica of Maxentius and Constantine.

Sylvester himself had conquered, converting the pagan skeptics to Christianity. Much as Sylvester's weapon had been words prescribed by Peter, the marchers' protection tonight will be the *Acheropita,* which has already been borne deep into the maw of the dragon's cave.

The uphill road to Mary's basilica. The procession passes through the ancient Forum of Nerva with its renowned colossal statue of the goddess Minerva still visible in her temple; the figure is now headless, another witness to Christianity's triumph over the pagan gods. In the distance are churches constructed into the walls of the Imperial Forum—Sant'Urbano ai Pantani, SS. Quirico and Julietta, and, within the hemicircle of the forum of Augustus, the church of St. John the Baptist (fig. 99). Beyond these rises the tower of the Militias, one of the most prominent of Rome's many defensive towers, built upon earlier Byzantine and ancient foundations. Moving alongside the imposing tower of the Conti, a fortified residence for one of the city's most powerful families, the marchers pass beneath an ancient arch and begin the ascent through the narrow streets of the

98

Basilica of Constantine and Maxentius, Cave of Latona. The opening into a passageway beneath the Basilica of Constantine and Maxentius was believed to be a dragon's lair, spawning the legend that, in this spot, Pope Sylvester had vanquished the monster and secured Rome's safety.

99

Imperial Forum. Shadows of medieval churches—outlines of peaked roofs, holes for beams, and even vestiges of apses—still mark the walls of classical buildings in the Imperial Forum. The Tower of the Militias is visible in the distance at the far left.

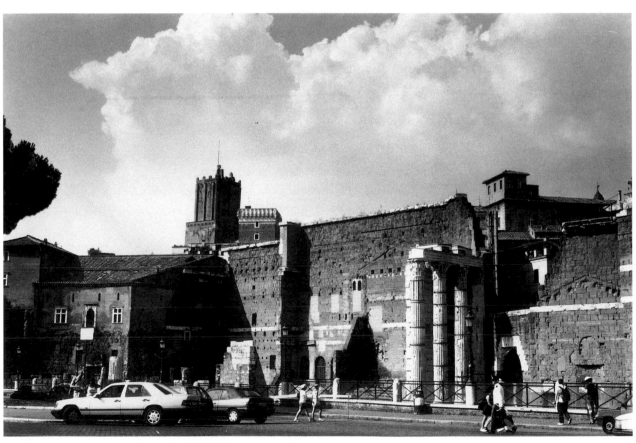

100

Capocci towers. Although heavily restored, the two towers near the church of St. Silvester (S. Martini ai Monti) provide a vivid impression of the fortified palaces that filled Rome at the time of the first Jubilee (see fig. 18). As in the fresco of Peter's martyrdom in the Sancta Sanctorum, such fortified residential complexes characterized the city's urban center. (The Baroque staircase in the foreground leads to the apsidal end of the church.)

Esquiline Hill. The procession bypasses the church of St. Peter in Chains, which the Empress Eudocia founded some nine hundred years ago to house the chains from which an angel released the imprisoned St. Peter.

Everywhere lookout towers erected to defend other grand houses pierce the night sky, some more than ten stories high (fig. 100). Two of the most impressive—the towers of the Capocci and Cantarelli families—loom directly overhead as the procession snakes its way through the steep Clivus Suburbanus to Sta. Lucia in Selci (fig. 101), another Christian building erected on an ancient ruin rife with mystery. Here, on this very day nearly half a millennium ago, Pope Leo IV exorcised a basilisk lurking in the ancient fountain of Orpheus. It is surely not by chance that the church right next to Sta. Lucia is dedicated to Sylvester, Leo's sainted papal predecessor who subdued another dragon in another ancient lair, the Arch of Latona. And the fact that the procession has passed both sites of papal triumph reenacts the special power of the *Acheropita;* the pilgrim is forcefully reminded of God's continuing protection of the faithful in his sacred city, through his servants, the popes of the Roman Church.

The Church of Santa Prassede

Turning north, the procession passes before another church that, for some of the marchers, piques irresistible interest. This is the basilica dedicated to St. Praxedes (Sta. Prassede), one of two daughters of the Roman senator Pudens, on whose ancient property the building stands. (Her head is now one of the principal relics in the Sancta Sanctorum.) According to legend, St. Paul himself converted Pudens to Christianity; his daughters, Praxedes and Pudentiana, were both martyred for their faith.

On first glimpsing the church of Sta. Prassede, some of the pilgrims may think that tonight's tortuous course has taken them back to S. Clemente (fig. 102). As differences confirm that this is not the twelfth-century basilica where some paused a few hours ago, observant marchers may begin to note that Rome has generated a characteristic church type: the churches dedicated to Saints Clemente and Praxedes are perfect representatives. Santa Prassede, in fact, was constructed three centuries earlier than S. Clemente, during the papacy of Paschal I (817–24)—the same pope who commissioned the grand reliquaries now in the Sancta Sanctorum—that is to say, at the peak of the cultural revival begun and nurtured during the reign of Charlemagne and his successors. Paschal I relocated the site of an earlier church dedicated to Praxedes and designed this basilica anew. (A fifth-century church dedicated to Pudentiana, Sta. Pudenziana, stands not far to the north.)

As austere as S. Clemente on its exterior, Sta. Prassede, too, is preceded by a small porch supported on columns (two instead of S. Clemente's four, one ancient spolia and the other medieval). Here, however, the small porch does not

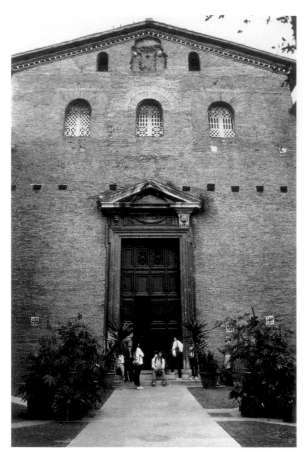

103

Santa Prassede, atrium. All four sides of
the forecourt were originally provided
with a covered passageway supported on
columns, the facade side serving as a
porch for the church. The holes for the
roof beams and a few of the columns
remain. The portal, by Martino Longhi,
was added under Charles Borromeo.

104

Santa Prassede, facade window. A frag-
ment on the intrados of the left window
establishes beyond doubt that the facade
was originally covered with mosaic. The
rather crude setting of the stones is a con-
sequence of the need, during the ninth
century, to reinvent the technique of
mosaic-setting. The choice of colors and
the geometric designs recur in the Zeno
Chapel inside, securing the date to the
pontificate of Paschal I (817–24).

open directly into an atrium but, rather, leads to a steep covered stairway; as a
result, the icon procession is again slowed, perhaps because the pope is again
washing the *Acheropita*'s feet. Once in the colonnaded courtyard at the top of
the covered stairs, the pilgrim sees that the atrium, too, resembles its S.
Clemente counterpart (fig. 103). The facade of Sta. Prassede, however, is unlike
any other seen tonight, for it is completely covered with mosaics: yet even the
light of procession candles does not allow the subject of the colorful entry wall to
be read in the dark (fig. 104).

Inside, the two basilicas' architecture and decoration have important com-
mon features as well as differences. As at S. Clemente, the basic plan of Sta.
Prassede is that of a relatively simple basilican church, with single side aisles sep-
arated from the nave by ancient spolia columns (fig. 105). And here, too, grand
golden mosaics lining the apse and the framing arch provide a focus on this, the
holiest spot in the church. The effect is also much the same as those in S.
Clemente: the viewer is drawn down the center of the nave toward the divine
realm rendered in mosaic. At Sta. Prassede, however, the nave columns support
not arches but a continuous architrave made up of ancient blocks. Regrettably,
the original post-and-lintel construction began to give way during the past cen-

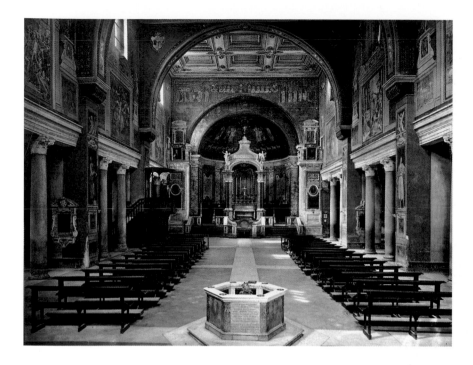

tury, and large transverse arches had to be introduced for structural reinforce-
ment. These disrupt the crescendo effect that the church's architect so carefully
constructed with the artful positioning of the more richly carved spolia closer
to the altar.

Moreover, although both S. Clemente and Sta. Prassede have mosaic-cov-
ered arches and apses that focus attention on the sanctuary (fig. 106), only Sta.
Prassede is fitted with a transept—that is, a rectangular architectural structure
before the apse that cuts perpendicularly across nave and aisles and makes the
ground plan of the church cruciform. Santa Prassede's transept, raised two steps
above the nave floor and marked off by T-shaped piers, is a distinct and separate
precinct. Indeed, it extends to the north and south beyond the width of the nave
and aisles. (During the twelfth century, a bell tower was erected over the left
arm, blocking this space.) Thus, although the resemblances to S. Clemente are
striking, the differences point to Sta. Prassede's distinct origin and function.

Paschal's haven for the dead. Pope Paschal's mission in building the church was
to provide a suitable resting place within the city for relics rescued from the now-
abandoned catacombs outside the walls, where graves were commonly plundered
by vandals. An inscription on a plaque (fig. 107) engraved in fine rustic capitals
(imitating ancient Roman epigraphs, see fig. 16) records the numerous bodies of
saints that Paschal brought to the safe haven of Sta. Prassede from the cemeteries
outside the walls where they had been scattered. (Many pilgrims, especially those
coming to Rome from the south and east, have taken the opportunity to visit the
catacombs.) The plaque lists twenty-three hundred in all, including first-century

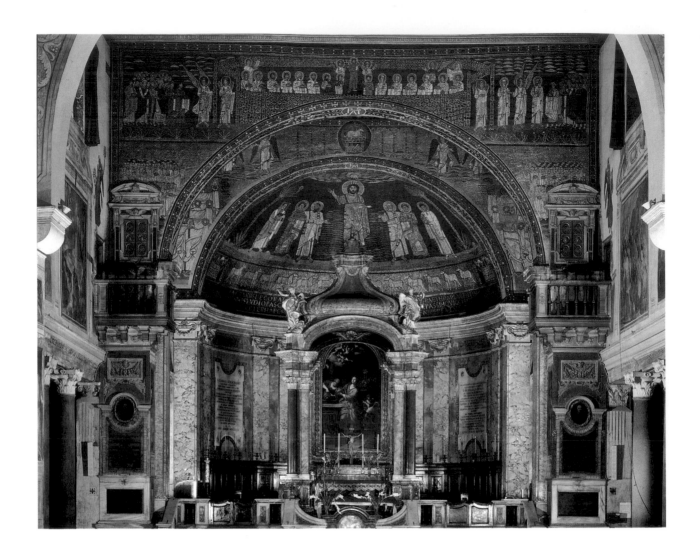

106

Santa Prassede, sanctuary. The two adorned arches were designed to function as an ensemble. The triumphal arch presents the Heavenly Jerusalem as a metaphor of the Church of Rome and, in turn, of Sta. Prassede itself, shelter of the saints. The apsidal arch represents the eternal liturgy, which the terrestrial liturgy reflects.

popes Miltiades, Pontianus, Celestine, Zoticus, and Felix, whose names, the plaque proclaims, are recorded in the book of life. Since 817, the principal relics have been ensconced in the semicircular crypt beneath the apse and in the passageway leading from the head of the crypt to beneath the altar.

For obvious reasons, frescoes on the transept walls of Sta. Prassede depict the deaths of these martyrs, row upon row higher than the eye can grasp, suggesting how vast the number and diversity has been of those who died rather than renounce Christ. Some saints are shown being condemned; others appear being led to death or buried. In each case, an inscription provides a brief identification: *Where St. Julian is beaten to death, Where Leo is sent to the flames, Where the Emperor Numerianus throws SS. Crisantus and Daria into the arena,* and so on. These confirm what the plaque's inscription asserts: that Paschal had the bones of these saints "translated," or transferred, to this church; he brought the relics of

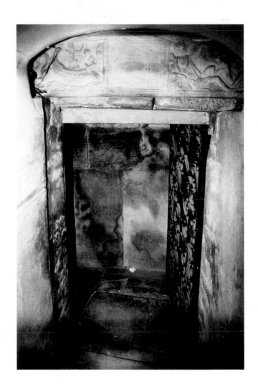

107
Santa Prassede, Paschal's inventory. A beautifully carved plaque (reworked during the Renaissance) records some of the saints whose bones Pope Paschal transferred to the church from outlying catacombs.

108
Santa Prassede, entrance to the crypt. The church's crypt allows visitors to circulate near the saints' graves without violating the sacred area around the altar overhead. The lintel, made from an Early Christian sarcophagus, sets the tone of the descent by picturing Jonah cast up from the sea monster's belly.

Crisantus and Daria, for instance, from their original resting place in a cemetery on the via Salaria (one of the main thoroughfares leading to Rome). At the same time, the pictures make vivid the sufferings of the martyrs who gave their lives for the faith and who truly constitute the Church.

The scenes of sacred sacrifice move the pilgrim to venture into the crypt to venerate the remains that Pope Paschal had brought here. As she and the others who are similarly moved descend, they must be careful not to bump their heads on a lintel (fig. 108) constructed from a sarcophagus of a third-century woman called Ulpia (the epigraph engraved nearly a millennium ago tenderly terms Ulpia "the rarest of wives"). On Ulpia's casket, the pilgrim can decipher pictures of Jonah and the sea creature that had swallowed him now disgorging him; this is the scene most commonly depicted on Early Christian sarcophagi, symbolizing hopes for resurrection after interment. Just as Jonah returned after three days in the belly of the whale, so, too, did Christ rise after three days in the tomb. The carved sarcophagus is particularly apt for the entrance to Sta. Prassede's crypt: it suggests the ancient tombs that were once the saints' burial places outside the walls and here recalls the everlasting life promised to the faithful.

Beyond the spolia lintel, the crypt's low, dark, winding corridor, covered in stone and stucco, actually resemble the catacombs from which Pope Paschal has rescued the many martyrs' remnants. Aided by lamps placed in alternating wall

niches, the pilgrims venture to the apex of the semicircular crypt and into the tongue of the subterranean corridor. This leads to a spot directly below the church's main altar, where the principal saints lie buried. Each pilgrim touches the tombs with pieces of cloth (*brandea*) they carry for this purpose, following a centuries-old practice based on the belief that the aura of the saint is transferred to the fabric and can thus be carried home. One by one, the travelers exit the crypt to ascend into the church's right transept.

In dramatic contrast to the gloom of the underground chamber, which is heavy with the feeling of death and mourning, the area around the altar visually sings of triumph and celebration. Six magnificent gray columns, perfectly carved with lush foliage and windswept leafy capitals, set off the sanctuary. More like living trees than inert stone, these shafts suggest the life-giving power of the Eucharist. The altar within this precinct stands in the shelter of a magnificent ciborium, a silver arched canopy on four porphyry columns (fig. 109). The ciborium alludes both to the Holy of Holies inside the Jewish Tabernacle, covered over with two cherubim, and, of course, to the portable canopies used to honor kings, emperors, and popes (see figs. 28 and 60).

At the gateway to the Heavenly Jerusalem. In the mosaic images above and beyond the ciborium, the worshiper again experiences a sense of déjà vu. This time, however, the apse mosaic of the church of SS. Cosmas and Damian comes to mind. To be sure, the figures in Sta. Prassede's mosaics lack the volume and detail of those in the sixth-century church; the bodies are flat, and the facial features are rather simple (fig. 110). But there is no doubt that Pope Paschal intended, with his new mosaic, to emulate the earlier composition in the Forum. As in SS. Cosmas and Damian, Christ floats on a bank of multihued clouds, the hand of God above bearing a crown that signals his glory. Here, too, six figures—Rome's *dioscuroi* (two apostolic protectors) among them—flank Christ, but where Pope Felix's mosaic honors two revered brothers, Pope Paschal's ninth-century reprise pays homage to two sainted sisters. Standing on the shores of the River Jordan, Paul and Peter conduct Praxedes and Pudentiana, each proffering a crown, into Christ's presence. Pope Paschal, a model of the church in his covered hands, stands at Praxedes's side; a tonsured saint whose identity the pilgrim cannot determine stands beside Pudentiana. As in both S. Clemente and SS. Cosmas and Damian, symmetrical queues of lambs emerge from Jerusalem and Bethlehem to meet the Lamb of God standing atop the four rivers.

Here, too, an inscription below documents Paschal's mission in building this church while also stating his ultimate hope:

EMICAT AULA PIAE VARIIS DECORATA METALLIS
PRAXEDIS D[OMI]NO SUPER AETHRA PLACENTIS HONORE
PONTIFICIS SUMMI STUDIO PASCHALIS ALUMNI
SEDIS APOSTOLICAE PASSIM QUI CORPORA CONDENS

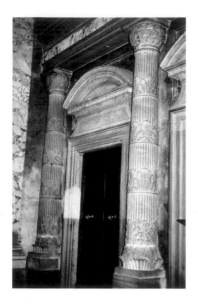

109

Santa Prassede, pergola columns. Now set against the walls of the apse, these unusual Hellenistic columns had been arranged during the Carolingian period as a pergola before the main altar. Like many other aspects of Sta. Prassede, this feature, too, imitated St. Peter's basilica.

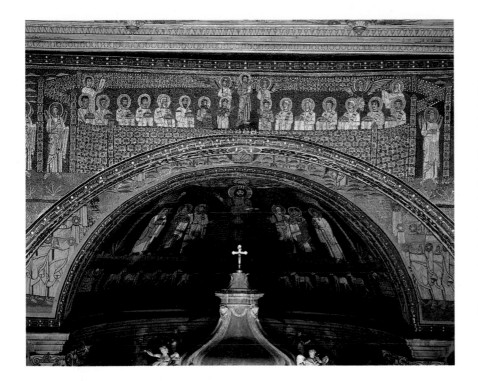

110
Santa Prassede, apse and apsidal arch,
detail. In the apse, Rome's two guardians,
Peter and Paul, conduct the sisters
Praxedes and Pudentiana into Christ's
presence. As in Sts. Cosmas and Damian,
the phoenix at the left and the inscription
(IORDANES) signal that this is a vision of
paradise. On the triumphal arch the apos-
tles, led by Peter, bear gold crowns to
Christ. The angel and graybeard at the
right may refer to the passage of the
Book of Revelation: "The angel who
spoke with me carried a gold measuring-
rod, to measure the city, its wall, and its
gates."

PLURIMA S[AN]C[T]ORUM SUBTER HAEC MOENIA PONIT
FRETUS UT HIS LIMEN MEREATUR ADIRE POLORUM
(The hall beams, decorated with gold and silver, in honor of the saintly
Praxedes, who has found pleasure with God in heaven above, through the
zeal of the Pontifex Paschal, raised to the apostolic throne, who collected
the bones of many saints and buried them under these walls, trusting that he
has secured a place in thine house by this service.)

Above the apse, the apocalyptic vision of the *Agnus Dei,* enthroned and
worshiped by angels, also recalls the Pope Felix's church in the Forum, as do the
seven candlesticks, four beasts, and twenty-four elders arranged in ranks on the
walls of the apsidal arch.

There can be no doubt that the derivative aspect of Sta. Prassede's apse
mosaic was planned. In following a model, Pope Paschal's design was to link his
ninth-century church to the Early Christian tradition and, in so doing, to mani-
fest the fundamental continuity of the Church of Rome. That seems to have been
a conscious objective, especially for the Carolingian period, during which
renewal of the Early Christian past and its art was paramount.

The mosaics of Sta. Prassede, when viewed from the church's main entrance,
visually merge into a single composition that appears to recede indefinitely into
the distance. Closer up, however, it is clear that they are spread over two dis-
tinct zones; one on the apsidal wall, as in S. Clemente and SS. Cosmas and

Damian, and the other opening onto the transept. Indeed, if Sta. Prassede's apse and apsidal arch mostly paraphrase earlier work, the mosaic of the arch before the transept known as the triumphal arch has its roots right here. The term itself may have been coined for Sta. Prassede when Paschal's biographer referred to the *arcus triumphalis* in his description of the church, for the first time applying to a church element a term used until then only for imperial victory monuments such as the Arch of Constantine (see fig. 83).

The imagery, too, is entirely original and suited to the specific function of Paschal's church. At the center of the triumphal arch is a depiction of the Heavenly Jerusalem. Its walls and gates, like the Bethlehem and Jerusalem in the apse mosaic, are of gold and gems, as Revelation describes: "So in the spirit he showed me the holy city of Jerusalem coming down out of heaven from God. It shone with the glory of God; it had the radiance of some priceless jewel, like a jasper, clear as crystal. The wall was built of jasper, while the city itself was of pure gold, bright as clear glass. The foundations of the city wall were adorned with jewels of every kind. . . . the streets of the city were of pure gold, like translucent glass" (21.10).

Christ appears at the center, his right foot forward and right hand raised in blessing; floating above the sacred city and flanked by angels, he represents the archetype in heaven. Mary and St. Praxedes, silhouetted against the angels, raise their hands toward Christ in prayer. And ranged on either side of the two women are Paul and Peter, the ten other apostles, and John the Baptist. All the men proffer crowns. In so doing, they paraphrase the twenty-four elders depicted not here on the triumphal arch but beyond, on the apsidal arch. The effect is to join the groups on the two, separate, consecutive surfaces.

At the left corner of the triumphal arch's walled city, a young man holds a sheet of vellum inscribed with the directive LEGE (read). Opposite, at the right, an angel appears with a bearded man; perhaps this is John, the evangelist and prophet, whose vision recorded in Revelation is realized in this mosaic. Angels stationed at the city gates are poised to greet the martyred saints, who stand, diversely clad and bearing crowns of martyrdom, in seemingly infinite numbers at the far right and left of the triumphal arch (fig. 111). Two women, probably St. Pudentiana and St. Agnes (another Roman woman honored in the church), lead the group at the left. Peter (with the keys to heaven) and Paul (with a scroll) sponsor the group at the right, which follows an angel bearing a great staff. The uncountable women and men surely represent the twenty-three hundred martyrs whose bones lie below and whose earthly deaths are pictured in fresco in the transept. Now entombed in Sta. Prassede, they are themselves the "living stones" from which the new Jerusalem is constructed. Depicted here in mosaic, alive in heaven, they unite the terrestrial church that shelters their physical remains with the Celestial City, where the vision of God is perpetually before them.

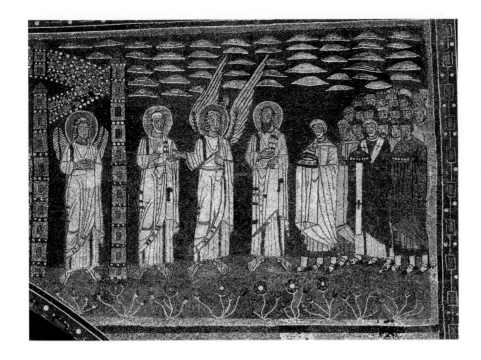

111
Peter, the apostle of Rome and first pope, is also the guardian of heaven, the keys to which Christ had bestowed on him. Flanked by two angels, he conducts Paul and numerous other saints into the New Jerusalem, built of "pure gold, like translucent glass," of which the church of Sta. Prassede clad in gold mosaics is an image.

The Heavenly Jerusalem, then, is Rome, where the martyred saints are honored. The church that harbors their earthly remains, "decorated with gold and silver, in honor of the saintly Praxedes," as the apse inscription declaims, is the city's image. A hymn to Rome, the *Urbs Beata Hierusalem*, when sung during the Mass, reminds the faithful of this relationship:

Urbs beata Hierusalem, dicta pacis visio,
Quae construitur in caelis vivis ex lapidus,
Plateae et muri eius ex auro purissimo;
Portae nitent margaritis.
(Blessed city, you holy Salem, named the place of peace, which is erected of living stones in heaven . . . your walls are built of the purest gold. Pearls shine on your doors.)

Still other figures appear in the spandrels of the triumphal arch (fig. 112). Again, there are infinitely many, but these figures are alike in physiognomy and white garb. Some bear crowns, others wave palm fronds. To indicate their diversity and incalculable numbers, the mosaicist has merely alternated red and yellow crescents in an abbreviation of row upon row of tops of dark and fair heads. These are the 144,000 martyrs—1,200 from each of the twelve tribes—envisioned in Revelation: "After this, I looked and I saw a vast throng, which no one could count, from every nation, of all tribes, peoples, and languages, standing in front of the throne and before the Lamb. They were robed in white and had palms in their hands, and they shouted together, 'Victory to our God who sits on

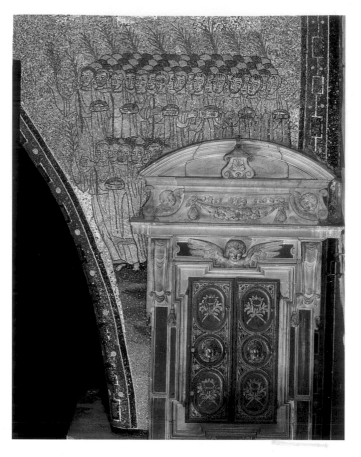

the throne, and to the Lamb'" (7.9–10). In the *Te Deum* of the Mass, "the army of martyrs dressed in white" worships Christ, "whose death opened up the kingdom of heaven to those who believe." This accounts for why Paschal's architect referred to this wall as an "arcus triumphalis": its theme is Christ's triumph over death on behalf of all humanity; through the multitude of palm-bearers, it connects with the humanity below whose numbers have come to Rome to seek redemption near the tombs of the martyrs.

The Zeno Chapel. By the time the pilgrim is finally ready to turn away from the apse and triumphal arch to return to this physical plane, a crowd of fellow marchers has gathered nearby in the right side aisle. These men and women are waiting for turns to pass through a small but sumptuous entryway (fig. 113). An inscription on the lintel proclaims that the chapel within and its tapestry of mosaics both inside and out were more gifts to God from Pope Paschal (fig. 114). The chapel is dedicated to St. Zeno, an Early Christian Roman priest first buried in the Praetextatus catacomb whose remains are among the myriad saints' bodies recovered and given sanctuary by Pope Paschal. Unlike a similar chapel dedicated to St. John across the nave, this one serves a particular function: it is the burial place of Paschal's mother, Theodora.

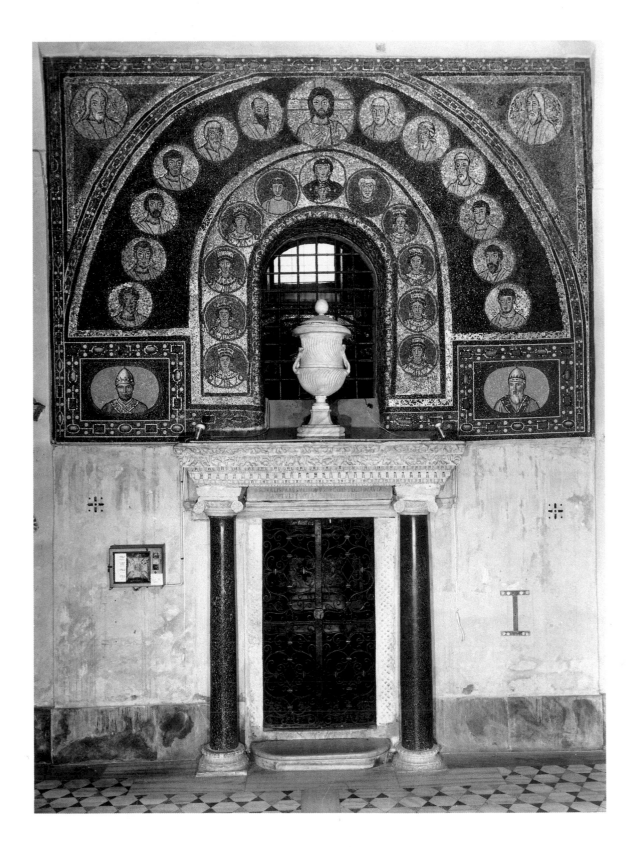

ACHEROPITA APPROACHES ITS DESTINATION 117

114

Santa Prassede, Zeno Chapel, lintel. To render a magnificent classical molding suitable for a lintel, the ninth-century stonecutter finished the ends of the piece; he managed to imitate the egg-and-dart and dentil designs but gave up entirely on the deeply cut palmettes, reverting instead to stiff, highly stylized leaves.

Because Christians believe that, at the resurrection, the heavenly spirits of saints will rejoin their earthly remains, they have sought burial places as close to those remains as possible, in order to be swept along during this reunion of body and spirit on Judgment Day. From the earliest times, therefore, the faithful have wanted to be buried *ad sanctos* (near saints), as the catacombs themselves attest. Fittingly, the Zeno Chapel is in the form of a *cubiculum* in an ancient catacomb—that is, a cross-shaped structure with a domical vault supported on columns at the corners. Now within a church inside the city walls, it perpetuates the ancient tradition.

Anyone observing even casually knows at once how important the Zeno Chapel was to its sponsor; the first clue is the quality of ancient spolia used to decorate the little chamber's entryway. Over the lintel there is a stepped, mantel-like cornice comprising five graduated tiers of deep, perfectly hewn, unblemished carving in the snowiest white marble. On either side, equally fine, matching Ionic capitals crown lustrous basalt columns that rest on paired spolia bases. Only at the entry to the baptistery in the Lateran papal complex has the traveler seen salvaged architectural elements of comparable workmanship and preservation. Again, one senses how carefully Paschal's artisans had studied the monuments associated with Rome's Christian foundation.

Over the entrance to the chapel, a mosaic billboard prepares the visitor for the colorful splendor of the interior. Each of two concentric arcs displays a series of clipeate (circular) portraits. The outer arc, in which Christ occupies the keystone position, presents the twelve apostles, with Paul and Peter on either side of

the Savior. In the inner arc, which is capped by the Virgin and Child, eight revered women appear; although their identities are unspecified, Praxedes and Pudentiana must surely be among them. At the upper corners appear two white-bearded Old Testament prophets, perhaps Enoch and Elijah, who both ascended to heaven and, hence, symbolize the hope of resurrection.

The promise inherent in the lavish use of exceptionally fine spolia at the chapel's entrance is fulfilled by the work contained within the chapel. Underfoot, opus sectile fitted around an enormous porphyry disk forms the floor. White marble slabs cover the walls. Supporting the springings of the vault, black marble columns have bases and capitals that combine ancient spolia and new carvings fashioned in ancient style. The most magnificent of the bases (fig. 115) is an elaborate composite constructed around an old capital, forming a perfect, fanciful garden of acanthus leaves, laurel wreaths, braids, rosettes, and stylized grapes in full fruit. Because the chapel is small, every detail of its dense decoration—even the celestial world peopled by angels and saints—seems within reach.

The Christian promise of eternal life provides an appropriate theme for the context of the funeral chapel's interior decorations. At the visitors' own level, the lowest tier—the physical world in which the living move—is constructed, appropriately, of fine but unadorned materials (fig. 116); here is where Theodora's mortal remains lie. In a mosaic above the sarcophagus, Pope Paschal's beloved mother is pictured together with SS. Praxedes and Pudentiana and the Virgin Mary (fig. 117). A square halo frames Theodora's head. As in the portrait of Paschal in the apse mosaic, this refers to portrait panels that attest to the actuality of the depiction. Unusually, however, the portrait of Theodora is labeled "Episcopa" (the title, bishop, in feminine form), apparently Paschal's expression of reverence for his mother and her own devoutness. The appearance of Theodora ad sanctos figures the actual fact that she is buried here beside the graves of Pudens's daughters, who now enjoy the presence of the Blessed Virgin in heaven.

Directly to the right, one sees the Harrowing of Hell (fig. 118). Christ, radiating divine light, breaks down the gates of hell to rescue Adam and Eve and the other "saints" who await him; this is another perfect emblem of the hope Christ offers—that death is only the beginning of a new life. In the lunette above, the lamb atop a hillock that spouts streams repeats the motif seen not only in the main apse of Sta. Prassede but also in the other apse mosaics witnessed in tonight's ritual walk through Rome, a scene signifying the redemptive power of Christ's sacrifice. As elsewhere, the deer that drink from the waters symbolize the faithful. Here the reference is to Theodora, who has been returned, through death, to Paradise.

Above these depictions, at the level of the little chapel's windows, the visitor sees Paradise represented (fig. 119). Saints Agnes, Pudentiana, and Praxedes, their hands covered with white cloths, bear crowns. Occupying parallel spaces across

115
Santa Prassede, Zeno Chapel, column base. Lavish materials purloined from classical monuments and freely recarved and redisposed impart a material luxuriance to the interior space.

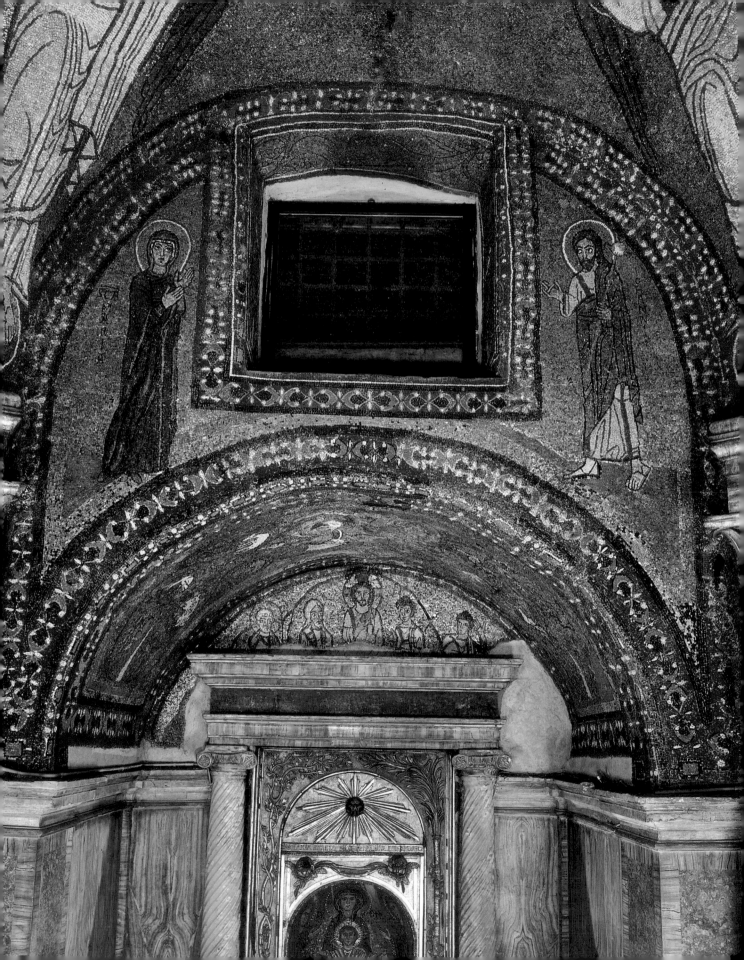

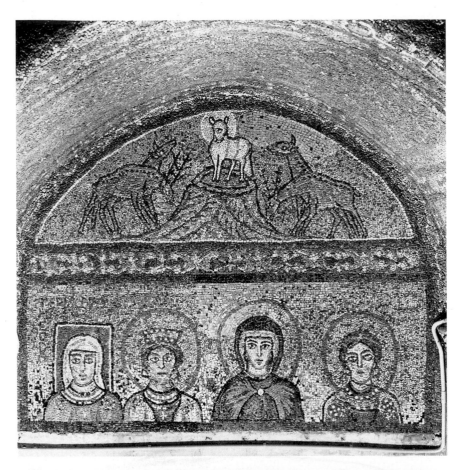

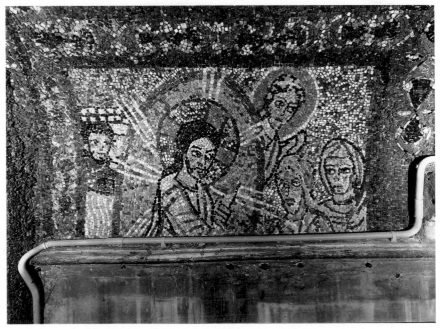

Opposite:

116

Santa Prassede, Zeno Chapel, altar wall. Light is the underlying theme on this wall. Directly above the altar is a depiction of Christ as the "light of the world"; in the conch is the Transfiguration, the biblical vision on Mt. Tabor when Christ radiated light; and at the top, Christ is substituted in the scene of intercession by real light entering the window.

117

Santa Prassede, Zeno Chapel, left wall. Above her tomb, Theodora is pictured with Mary and the two saints especially honored in the church, Praxedes and Pudentiana. The Lamb of God atop a hillock from which streams flow to refresh four deer is a paradisaical motif well known from Early Christian art and chosen for its suitability in a tomb.

118

Santa Prassede, Zeno Chapel. Invented only in the seventh century, the image of the *Anastasis* (Harrowing of Hell) was particularly popular in eighth- and ninth-century Rome. Christ is believed to have descended into Hades after the Crucifixion to conquer Satan and to release Adam and Eve and other Old Testament "saints."

119

Santa Prassede, Zeno Chapel. As in the much later Sancta Sanctorum, the central domical vault is conceived as a separate, heavenly area where four exceptionally lovely angels support a clipeate portrait of Christ.

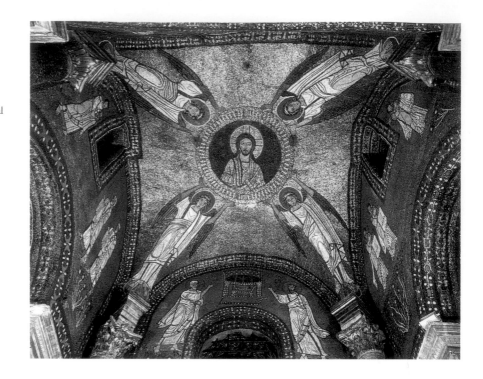

the little chapel, three male saints in mosaic—John, Andrew, and James—provide perfect counterparts to the three sainted Roman women. Like the women, the men walk with covered hands, bearing not crowns but books (John holds a codex, Andrew and James hold book rolls). Below them, in a lunette opposite the depiction of Christ as the lamb, Christ appears again, now as a man, in the company of two other saints.

Turning back to look above the entranceway, one sees Peter and Paul. Peter holds the keys to heaven, Paul, a book roll. Each raises a hand toward the "prepared throne" that awaits Christ at the Second Coming—another reference to the promise of resurrection. And the same paradisaical theme is taken up again on the opposite wall above the chapel's altar, where a vine-scroll adorns the arch over the altar. Alive with animals, it recalls the food of Paradise, superseded now by the Eucharist. In the lunette behind is Christ's Transfiguration, his appearance on Mt. Tabor with Moses and Elijah to SS. John, James, and Peter. The primary meaning of the scene is the demonstration of Christ's human and divine nature. As understood by theologians, however, the Transfiguration also prefigured Christ's Second Coming and the judgment he will mete out to humankind.

This is precisely the theme pictured above, but in a most remarkable manner. John the Baptist (who holds a cross adorned with the Lamb of God) and Mary—who will, it is believed, intercede on behalf of humanity at the Last Judgment—appear; but the judging Christ is missing. In his place is the window that

Santa Prassede, Zeno Chapel, altar niche.
Although added to the ninth-century
complex only in the middle of the thir-
teenth century, the mosaic perpetuates
the themes underlying the earlier decora-
tion: the Christ child as light and the role
of Praxedes and Pudentiana as intercessors.

lets light into the chapel. The message is this: in the temporal realm, the closest
we can come to seeing God is through the light that emanates from heaven.
Only at the end of time, the blessed are promised, will they see God "face to
face." The conceit that light conveys the highest nature of the celestial Christ is
prepared by the mosaic icon (fig. 120) directly behind the altar.

Though the icon is in fact a recent addition to Theodora's funerary chapel—
probably only fifty years old at the time of this first Jubilee—it nonetheless fits
perfectly into the ninth-century scheme. Repeating the imagery directly to the
left of Mary flanked by SS. Praxedes and Pudentiana, it adds the Christ Child, as
is appropriate, near an altar. Here, Christ's garments and halo are particularly
radiant; and lest the association with his resplendent appearance in the Trans-
figuration and with the window illuminating the chamber be lost, he holds a
scroll bearing words from John's Gospel, EGO SUM LUX (I am the light [of the
world], 8.12).

Literally structured to establish a gradual elevation from the physical realm
(containing the remnants of Theodora's body) to the sanctified realm (sheltering
the altar from which the sacraments are dispensed), to the paradise of the saints

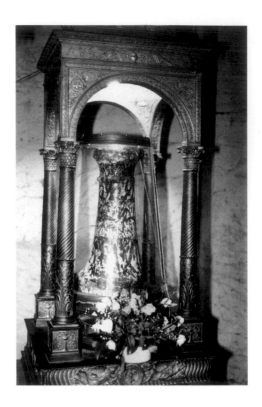

121

Santa Prassede. The mottled marble fragment of what is believed to be the column on which Christ was flagellated is still worshiped today in a small room adjacent to the Zeno Chapel.

(with its sacred images), and finally to pure light, the Zeno Chapel culminates in a glimpse of heaven itself. In the golden ceiling vault, which rises from great columns to fill the room's corners, four white-clad angels form overhead arcs. They are fully twice as large as any of the chapel's other figures, and their feet rest on cosmic orbs—green below and blue above—that symbolize the transition between this world and that. Poised like ancient caryatids, they bear a great wreath, the emblem of triumph. In it Christ appears again, this time on a deep blue ground. This is God's Son, who conquered death and returned to heaven, where he awaits the final days. The pilgrim pauses to contemplate his beautiful face; she must surely see in it an image of what she will really find if she is deemed worthy on Judgment Day. This is the thought with which each believer should leave the chapel to Paschal's mother.

But the exit from the Zeno Chapel is impeded by congestion to the left of the doorway. A small colonette of mottled marble (fig. 121) has riveted the attention of many marchers. Word passes through the crowd that it is a portion of the column to which Christ was lashed to be flagellated before his Crucifixion. On one hand, the object seems too small to have constrained the Lord's person. On the other hand, it has an exotic appearance that suggests that it has indeed come from far-off Palestine.

Stragglers have run out of time for Sta. Prassede. Certainly the *Acheropita* must long since have been carried through the right transept and out its door to the

Santa Prassede. A pier across from the Zeno Chapel is adorned, slightly above eye level, has a small, devotional image in fresco of the Crucifixion. The simplicity and emotional pitch contrast to the more formal, earlier depictions and render the subject and its mood directly accessible to pilgrims.

street. Nonetheless the pilgrim pauses here one more time, now beside a pier on which a fresco has been painted just above eye level (fig. 122). One can approach the painting so closely that one can be sure the image is freshly painted. In contrast to the exalted depictions in Sta. Prassede's apse, on its arches, and the chapel to St. Zeno, the image here is simple, humble, and direct. Christ, in agony but at the same time at peace, hangs on a Y-shaped cross, his brows forever straining in anguish and his feet twisted around a single nail. He is fixed at the instant of death. Beside him, his mother, Mary, and his disciple John give way to the deepest sorrow as they meditate on the meaning of Christ's sacrifice. Stirred by infinite compassion, the pilgrim offers a last prayer in Sta. Prassede.

Finally departing through the transept door, the pilgrim has reached the brink of tonight's destination. From here, two minutes' walk will take her to the broad square before the basilica of Sta. Maria Maggiore.

5

WHERE SON
AND MOTHER REUNITE

By dawn on August 15, the day of the Feast of the Assumption, the procession
has reached its destination. At last, the sacred reunion that has been the goal of
the preceding night's tortuous walk from the Lateran can take place. The crowds
of clerics and lay persons that have accompanied the *Acheropita* through the
night are gathering before the main entrance to Rome's principal church dedi-
cated to the mother of Christ (fig. 123). The great basilica is called by various
names: Liberiana, for its original papal patron, Pope Liberius (352–66); Sancta
Maria ad Praesepem, for its most cherished relic, the crib (*presepio*) in which the
newborn Christ Child had lain; and Sancta Maria Maior (Sta. Maria Maggiore)
for its place in the ecclesiastic hierarchy of Rome.

Mary's basilica crowns a gently rounded hill, so the approaching pilgrim
ascends a broad, inclined piazza to reach the entranceway. Having trekked all
night through a city lighted only by marchers' candles, the pilgrim stops at the
top of the hill to look back over Rome in the rising light of day. Along with
many fellow travelers, she faces southeast toward the point of departure of the
procession. After the myriad sacred and pagan sites they have just seen, some of
the marchers must expect to find Mary's basilica walled in by a craggy skyline of
church towers, defensive battlements, triumphal arches, columns, and capitals.
But because of its elevation, the church in fact commands a panoramic view and
a direct sight line to the campus Lateranensis (fig. 124). Moreover, having taken
last night's long, winding course, pilgrims from faraway places may be surprised
to realize that the papal complex is actually not far at all from Mary's basilica. In

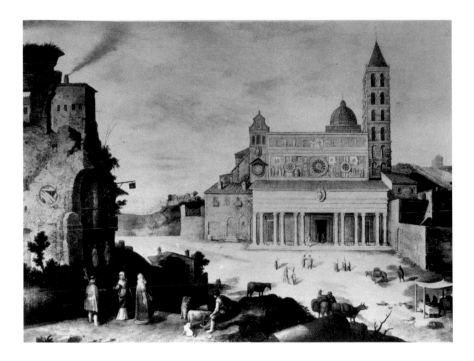

fact, the builders of Sta. Maria Maggiore planned it to face the Lateran. The fac-
ing relationship of the two holy sites is especially appropriate to today's reen-
acted reunion of Son and Mother.

The air fills with the solemn tones of *Kyrie eleison, Kyrie eleison,* the voices of
marchers now joined by those of women and men who emerge after a nightlong
vigil within the church. On this day of miracles, it is said that the candles within the
basilica have burned throughout the night but have not diminished in size.

The Facade Mosaics

The pilgrim can "read" right on the facade the legend of the basilica's founda-
tion on this spot. The origins are recounted in pictures above the doorway (fig.
125). According to tradition, the Virgin herself determined that the basilica to be
erected in her honor be situated here. The legend of how Mary made her choice
known and her desire carried out is told in the lower register of two tiers of
mosaics. As the pilgrim traces episodes of the earthly miracle that occurred here a
millennium ago, she can also look up at residents of heaven. These appear in the
upper tier of mosaics, where Christ is depicted with the saints and creatures of
the prophetic vision on a background of gold. The builder of the church, with
the cooperation of the mosaicist, has differentiated earth and heaven in the very
structure of the facade. While earthly scenes are arranged on the lower, flat wall,
the heavenly realm occupies the *cavetto,* the upper portion of wall that curves
gently outward.

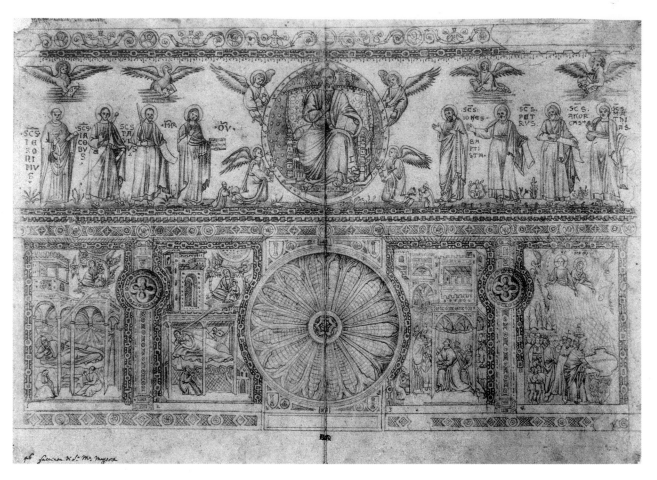

125

Santa Maria Maggiore, facade. This drawing by a sixteenth-century artist whose name is unknown provides the best record of the facade mosaics as a whole, including the two patrons kneeling at the feet of the candle-bearing angels.

In the leftmost of the four lower panels, one sees the sleeping Pope Liberius. He wears a nightcap in place of his papal tiara; otherwise, he is in full papal regalia. From above the pontiff's canopied bed, the Virgin, with the young Christ on one arm, addresses the dreaming prelate. An aureole supported by four angels frames the figures in the vision, which in fact looks quite like an icon. Mother and Child each extend a directing hand to tell the pope that, during the night of August 4–5, snow will fall; he is to build the Virgin's church on the spot where the snow settles. A second, similarly composed panel, again with an icon-like Virgin and Child, also depicts a dream vision. This time the sleeper is John the Patrician, a wealthy Roman with the means to finance the construction of a great church. The dreams' similarity verifies their authenticity: if two men simultaneously have the same vision, it must be true. This is confirmed in a third scene, in which John the Patrician reports his dream to Liberius (fig. 126). Finally, in a fourth panel, the Virgin's command is carried out. Christ, now an adult, appears alongside Mary in a star-studded aureole (again, recalling an icon). The two reach out to unfurl a curtain of snow. Below them, Liberius bends over a stylus to etch in the snow fallen on the Esquiline Hill's summer flora the plan

126

Santa Maria Maggiore, facade mosaic, detail, *John the Patrician Reports His Dream to Pope Liberius*. The miraculous event, held to have occurred in the fourth century, is depicted as though staged in contemporary, thirteenth-century garb and setting. Liberius is seated on the lion-headed sella curulis, in his day not used by popes, and the Lateran palace—actually just up the street—is depicted as a modern Gothic building with French-influenced pointed, ribbed vaults and lancet windows.

127

Santa Maria Maggiore, facade mosaic, detail, *Miracle of the Snow*. Pope Liberius etches the ground plan of the basilica in the site that Mary and Christ have indicated with the miraculous August snowfall on the Esquiline Hill. The mosaicist has suggested the time of year by including luxuriant foliage. The umbrella, pastoral cross, and assembly of clerics and aristocrats echoes the contemporary procession (see fig. 1).

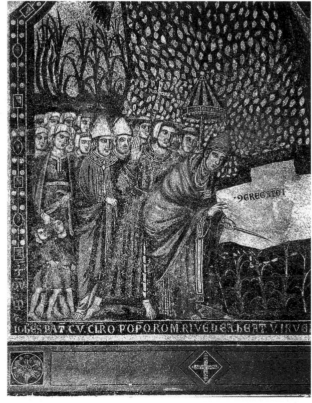

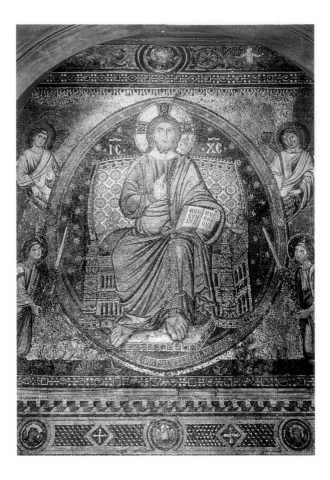

128

Santa Maria Maggiore, facade mosaic, detail, *Christ in Majesty*. This mosaic's placement at the summit of the facade makes the sacred icon present at the church throughout the year.

of the basilica he will build here (fig. 127). On the plan is inscribed the word [CON]GREGATOI [sic], meaning both an accumulation of snow and the congregation of the faithful. John the Patrician, with his wife and sons, members of the Curia in their miters, and other clerics look on in awe.

Although it depicts an episode that is dated to 358, Sta. Maria Maggiore's facade mosaic is new at the time of the first Jubilee; indeed, it is only now being completed. Leaping almost a millennium, it treats its subject as a thirteenth-century event. Architecture and apparel, as well as artistic conventions, are entirely contemporary. The fourth-century Pope Liberius, for instance, is pictured with all the trappings of the imperial papacy that had developed only during the past century. His regal tiara and umbrella, in fact, recall the attributes of Boniface VIII depicted in the Lateran loggia (see fig. 28). Moreover, the onlookers at the spot designated by the Virgin in the dual vision are rendered as marchers in a liturgical procession, with a tonsured deacon carrying a liturgical cross beside the two cardinals (who may in fact be the mosaic's patrons).

At the center of the heavenly upper register of mosaics, Christ appears in a near-replica of the *Acheropita* (fig. 128). He sits on a sumptuously jeweled throne,

blessing with one hand and holding an open book in the other; the book bears a formula seen also in S. Prassede: EGO SUM LUX MUNDI QUI (I am the light of the world, who [takes away the sins of the world]). The star-filled sky behind the throne and the angels arrayed around the framing aureole convey plainly that the majestic Christ is the living Savior looking down from heaven and is the subject of a celestial liturgy, as the pilgrim has seen before in many churches. Indeed, in this mosaic, the angels around Christ's aureole are shown swinging censers and carrying candles to establish the image's liturgical context and to connect the pictured theophany to its terrestrial reenactments. In all the other churches, this vision is restricted to the sanctuary; at Sta. Maria Maggiore, however, it graces the outside of the church, because on the Feast of the Assumption the entire piazza becomes a church, and its outward-curving facade a kind of apse.

As in most apse decorations, saints stand to the left and right of the central Christ figure. Mary appears in this grouping, her head covered with a deep blue cloth trimmed in gold. The epigram in Greek, MP ΘΥ identifies her as *Meter Theou* (Mother of God). Elevated to stand beside her son at his left, she mediates on behalf of the People of Rome, her right hand raised to her breast, just as in the reliquary of the Holy Cross in the Sancta Sanctorum (see fig. 50). To Christ's right is John the Baptist, humanity's other intercessor with God, completing the same grouping that had so impressed the pilgrim in Sta. Prassede's Zeno Chapel: Mary and John intervening with God on behalf of the faithful (see fig. 116). Here, however, the *Lux Mundi* is fully figured rather than symbolically present as natural light passing through a window. On either side of the three main figures are Rome's ubiquitous apostolic protectors, Paul and Peter, then the Apostles James and Andrew, and, finally, Jerome and Matthew, whose relics are preserved in the basilica.

At the feet of Mary and John appear the miniature figures of two kneeling men. They are Pietro and Jacopo Colonna, both powerful cardinals (1288–1326, 1278–1318, respectively). As members of Rome's prestigious Colonna family, they are Pope Boniface's sworn enemies; now, indeed, they are in exile. (In fact, Boniface has resolved, in this first Jubilee year, to deny them the plenary absolution he has offered the faithful.)

Boniface's animosity notwithstanding, the Colonnas are owed gratitude for having engaged for the task of decorating the facade the painter Filippo Rusuti (?–1317/21), who has signed the work quite conspicuously, in the center beneath Christ's footstool. Artisans have only recently begun to sign their works (Magister Cosmati's bold claim of authorship in the Sancta Sanctorum is a rarity), and in fact, they are just now starting to think of themselves as "artists" rather than as unnamed members of craft workshops. Rusuti's signature here, however, is as much an appeal for God's blessing as a claim of artistic individuality and pride. The same motive underlies the two patrons' tiny representations.

A plea for heavenly grace is manifested once again in an inscription on the columned portico below (fig. 129), a gift of Pope Eugenius III (1145–53).

Santa Maria Maggiore, portico inscription. The inscribed lintel of Pope Eugenius III is now embedded in a wall outside the church's sacristy.

TERTIUS EUGENIUS ROMANUS P[A]P[A] BENIGNUS OBTULIT HOC MUNUS VIRGO SACRATA TIBI

QUE MATER [CH]RISTI FIERI MERITO MERUSITI SALVA PERPETUA VIRGINITATE TIBI

ES VIA VITA SALUS TOTIUS GLORIA MUNDI DA VENIAM CULPIS VIRGINITATIS HONOR

(Eugenius III, the Roman pope, willingly brings this gift to you, Virgin Mary, you who truly deserved to be the mother of Christ and perpetually preserved your virginity. You are the way, the life, the salvation, and the glory of the entire world. Oh honor of virginity, grant forgiveness for sin.)

Architectural framing depicted in the facade mosaic reinforces the links between the heavenly church, the sanctioned basilica represented in the Liberius panels, and the congregation on the ground below. The upper realm, with its abstract gold background, is separated from the lower not only by illusionistic structures but also by actual travertine molding, which together reaffirm that the celestial realm must be kept apart from the present world. The two connect only at God's will, which is manifested, for example, through visions or miracles. There is, however, one rather subtle juncture: separating the two scenes at the left and the two at the right are majestic columns, rendered illusionistically in mosaic; each supports one of the two "pillars" of the Roman church, Paul and Peter. Moreover, they symbolize the Colonna, the church's aristocratic patrons, whose name means "column" and whose family emblem, a column, appears within the escutcheons around the rose window. Finally, below, the past pictured in rich mosaic merges with the real columns of the basilica's portico and the actual events that take place before and inside the church. The past is thus as firmly unified with the present as the worldly is with the divine.

Other images connecting today's liturgy with heaven literally enshroud the pope when he appears at the basilica to say Mass and to officiate over today's ritual reunion of Son and Mother. If the pilgrim can manage to glimpse Boniface now, she will see that he wears a magnificent cope of silk and gold thread woven into pictures (fig. 130). Scenes on the tapestry garment illustrate the life and death of Christ and, in a vertical row that interrupts these, the Death and Assumption of the Virgin. Entirely appropriate to the papal welcome of the *Acheropita* at the church that shelters Rome's most revered icon of Christ's mother, the vestment is but one more element in an elaborate set of claims put forth in Sta. Maria Maggiore. The liturgy of the meeting of icons of Mary and Christ presided over by Boniface is a reenactment of the true meeting of Christ and Mary, which took place in heaven. Witnessed every August 15 by the faithful gathered at this consecrated place, that reunion establishes the historical continuum at the heart of Christianity and elevates the faithful almost into the true presence.

A House Worthy of the Queen of Heaven

With the basilica's doors now flung open, anyone who peers in might wish to fly the full length of the church (fig. 131). From the far end of the nave (which measures more than 110 yards from facade to apse), the shimmer of gold and myriad colors beacons. The basilica's mosaics seem to illuminate the distant apse, apsidal arch, and triumphal arch. Gemlike, these decorations perfectly set off the two tabernacles that house the church's treasured icon and relics. Continuity with the facade mosaics is patent even over the length of the nave: Christ and Mary, just seen on the exterior wall over the portal, reappear now at the church's interior focus, united, as they will be when the two icons meet.

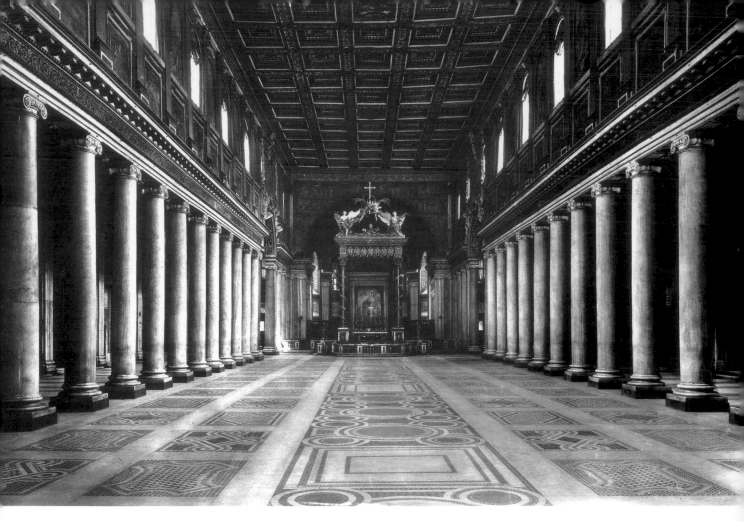

131
Santa Maria Maggiore, nave. Although it has been continuously rebuilt and even the columns have been replaced, the basilica has largely retained its original character to the present day. The medieval church, however, had a continuous clerestory, open-beam ceiling, no confession, and no interruption in the series of nave columns. The arches that now interrupt the colonnade at either side of the altar were introduced when the Pauline and Sixtine Chapels were built at the end of the sixteenth century. Of course, all the medieval church furniture is also gone, including the schola cantorum and great tabernacles.

A prominent inscription on the keystone of the triumphal arch and visible even at a distance adds to a traveler's knowledge of the basilica's history. Its message is puzzling, however, for it names as the church's patron not Liberius but Pope Sixtus III (432–40): XYSTUS EPISCOPUS PLEBI DEI (Sixtus, the Bishop of the People of God, fig. 132). The history of Sta. Maria Maggiore has, in fact, become confused. Pope Liberius did indeed build a church dedicated to the Virgin; that church, however, was not on the summit of the Esquiline but a short distance away. It seems to have been Pope Celestine I (422–32), Sixtus's predecessor, who began the construction of this structure. In 431, Celestine had presided over the Council of Ephesus, at which a monk called Nestorius made claims that there were two separate persons in the Incarnate Christ, one human, the other divine; Nestorius's assertions were rejected. A grand, new basilica seems to have been a suitable affirmation that Mary was the "bearer of God" (*Theotokos*). It was Sixtus, a great builder with the Lateran baptistery among his accomplishments, who brought the church to completion.

As the pilgrim proceeds into the nave, she feels at once awestruck but not made insignificant by the grandeur of the Sta. Maria Maggiore. Though enor-

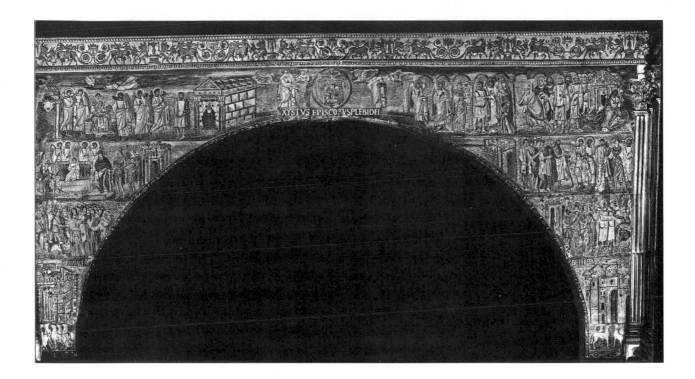

mous, the church's interior has a coherence that is rare in Rome's churches. Inside, Sta. Maria Maggiore is distinctly antique in feeling—not so different, in fact, from the pagan basilicas left in ruins in the Forum. Virtually unchanged since its construction some eight hundred years ago, the broad central nave is divided from single side aisles by simple Ionic columns, which support not arches but, in orthodox classical fashion, a continuous architrave that gives the visiting worshiper a comfortable sense of solidity. With the summer sun now streaming in through large, arched windows, there is ample light. Above the architrave, handsome stucco pilasters and colonettes frame the windows and carry a carved molding and open-beam ceiling. Beneath each window on both sides, picture panels in mosaic trace biblical stories. Each of these calls for study, but the pilgrim has been advised that the pictorial narratives in Roman churches begin at the altar and progress toward the door, so she proceeds directly with dispatch to the apse end of the nave. There is much to divert her on the way, however.

Although most basilicas founded by Constantine and his immediate successors served to mark the graves of saints or to house precious relics, Sta. Maria Maggiore was not built with that purpose. The reason is simple. According to doctrine, the Virgin Mary, after her death, was assumed, body intact, into heaven, and so left no essential physical remains behind on earth. Santa Maria Maggiore thus originally had no transept, for there was no need for a separate

132

Santa Maria Maggiore, triumphal arch. In the fifth-century basilica, this wall served as the frame of the apse; but when Pope Nicholas added a transept and new apse to Santa Maria Maggiore, it was de facto transformed into the triumphal arch. The reference to the Chosen People incorporated in Sixtus III's inscription reflects the extended claims of papal authority following the removal of the seat of government to Constantinople and the Visigoth king Alaric's invasion of Rome in 410. (The photograph predates restoration.)

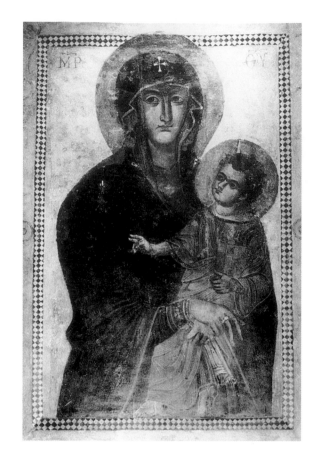

133
Santa Maria Maggiore, *Regina caeli*
(Queen of heaven). In its current state,
the great icon seems to be a work of the
thirteenth century. But areas of illusionis-
tic painting—for example Christ's right
hand—suggest that this is a repainting of
a much earlier work.

space to accommodate pilgrims' visits to a grave. Indeed, a transept was added to
Mary's basilica only during the papacy of Nicholas IV (1288–92), requiring in
turn the construction of a new apse. Over the centuries, Sta. Maria Maggiore
has acquired numerous secondary relics, including some of the Virgin's milk,
hair, and garments, the bones of SS. Matthew and Jerome, and the arm and skull
of St. Thomas Becket. One of the most famous of the church's sacred vestiges
is Christ's crib (*praesepe*). It has been kept in a special oratory perhaps since it
was brought to Rome by Pope Theodore (642–49) shortly after Jerusalem fell to
the Muslims in 638. Another is wood from the stable in which Christ was born.
And the third is the icon of Mary holding the Christ Child (fig. 133), which, like
the *Acheropita,* has been attributed to the hand of St. Luke.

Many of the relics are kept in a fine Cosmatesque tabernacle in the nave to
the right of the schola cantorum, which is furnished, as is typical, with two pul-
pits. The lower level of the tabernacle is equipped with an altar, and the upper
story shelters the precious remnants, outfitted with a balcony from which they
can be displayed (fig. 134). The tabernacle was donated in 1256 by Giacomo and
Vinia Capocci, members of one of Rome's patrician families with close ties to
this basilica. (One of the fortified residences that the procession passed on the

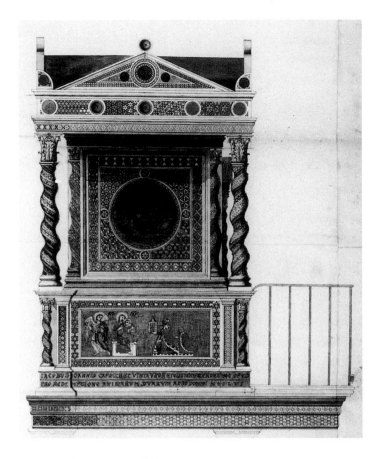

ascent between the Forum and Sta. Maria Maggiore belongs to the same
Capocci family.) A mosaic on the tabernacle's left side prominently shows the
patron couple (fig. 135). Kneeling magi-like before Mary and Christ, the Capocci
offer the shrine and altar, while an angel to the left of the Virgin looks on in
apparent wonder. The now-familiar Greek epithet MP ΘΥ that appears near
Mary's head states that the Virgin and Child in the mosaic are as much a depic-
tion of the church's icon relic as a representation of the incarnate Mary and
Christ; indeed, Mary's headdress and Christ's blessing gesture clearly reflect ele-
ments of the church's treasured icon.

For centuries, the Mary icon resided above the door to the basilica's baptis-
tery. Recently, however, it has been installed in the nave, in a shrine directly to
the left of the relics tabernacle, and its functional counterpart. In every way a
pendant to the relics tabernacle given by the Capocci, the icon tabernacle is nev-
ertheless rendered in the new opus francigenum style that characterizes the
Sancta Sanctorum, fitted out with finials and pinnacles. With its lower level con-
taining an altar and upper compartment closed off by doors decorated with
cherubim, it is intended to recall the Old Testament Holy of Holies. It thus
embodies a sacred analogy: Mary has long been likened to the Ark of the

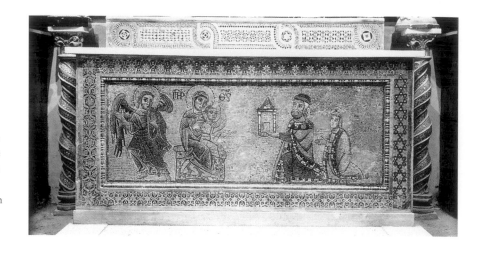

Santa Maria Maggiore, relics tabernacle, dedication mosaic. Reused as part of the altar in Vico, the mosaic from the tabernacle marks the radical change that occurred in Roman art between 1256, when the mosaic was made, and the last quarter of the century, when the Sancta Sanctorum was decorated and the facade and apse mosaics in Sta. Maria Maggiore were laid. In style, the dedication mosaic is closer to the niche mosaic in the Zeno Chapel of Sta. Prassede (see fig. 120) than to the facade and apse mosaics in Sta. Maria Maggiore itself.

Covenant sheltered within the inner sanctum of the Jewish Temple because she bore Christ within her, who then superseded the Old Law.

Known as the *Regina caeli* (Queen of heaven), the Sta. Maria Maggiore icon is perhaps the oldest in the city, and to some extent it retains its Early Christian character: it is a half-length portrait, showing the Virgin gently clasping her hands around the quite maturely developed and attired Christ Child. In the manner of a grown man—and of Christ of the *Acheropita*—the infant holds a book with his left hand and forms a gesture of blessing with his right. Mary's stately posture and the Child's lively turning attest to the antiquity of the painting, but more recent touching-up accounts for the rather set features of the faces and the stylized linearity of the folds of Christ's garments. It was this Virgin and Child, of course, that appeared to Liberius and John the Patrician to command the building of Sta. Maria Maggiore. No wonder, then, that Rusuti fashioned the dream visions on the facade mosaics after the church's beloved icon. Today awaiting the arrival of her son in the form of the *Acheropita*, the *Regina caeli* sheds its allegorical and historical meanings; the image is the Virgin herself and, as such, the Church of Rome.

Having paused at the tabernacle that holds the precious relics, the pilgrim offers a prayer first here and immediately again at a slightly raised apse covered with porphyry and marble. She kneels at the magnificent porphyry slab that designates the presence below of the relics of St. Matthew. She then moves into the right aisle to the altar of St. Jerome.

Just a few steps ahead is the tomb of Cardinal Gonsalves Garcia Gudiel, the bishop of Albano, who died only last year (fig. 136). An inscription announces that the elaborate marble and mosaic shrine is the work of one John of the Cosmati clan; the lettering identifies the artisan proudly as a Roman citizen: HOC OP[US] FEC[IT] JOH[ANN]ES MAG[IST]RI COSM[A]E CIVIS ROMANUS. Beneath a pediment edged with leafy tendrils, the cardinal's effigy lies atop the

136
Santa Maria Maggiore, tomb of the bishop of Albano. Completed on the eve of the Jubilee, the tomb of Cardinal Gonsalves Gudiel is typical of late Gothic sepulchral monuments. Above the sarcophagus proper is a life-size effigy of the bishop, dressed in his episcopal vestments and miter. Two angels draw closed a symbolic curtain. Gonsalves appears again above, here portrayed in the more ethereal material of gold mosaic—and alive, that is, in heaven.

137
Santa Maria Maggiore, tomb of the bishop of Albano, detail. Matthew and Jerome are shown ushering Gonsalves before Mary and Christ. The Virgin and Child are adapted from the *Regina caeli,* the church's relic-icon, also sheltered not far away. (Photograph predates restoration.)

sarcophagus. Angels at the reclining figure's head and feet draw a curtain on Gonsalves's earthly sojourn. In the more etherial material of gold mosaic above, the cardinal is depicted again (fig. 137), now in the new, eternal life he has entered. Cardinal Gonsalves is flanked by figures of Matthew and Jerome, who hold inscriptions attesting to the presence nearby of their relics: ME TENET ARA PRIOR (The high altar contains me) and RECUMBO P[RAE]SEPIS AD ANTRU[M] (I rest next to the grotto of the crib.) Gonsalves himself is shown kneeling before the enthroned Virgin and Child. Mary is again rendered as *Regina caeli,* with the Greek epithet that identifies her on the icon and on the basilica's facade. Installed close to the relics of Matthew and Jerome and, referring in the images, to the church's great icon and facade decorations, Gonsalves's funerary monument embodies the belief and the pilgrim's hope that by visiting the sacred sites and praying before the remains of holy persons, her soul, too, will be assured a place in heaven.

Christ's crib. Pope Nicholas IV—a Franciscan and hence especially devoted to the infant Christ—had taken particular interest in the relic of Christ's crib in Sta. Maria Maggiore. In 1291, therefore, at Nicholas's urging, the basilica's canon Pandolfo Ipontecorvo commissioned the sculptor Arnolfo di Cambio to rebuild and transform the oratory in the right aisle that housed this sacred remnant. Over the door of the chamber, Arnolfo has carved two prophets bearing scrolls with long inscriptions. The youthful figure at the left greets the visitor with the words INTROITE IN ATRIA EIUS ADORATE DOMINUM IN AULA SANCTA EIUS (Enter into his house and adore the Lord in his sacred hall). At the right, an old man proffers the words of Luke 2.7, ET PANNIS INVOLUTUM RECLINARIT EUM IN PRAESEPIO (She wrapped him in swaddling clothes and laid him in a manger).

Within the little oratory, Arnolfo has created an ensemble of brightly painted stone figures that, though less than half life-size, engages the viewer totally; a visitor cannot but feel as part of the group gathered to honor the newborn savior. At the center of the diminutive scene, Mary rests on a mattress and supports the Christ Child to face the worshipers who have come from far away to adore him. Closest is the oldest of the Eastern kings, Balthasar, who, for all his wealth and power, kneels in reverent humility (fig. 138). The two younger magi stand behind him, holding offerings of frankincense and myrrh as they talk of the miracle. On the other side of the Mother and Child are Joseph (fig. 139), a somewhat worried look on his elderly face, and the ox and ass that symbolize the Christians who accepted Christ and the Jews who did not. Arnolfo's is the most dramatic setting of a precious relic the traveler has ever seen, more expressive even than the beautiful images she has previously prayed before; the carved stone seems so alive as to make each viewer feel present at Christ's birth.

Only the sound of singing and the rustle of a crowd now draw the pilgrim out of the oratory and back into the nave.

138
Santa Maria Maggiore, Oratory of the
Crib, *Three Magi*. Ubiquitous today,
crèches, or *praesepi*, were a thirteenth-cen-
tury invention much promoted by the
Franciscans; Francis himself had installed
one at Greccio in 1223. The Virgin and
Child of Arnolfo di Cambio's oratory
have been lost, but the other figures sur-
vive and have been reassembled.

139
Santa Maria Maggiore, Oratory of the
Crib, *Joseph*. Like the magi, Joseph was
meant to set the proper tone of quiet
humility for those worshipers praying
before the relic of the manger.

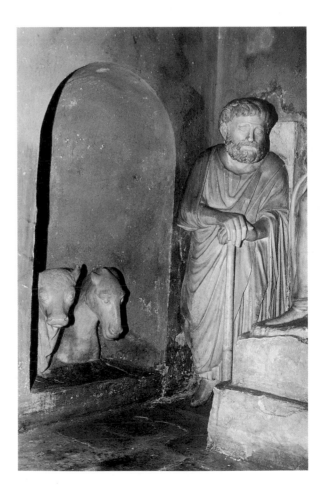

Crowning Glory: The Apse Mosaic

The pope and his Curia, preceded by the great stational cross brought from the Lateran, have entered Mary's basilica and are taking their places in the apse behind the altar. The lay brothers honored to bear the *Acheropita* now place it on the Gospels pulpit within the schola cantorum. Other bearers, meanwhile, follow with the *Regina caeli* and place it, across the enclosure normally reserved for the clergy, on the Epistles pulpit. Escorting Christ and Mary into a sanctified chamber, the procession realizes the language of love from the Song of Songs and other texts underlying the liturgy of today's feast. Christ takes his mother to heaven, as a groom leads his bride into the wedding chamber (though, of course, this ceremony is entirely chaste). Enacted by two of Rome's principal icons, moreover, and under the auspices of the pope, the ceremony also symbolizes the marriage with the *Ecclesia Romana,* the Church of Rome.

This extraordinary dogma is presented fully in the enormous mosaic that fills the apse with a narrative depiction of the Coronation of the Virgin, which provides the perfect background for the events and ceremonies produced on this day (fig. 140). Seated together on a single throne, Christ places a spectacular crown on his mother's head, thereby elevating her as Queen of Heaven. An inscription taken from the Assumption Day liturgy brings everything together:

MARIA VIRGO ASSU[M]PTA EST AD ETHEREU[M] THALAMU[M] IN QUO REX REGU[M] STELLATO SEDET SOLIO
EXALTATA EST SANCTA DEI GENETRIX SUPER CHOROS ANGELORUM AD COELESTIA REGNA
(The Virgin Mary is received into the celestial bridal chamber in which the King of Kings is seated on a starry throne.
Mary, the holy bearer of God, is raised into heaven above the choirs of angels.)

As on the facade, the enthroned Christ of the apse mosaic is pictured within a starry blue aureole; here, however, instead of just four angels, he has nine on each side to designate the three choirs within the three angelic hierarchies: Seraphim, Cherubim, and Thrones; Dominations, Virtues, and Powers; Principalities, Archangels, and Angels (fig. 141). In the open book that Christ holds here, one can read: VENI ELECTA M[E]A ET PONAM IN TE THRONU[M] MEU[M] (Come my chosen one and I will put you on my throne). The words are meant to recall verses in the Song of Songs (4.8) recited in the Assumption Day liturgy: "Come from Lebanon, my bride; hurry down from the top of Amana." The throne referred to in the words is rendered as a jeweled splendor, surpassing even the throne in the facade mosaic. And now, significantly, it is wide enough to accommodate two. The throne floats above the firmament; the sun carefully placed beneath Christ's feet, the silver moon beneath Mary's.

Opposite:

140

Santa Maria Maggiore, apse. Although the Bible makes no mention of Mary's assumption to heaven or her reception by Christ, the Coronation of the Virgin had a long history in Church writings and became a popular theme in thirteenth-century art. The mosaic in Sta. Maria Maggiore is not the first rendering of the subject; it appears, for instance, on Boniface's cope (see fig. 130). But the representation here is an original composition. The Adoration of the Twenty-four Elders filling the spandrels of the apsidal arch normalizes the imagery of the early fifth-century basilica; the Lamb of God is the keystone. Between the Gothic windows below are fives episodes featuring Mary: the Annunciation, Nativity, Death, Adoration of the Magi, and Presentation of Christ in the Temple. Interrupting the lateral narrative flow, the scene of the Death of the Virgin functions as part of the Assumption scene above.

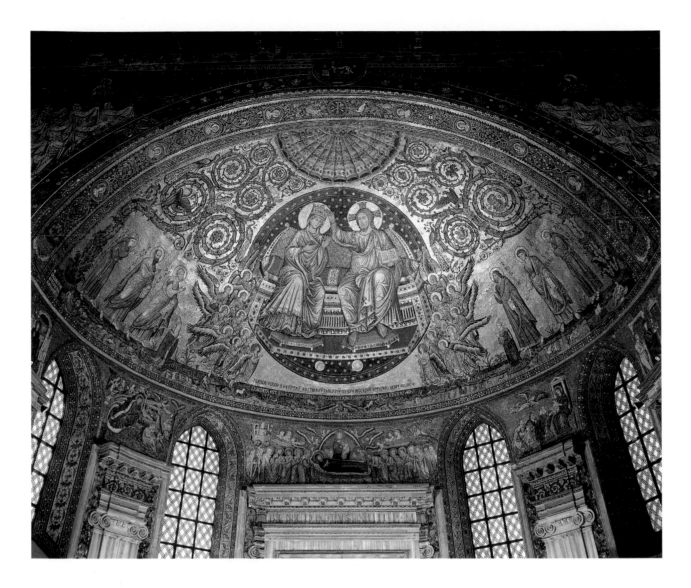

The Virgin's face is depicted much as it is on the *Regina caeli,* oval in shape with arched eyes turned outward and framed by a heavy blue *maphorion* (mantle). But Mary's intercessory gestures, one raised hand and the other across her chest, belong not to Sta. Maria Maggiore's great relic-image but rather to the Virgin, who intercedes in scenes of judgment, such as those on the Sancta Sanctorum reliquary and in the Zeno Chapel in Sta. Prassede (see figs. 50 and 116). Mary, the mosaic suggests in this way, sits beside her son, not only in glorification, but also to continue her work of intervention on behalf of all penitents.

Like the facade mosaics, these in the apse are not venerable; in fact, they have been completed only recently. They are the work not of the facade's mosaicist, Rusuti, however, but of the painter Jacopo Torriti (dates unknown), who, like Rusuti, has signed his name to his work. The letters are clear in the

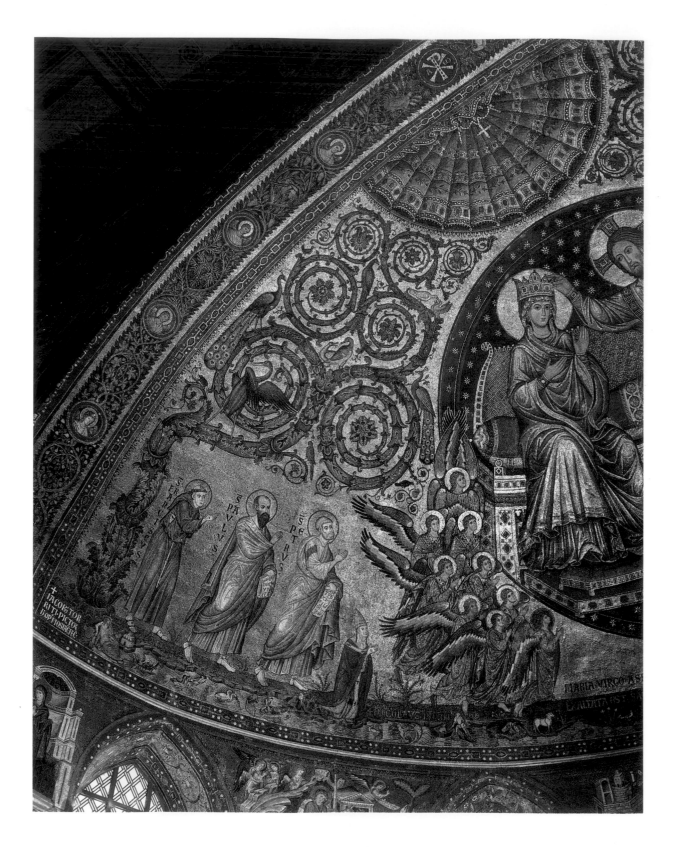

apse conch's far left corner: IACOB TORRITI PICTOR H[OC] OP[US] MOSIAC FEC[IT] (James Torriti, painter, made this work in mosaic).

The close relation of the apse mosaic to its counterpart on the facade is a result of the active participation of Pope Nicholas IV in the design of the entire decoration. Indeed, the pope outlined the subject matter of the complex image in the apse in a letter he wrote late in 1288 to Jacopo Colonna, one of the renovation's sponsors. In his letter, the pope describes Mary in apocalyptic terms as the "woman clothed in the sun with the moon beneath her feet" and includes phrases referring to her elevation that are virtually identical to elements found in the mosaic. It is not surprising that a learned patron was closely involved in such a great work; theologians participate actively, and craftsmen such as Rusuti and Torriti execute their work. Only now is this system beginning to cede some autonomy to "artists" themselves.

More traditional are the saints bordering the central image, though even here, Torriti has introduced important innovations in the realms of both doctrine and visual presentation. Rather than flanking the central figure, Peter and Paul appear together to the left. With them is St. Francis, rendered on a slightly smaller scale and identified (like all figures depicted here) in an inscription—S FRANCISCUS. Canonized only in 1228, Francis was a quite new saint when Torriti worked. Although at the time, the belief was widely accepted that, at death, Mary was assumed into heavenly glory in body as well as in soul, the concept of the Assumption had not yet become Church doctrine. Francis, however, had been particularly devoted to the Virgin, and the Franciscan theologian Bonaventura, Nicholas's predecessor as head of the order, had been a strong advocate of the Marian dogma; he had even written sermons for this day celebrating the Feast of the Assumption. Francis and his followers, including Pope Nicholas IV, were closely identified with the doctrine.

It is no accident, surely, that the pope has had himself portrayed on this side, below the Virgin and in the foreground before Peter and nine angels adoring the Queen of Heaven. Nicholas is a good deal smaller even than Francis, but he is fully attired in the papal regalia of tiara and red cope and identified in an inscription at his feet—NICHOLAS P[A]P[A] IIII. To the right of the enthroned Christ, in a corresponding grouping, are John the Baptist, John the Evangelist, and another Franciscan, St. Anthony of Padua. Beneath them, as a counterpart to the diminutive Nicholas, is a tiny standing figure of the basilica's titular cardinal, Jacopo Colonna, also in the regalia of his office and identified in an inscription.

The quartets of saints and patrons stand on the banks of a river alive with fish and fowl, boats, fishermen, and putti; one vignette showing a man saved from a shipwreck symbolizes the salvation of those who, abandoning worldly concern, attend to their spiritual lives. Classical personifications of river gods, with upturned urns, anchor the waterway at each end. At the center—in an image the pilgrim has seen already three times in the preceding night—the river

Opposite:
141
Santa Maria Maggiore, apse, detail. In a gesture of ecumenism inside Rome's supreme Marian church, Jacopo Torriti subsumed references to another of the city's venerated Mary icons, the *Madonna avvocata,* which pictures the Virgin appealing to Christ on behalf of sinners. Famous replicas of this type of Madonna icon were those of Sto. Sisto, Sta. Maria in Via Lata, S. Gregorio Nazianzeno, and Sta. Maria in Aracoeli; Sta. Maria Maggiore itself may also have had one. The recently canonized St. Francis is pictured at the outer edge, and in a slightly smaller scale, behind Peter and Paul. Wearing the tiara, red cape, and pallium, Nicholas IV—much smaller in scale than the other figures—prays to the Virgin.

divides into four streams, which define it as the river that flowed from Eden to water all the earth. Following a well-established Roman tradition of apse decoration, the river of living waters in Paradise is shown to symbolize Christ's sacrifice, which, through the Eucharist, offers redemption; accordingly, two deer drink from the streams. At the center, Eden is to be seen, the gold- and gem-clad city; in contrast to the vision above flanked by seraphim, a sword-wielding seraph closes off this paradise. Within the walls are Enoch (Gen. 5.24) and Elijah (2 Kgs. 11), the two Old Testament figures who ascended to heaven (and who for the same reason were portrayed over the entranceway to the Zeno Chapel); they are perfect counterparts to Christ and, in particular, to Mary above.

The continuity from the terrestrial to the heavenly paradise is figured, finally, by enormous vine scrolls that sprout from each end of the river. Recalling the church's earlier apse, torn down to make this one, and, in turn, the mosaics in the Lateran baptistery and in S. Clemente, tendrils sprouting myriad spirals wind upward toward a fan of heaven at the center of the top of the vault; the vine scroll here is filled with birds, some eating fruit, others feeding their young. Peacocks are especially featured, symbols of Paradise, here magnificently realized through the mosaicist's art and thus bridging, through the decoration itself, this world and the next.

Glittering in the light of a thousand and more tapers, the apse of Sta. Maria Maggiore is like nothing any traveler has ever seen. The rapt faces of the pilgrims beneath the depiction of the Christ figure crowning the Virgin convey clearly that this is the closest these followers of Christ will ever get to heaven while they still walk the earth.

Along the apse arch's edge, more stylized floral scrolls rendered as growing from large planters anchor the ensemble in the architectural space. These are inhabited by animals and are heavy with grapes, figs, and other fruit symbolizing the spiritual elevation from earth made possible through God's bounty. Medallions with busts of angels interrupt the vine, and at the top, directly above a cross suspended in the fan of heaven, are the Chi-Rho and Alpha and Omega, ancient symbols of the eternal Christ.

Torriti has broken new ground to extend the imagery to a band below the apse conch. Four scenes depicting Mary's role in the Incarnation frame the windows: the Annunciation, Nativity, Adoration of the Magi, and Presentation in the Temple (fig. 142). The vision of earth elevated to heaven, which dominates the apse, is underlined by events from that golden moment, commemorated in this church, when heaven descended to this world in the person of Christ. And in a double scene at the center of the band, the two realms are joined in a different way. Instead of the Virgin bringing Christ into the world, Mary is seen at the end of her life (fig. 143); Christ fetches her soul and carries it beyond. Indeed, the tender image at the very center, in which Christ cradles the little figure of Mary, recalls but inverts the group of the *Regina caeli* icon.

142
Santa Maria Maggiore, apse, *Presentation in the Temple*.
Although the composition of Mary offering the Child to the
Jewish priest Simeon is traditional, it is staged in a setting of
Cosmatesque furniture rendered in a kind of perspective that
attests to Torriti's looking at the world around him.

143
Santa Maria Maggiore, apse, *Dormition of the Virgin*. The cen-
tral panel effects an ascent from the bodily remains of Mary,
through her diminutive soul cradled in Christ's arms, to the
emblem of Eden occupied by Enoch and Elijah and guarded
by the flaming sword, beyond the river and the firmament
(with sun and moon), to heaven itself.

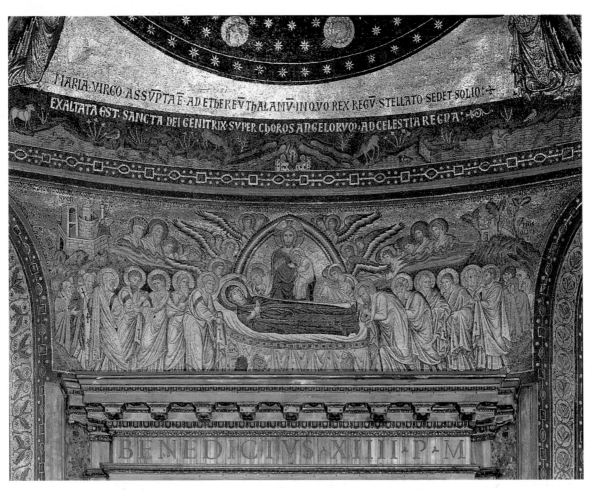

Beginning with a well-known composition for showing the Death of the Virgin attended by the apostles, Torriti has elaborated a new iconography. He has added male and female saints to the corps, and in the clouds above, along with David and Moses, he has again included both Enoch and Elijah, men who, like the Virgin Mary, also miraculously ascended. Moreover, Torriti has situated the burial between Mt. Zion and the Mt. of Olives—that is, precisely in the place specified in a letter ascribed to Jerome: "the grave of Mary is in the Valley of Josaphat, half-way between Zion and Olivet." He even pictured the column on which Christ was flagellated, which had been preserved in a shrine on Mt. Zion and is now in the nearby church of Sta. Prassede (see fig. 121).

Torriti has also adapted the imagery to the space itself, using the pointed aureole that encloses Christ in such a way as to make the image seem to be a fifth window within the apse. As the majestic Christ figured at the center of the facade declaims in words on the open book, Christ is shown here, too, to be the true light of the world. And by directing the viewer's focus upward, the placement of the pointed aureole establishes a vertical axis that extends from the dead body of Mary to Christ holding her soul, to Enoch and Elijah in Eden, to heaven parted to show the Coronation of the Virgin, and finally to heaven itself.

At the bottom of this axis, beneath Mary's bier, three men kneel in prayer, two of them identifiable by their brown habits as Franciscan friars. It is not clear who these men are, but like the figures of Pope Nicholas and Jacopo Colonna in the apse above, they cue the viewer's response to the dazzling display of sacred images. The pilgrim kneels yet once more and offers a prayer to the Blessed Virgin.

The apsidal arch. When the pope, saying the Mass in Sta. Maria Maggiore, begins the special liturgy for the Feast of the Assumption with its readings from the Song of Songs, the Gospels, and the Church Fathers, the multiple meanings of the mosaic behind him become clearer. The readings explain, for instance, the scene on the left side of the apsidal arch, depicting St. Jerome reading from a pastoral letter (written, in fact, by the ninth-century theologian Paschasius Radbertus) addressed to two Roman women, identified as Paula and Eustochium (fig. 144). Although Jerome's presence here—like Matthew's on the opposite side—is to be explained in part by the presence of his relics in Sta. Maria Maggiore, the selection of this episode from his life is attributable to the fact that the Letter to Paula and Eustochium argues that Mary entered heaven in both body and soul. In the mosaic, Jerome sits with a book beneath the coffered ceiling of a little chamber as he reads to the kneeling women the words "Cogitis me" (Think of me)—the beginning of the letter read in the Assumption Day Mass.

While the liturgy clarifies the meaning of the pictures, the imagery in turn dramatizes and substantiates the words and hymns that fill the sanctuary. The inclusion of the Jerome episode and its placement at the left, rather than near the altar in the right aisle honoring the saint's remains, seems certainly to have been made for personal reasons as well as for liturgical ones. Before his eleva-

tion to the throne of St. Peter, Nicholas's name had been Girolamo (Jerome) da Ascoli. Nicholas né Jerome now lies buried just within the choir in the left transept—that is, directly below this scene, which serves as a kind of mediator with the vision of heaven above it.

That vision, stretching over the expanse of the apsidal arch, is the traditional one in Rome, the subject already familiar to the pilgrim from SS. Cosmas and Damian, Sta. Prassede, and other churches, of the twenty-four elders of the Apocalypse adoring Christ, flanked by the four evangelical creatures and seven candlesticks. Here, Christ appears at the pinnacle of the arch—the Lamb of God, standing on a throne within a clipeus filled with stars, the sun, and the moon. As such, it is also the culmination of the hierarchical ascent that begins on earth at his mother's deathbed, continues to heaven, where he presides, and presents the future when he will open the sealed book at the end of time.

Appropriately, the beginning of time is also pictured in the adjacent space, albeit in the less-exalted medium of fresco. Still unfinished at the time of the Jubilee (perhaps work has stopped because the church's patrons, the Colonna, are in exile), scenes from the Book of Genesis are being painted on the three walls of the new transept, beneath a frieze containing magnificent medallion portraits of Old Testament prophets (fig. 145). This promises to be one of the finest

144
Santa Maria Maggiore, apsidal arch, *Jerome Reading to Paula and Eustochium.* Jerome, whose relics were sheltered nearby, is pictured here primarily because a letter (falsely) attributed to him provided a fundamental argument about the ascension of the Virgin and was read in the Feast Day service. The fourth-century saint is attired here as a thirteenth-century bishop. (The mosaic is heavily restored.)

145
Santa Maria Maggiore, left transept. The transept, added only when Nicholas IV remodeled the basilica in the early 1290s, was never completely decorated, but what remains of the painting is of the highest quality. The illusionistically rendered cornice surpasses anything else known to that time; the roundels with portraits of the prophets are as strong as the work of Giotto and Cimabue, and betray the same interest in the revival of ancient painting. The division into panels is the product of restoration work earlier in the twentieth century, but it is more or less faithful to the original intent. The only fragment of the narrative to survive is the scene at the left of God ordering the world into being; the universe is represented as an enormous orb.

examples of the new Roman style of painting, with its classical vine scrolls, illusionistic faux architecture, and lifelike portraits. The first scene of the narrative cycle shows the bearded Creator seated on a globe, where he calls into existence the mundane universe; the rest of the Creation and Fall stories are to follow.

From here, the transition is logical and natural to the mosaics on the triumphal arch and Old Testament cycles in the nave, which treat the earthly story of Christianity and its origins. The pilgrim is therefore ready now to withdraw from the sanctuary to "read" history on the outer walls within in Sta. Maria Maggiore.

The Triumphal Arch and Nave Mosaics

Stepping back into the nave, the pilgrim also steps back in time more than half a millennium. The mosaics that cover the venerable triumphal arch and proceed down the nave, still remarkably intact, reflect the patronage of Sixtus III and the mastery of fifth-century craft. Like the architecture, these breathe of ancient Rome in their iconography of triumph and in their deft impressionistic style.

The themes of the triumphal arch are not entirely unrelated to those of the apsidal program. At the summit, for instance, a clipeus presents images from Revelation: the sealed book and jeweled throne, flanked outside by the four evangelical creatures. The Lamb is missing, and in its place are the cross and crown, emblems of the victorious Christ, who is in heaven but who will return to rule from the imperial throne, here adorned with lions' heads in profile. Medallions of Peter and Paul on the throne suggest that, in the interim, it is the pope—Peter's successor in Rome—who governs in Christ's place. The point is reinforced both with full-length figures of the two Apostles on either side of the clipeate medallion and with the inscription proclaiming Sixtus as bishop of God's people. As "Apostle to the Jews" and "Apostle to the Gentiles," respectively, Peter and Paul represent the entire faithful populace now led from Rome by the pope. Understood together with the thirteenth-century scene of adoration on the apsidal arch, a traditional scheme of the heavenly Church, the composition on the triumphal arch represents the present Church on earth, established at the Incarnation and governed by the pope.

The early life of Christ, a particularly fitting subject for this church dedicated to Mary, appears below. The ecclesiological theme introduced in the keystone receives special attention. Beginning at the left, Mary sits to the right of the Jewish Temple, weaving purple wool. She is making the curtain that, according to the Epistle to Hebrews (10.19–20), separates the outer court of the tabernacle and the inner sanctum; the curtain, in turn, is identified with Christ's flesh, which, at the Crucifixion, was rent to provide humankind a direct way to heaven. The yarn Mary weaves is a metaphor, therefore, for the Incarnation, which is announced by the angel approaching Mary from the right and which is effected by the dove and angel in the sky above (to the right, an angel tells Joseph of the

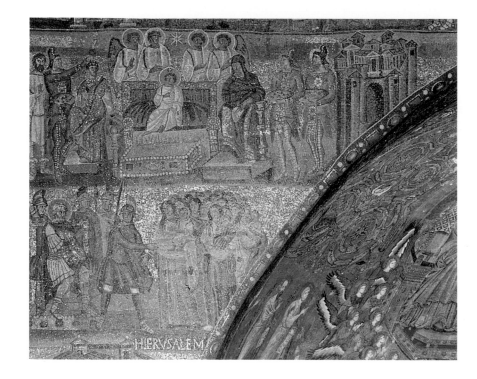

146

Santa Maria Maggiore, triumphal arch, detail. Christ, the scale of a child but clad as an adult, is enthroned like a prince and adored by angels, kings, and his mother. The scene of the Massacre of the Innocents, below, still deploys classical conventions for a dramatic effect.

miraculous birth). Enthroned and dressed in gold garments like a Roman princess, the Virgin at once embodies the humblest and most elevated of all conditions; she is the *Theotokos*.

On the other side, Mary, accompanied by angels, appears within the Temple courtyard, where she presents the Child to Simeon and the other priests; the presence of Anna in the scene signifies the Jews' recognition of Christ's divinity. In the far corner, an angel approaches Joseph a second time, now to tell him to flee to Egypt. This time, Joseph sleeps outside the Temple, a pagan structure adorned with a depiction in the pediment of the *Dea Roma* (personification of Rome) and roof ornaments in the form of masks along the gutter.

In the second register, Christ occupies the gemmed throne—a diminutive figure now, dwarfed on an enormous cushion, his feet nowhere near to reaching the gem-trimmed footrest (fig. 146). Mary sits to the left; on the right sits Ecclesia, dressed in the blue maphorion and hence closely identified with Mary. The gift-bearing magi, in Persian garb to indicate their Eastern origin, approach from both sides to convey the reach of Christ's true dominion. The angels and stars behind the throne symbolize the young Christ's divinity, the cross in the halo his humanity. In the counterpart scene at the right, another pagan king recognizes Christ, this time the Egyptian ruler Aphrodosius, who, according to legend, greeted the holy family in flight from Palestine (fig. 147).

In the third register down at the left is the Massacre of the Innocents, who died for Christ. The Magi Consulting Herod and His Advisers is represented at

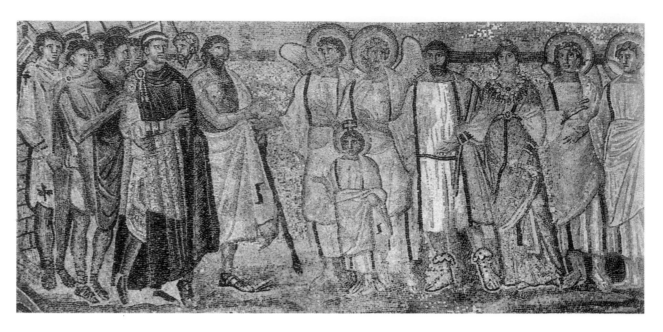

Santa Maria Maggiore, triumphal arch,
detail. The scene of the governor of Egypt
greeting Christ was interpolated to
emphasize Christianity's appeal to gentiles.

the right, the episode in which Christ is named as the "leader of my people Israel"
(Matt. 2.6)—an obvious reference to the central theme and to Sixtus's epithet in
the inscription. Herod, flanked by armed men, wears military garb, representing
the pagan world gone astray and in need of redemption through Christ.

Finally, at the bottom at left and right, Jerusalem and Bethlehem are repre-
sented as Christian cities, indicated by crosses in their portals. Flocks of lambs,
representing the faithful, congregate before the portals. The two cities may be
understood, perhaps, as Rome, with receding colonnades so carefully depicted
inside as to extend visually the actual rows of columns in Sta. Maria Maggiore.

While honoring Mary and her role in sacred history, the triumphal arch mosaic
introduces a political message into the story of the Incarnation. Devised only a gen-
eration after Alaric's sack of the city in 410 and at a moment when the papacy was
establishing its secular authority in Rome, it emphasizes Christianity's dominion in
the pagan world; in so doing, it asserts the Church's universal claims over pagans as
well as Jews. Still, it is surprising that the Nativity—surely the central event in Mary's
life—is missing from the triumphal arch sequence. Perhaps this was not always so,
and the scene of Christ's birth did in fact appear in the fifth-century mosaics in the
original apse or elsewhere below; the omission here is a puzzling one, which Torriti,
in his mosaics of more than eight hundred years later, did not perpetuate.

The Nave Mosaics: God's People

Finally turning away from the triumphal arch, the pilgrim gazes down the length
of the nave toward the main door and begins to study the mosaics in the stucco
aedicules beneath each window. These present the triumph of the Israelites, run-

148

Santa Maria Maggiore, nave. The fifth-century mosaics are now set within new frames in the remodeled nave. The selection and presentation of scenes reveals an Early Christian attempt to appropriate Hebrew Scripture as Christian prophecy.

ning on each side from the apse wall to the door and, thus, in two parallel sequences. Like the mosaics on the triumphal arch, the nave walls reflect fifth-century artistic mastery and interests. The artisans whose work is to be seen in abundance here were certainly familiar with pagan Roman painting techniques and visual vocabulary, and they have applied these in rendering sacred Scripture on these walls. In obvious distinction to the more formal style of the New Testament episodes on the triumphal arch, the scenes from Jewish history in the nave are treated in a free, impressionistic manner that conveys the factuality of the episodes.

At the same time, the makers of these mosaic panels have carefully selected subjects and adjusted compositions to convey a sophisticated, assertively theological message. Thus, the first scene is not from the Creation story (which would be added on the adjacent wall of the newly built transept only eight centuries later). The sequence begins with Melchizedek's presenting Abraham with bread and wine (Gen. 14.18–20, fig. 148); this marks an obvious typological significance for the celebration of the Eucharist on the main altar and provides for the even more important reference to the claim (Heb. 6.20–7.28) that the Christian priesthood "in the succession of Melchizedek" had superseded the rites of the Jews, established by God with Aaron. The point is made abundantly clear: Christ, appearing in heaven, gestures not toward Abraham (who, in the manner of a Roman emperor, approaches with his men on horseback) but to Melchizedek.

The third aedicula introduces a related typology. Ostensibly depicting the story of Abraham's hospitality (Gen. 18.6–8, fig. 149), it shows one of the three messengers whom the Patriarch greets enclosed in an aureole to signal that this

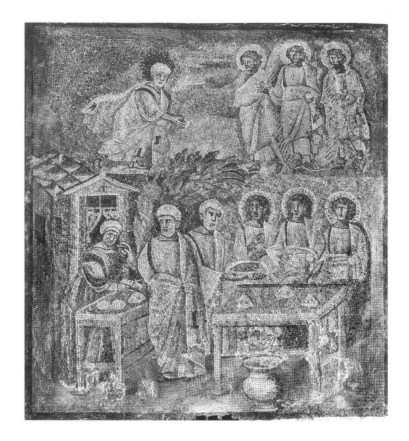

149

Santa Maria Maggiore, left wall. The narratives have very much the character of contemporary illustrated books; whether or not they actually copy manuscript models, they would have evoked textual art in the minds of educated fifth-century viewers. Nonetheless, the meaning was anything but literal. The three messengers of Genesis are figured as the Trinity, and Sarah, another type of the Church, stands before a basilican structure marked with a cross. (Photograph predates recent restorations.)

figure is Christ or, more precisely, that the three are the Trinity. Below, in the same panel, a cross is introduced over the doorway of Abraham and Sarah's house, and bread and wine (the Eucharist) are offered in the final moment of Abraham's offering sustenance to his guests.

The stateliness of these depictions, appropriate in the zone of the church close to the altar, yields to a less ceremonial and more animated style farther along the nave. There the emphasis is less on liturgical typology than on the theme of the transfer of God's covenant from the rightful brother to a younger sibling, as exemplified by the story of Jacob and Esau. In this lively rendering of Jacob's fooling his father, Isaac, the blind patriarch, leans up in bed and, encouraged by Rebecca, bestows his blessing on the younger son.

The ordering of scenes and modes of representation are also evident on the opposite wall. For instance, the Trial of Moses and Moses Disputing the Egyptian Wise Men (fig. 150) near the triumphal arch are formal and detailed. Derived from legends rather than the Bible, the two scenes are connected to the apocryphal story, depicted on the triumphal arch, of Christ entering Egypt, and they establish the heroic leader of the Israelites as a type of Christ among the pagans. Pharaoh's daughter, attended by ladies in waiting, sits enthroned in her palace to receive her adopted son, who in a test has rejected the offer of precious stones.

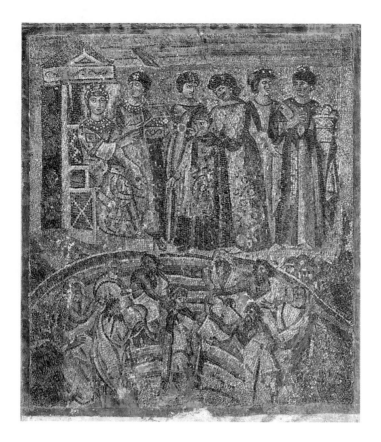

Santa Maria Maggiore, right wall. The
apocryphal story of the Trial of Moses
was introduced to demonstrate how the
gentiles were preordained to accept
Christianity. Moses Disputing the Wise
Men of Egypt, in turn, was a type of
Christ disputing in the Temple.

Below, in a scene that recalls Christ teaching in the Temple, the lad appears again,
now defeating the wise men with his divine knowledge.

Farther along the nave, Moses and his successor Joshua—whose name was
the same as Jesus's—are shown overwhelming their enemies in a more literal
way and in a more epic mode of rendering; thus Moses's inundation of
Pharaoh's army (fig. 151) is executed with the vigor and prowess of the military
encounters pictured on the ancient triumphal columns of Trajan and Marcus
Aurelius still prominent in the city. Having secured the safety of his followers,
Moses turns back and, with his staff, closes the Red Sea just in time to halt the
Egyptian troops. Emerging from the walled city on horseback and in chariots,
many of the aggressors are caught by the waters. In the distance, one of the
Egyptians, perhaps Pharaoh himself, waves his shield futilely as he sinks into
the depths.

Santa Maria Maggiore's nave mosaics make it clear that many secrets are
hidden in the deeds recorded in the Old Testament, prophecies of God's dispen-
sation with a Chosen People. Among others are the guarantee of God's perpetual
protection and of the transfer of that protection to the Jews' younger brothers,
the Christians. Still, the messages seem almost beside the point in a church ded-
icated to the Virgin; the special importance given to women in these pictures, to

151

Santa Maria Maggiore, right wall, *Crossing of the Red Sea*. Classical traditions, still very much alive in the fifth century, were readily adapted to the Old Testament battle scenes.

Rebecca, Rachel, and Leah and to Pharaoh's daughter, is clear: these women are to be understood as types of Mary.

Departure. Approaching the door to leave Sta. Maria Maggiore, the pilgrim must stand aside with the crowd of worshipers while the *Acheropita* is borne out of the basilica to return (by a much more direct route than last night's) to its home in the Sancta Sanctorum. While the retinue carrying the Lateran icon passes, custodians of Sta. Maria Maggiore are installing the *Regina caeli* in its tabernacle, the doors of which will be left open now for eight days so that pilgrims can continue to worship the sacred presence.

Above the doorway on the inner wall of the facade, a final image strikes awe into the pilgrim. It is an enormous clipeus enclosing the Lamb of God amid luxuriant acanthus scrolls (fig. 152). The depiction is rendered in fresco, not mosaic, and because the painting is not yet finished, the pilgrim cannot be absolutely certain what to make of the subject. It recalls a similar figure pictured at the other end of the church at the summit of the apsidal arch, where there is a sign of the final days. Perhaps the Lamb here is the culmination of a Last Judgment scene. For obvious reasons, this subject is often depicted on the reverse facades of Roman churches, where it reminds worshipers, as they leave the house of God and reenter the physical world, that they must one day face their Creator.

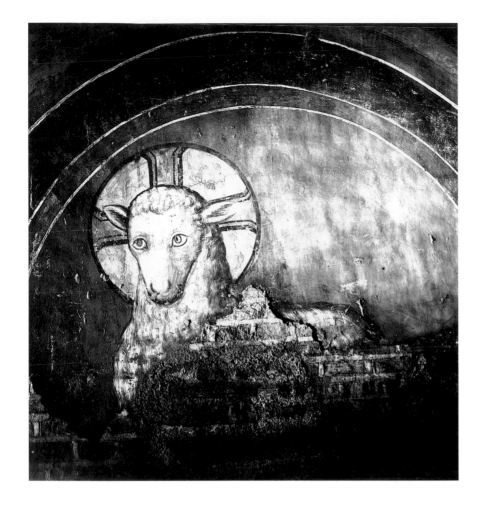

152
Santa Maria Maggiore, inner wall of facade. All that remains of the decoration at the summit of the entry wall is the Lamb of God within a clipeus, perhaps from a Last Judgment.

Lower down, the dedication of the basilica eight centuries before conjures up far more historical recollections. Immediately brought back to mind are Mary and the popes who founded her church and have maintained it through the ages:

Virgo Maria tibi Xystus nova tecta dicavi
 digna salutifero munera ventre tuo.
Tu genitrix ignara viri te denique feta
 visceribus salvis edita nostra salus.
(I, Sixtus, have dedicated a new temple to you Virgin Mary, worthy of honor because of your salvific maternity. Mother without having known a man, you conceived our Salvation.)

6

THE TWO APOSTOLIC BASILICAS

Visits to the great basilicas dedicated to the apostolic martyrs Peter and Paul conclude the pilgrim's peregrinations in Rome. The two churches are not neighbors, nor is either particularly close to Sta. Maria Maggiore, so considerably more walking is in store for the pilgrim. Moreover, they are very differently situated. One, on the east side of the Tiber beside the road to the ancient coastal city of Ostia, lies on low ground in open, empty countryside. The other overlooks the Tiber River from atop the Vatican Hill in a busy, populous portion of the medieval city on the west side of the river. The pilgrim has planned to visit them in immediate sequence, saving St. Peter's for last, for it is there, and only there, that she will ultimately obtain the absolution for which she undertook her pilgrimage to Rome.

Saint Paul's Outside the Walls

First, she makes her way to the church of St. Paul, which Pope Boniface has declared an obligatory station for pilgrims seeking plenary indulgences. The basilica dedicated to Paul is the largest church the pilgrim has visited so far, and a magnificent structure it is (fig. 153). Its solitary situation exaggerates St. Paul's size. It has been erected outside the city because it marks the site of the apostle's grave, and so, in accordance with the ancient law forbidding burials within the city, it must be outside the city walls. (This is the same law that accounts for all the catacombs being beyond Rome's perimeter.) Indeed, its very remoteness has become incorporated into the name by which it is called, *ecclesia beati pauli extra*

muros, church of St. Paul's Outside the Walls (San Paolo fuori le mura). But for its location, however, there is nothing rustic or humble about St. Paul's. The basilica is imperial in origin, scale, and splendor.

Saint Paul's, in fact, is one of the last great products of imperial patronage in Rome. It was erected by Theodosius (347–95) and his sons to replace a smaller memorial that Constantine had built on the same spot earlier in the fourth century. The "Apostle to the Gentiles" was particularly venerated by Theodosius's generation, which banned the practice of pagan cults and declared Christianity the sole licit religion in the empire.

The monastery. Because of its remoteness, St. Paul's became increasingly difficult to maintain when the population of Rome began gradually to shrink early in the fourth century, after the government was removed to Constantinople. But the same isolation that has led to some neglect also made the basilica a perfect site for a monastery, and by the sixth century, both women and men dedicated to the *opus dei* (the divine office comprising prayer, study, and work) had established communities near the apostle's cemeterial basilica. Since the tenth century, the monastery at St. Paul's has grown into one of the principal centers of Benedictine monasticism, adhering to the rule of the great sixth-century spiritual leader. Serving the community has occasioned the building of an array of workrooms, chapels, dormitories, and refectories. Nestled in the tract bordered by the basilica's outer nave wall and right transept, these buildings make up the monks' private space (fig. 154). Outsiders may not enter here.

Although each monk takes a vow of poverty, the order as a whole is not embarrassed by its wealth. Indeed, the abbey of St. Paul's is elaborately adorned.

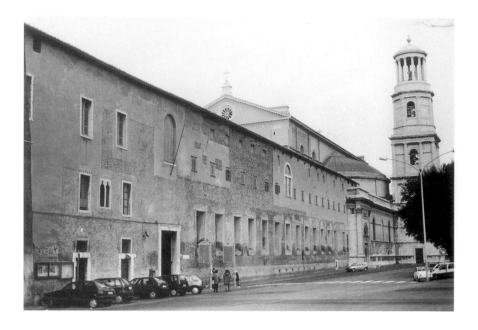

In the refectory, for instance, a magnificent twelfth-century painting of Christ's
Last Supper provides a fitting mealtime model for the monks, who of course
identify themselves as descendants of the apostles. And the cloister onto which
the several monastic buildings open is as splendid as it is serene (fig. 155); indeed,
here the arts of humanity and nature mingle to make this the most beautiful
cloister in all Rome. An inscription running beneath a frieze of porphyry and
serpentine disks declaims the cloister's function to be a garden where the monks
come to read, study, and pray.

Begun during the pontificate of Innocent III (1198–1216) on a commission
from the Abbot John of Ardea, the cloister was completed by 1230. It is the
handiwork of Pietro Vasselletto, a master practitioner of Cosmatesque stone
inlay in kaleidoscopic geometries of stones of brilliant hues set into snowy white
marble. Double colonettes, some straight, others entwined, support a gracious
four-sided portico that joins the church to the monastic complex; a fountain
plays at the center of the cloister garden. But cautionary notes are sounded in
the cloister. One is a sculpted relief of Adam and Eve in that other paradisaical
garden (fig. 156)—the couple disobeying God as they eat from the tree of the
knowledge of good and evil and invite eternal punishment. Another pictures a
fox in monkish garb, distracted from his reading by a goat passing by. Still others
warn of the dangers lurking in nature—a demonic face emerging from a leaf, for
example, and a crowned head that forms both a front view and left and right
profiles. The messages in this haven are chastening.

Entering the basilica. Unlike the monastery, St. Paul's basilica opens its doors
to all laypersons. Worshipers enter the church proper through a set of remarkable

bronze doors (fig. 157) in which fifty-four panels are inlaid with figures and inscriptions in silver. One of the inscribed plaques pictures Pantaleone, the merchant from Amalfi who commissioned the panels when Hildebrand (who was to become Pope Gregory VII, 1073–85) was abbot at St. Paul's; in a scene that has become familiar, the donor is here being introduced into Christ's presence by the apostle. The meaning is clear: as Pantaleone's patron, Paul opens the portals of eternal life for him. The doors were made in Constantinople in 1070 at the direction of Abbot Hildebrand; that accounts for the inscriptions' being in Greek as well as Latin and for the hybrid imagery. They are among the earliest witnesses of the revival of art and culture that has come to be thought of as the "Gregorian Reform," after this very patron.

Guided by Paul's teachings on Christ's incarnation and resurrection, the panels represent the major events from the life of the Savior: the Annunciation to the Virgin (fig. 158), the Visitation of Mary and Elizabeth, the Presentation of Jesus in the Temple, Jesus' Baptism, the Transfiguration, the Entry into Jerusalem (fig. 159), the Crucifixion, Christ's Deposition, the Harrowing of Hell, the Appearance to the Apostles, the Ascension of Christ, and Pentecost. In Byzantium, these episodes set the great annual feast days of the church calendar—the life of Christ made meaningful during the cycle of months and in the daily liturgy. Here, however, Christ's life on earth is meant to culminate at Pentecost in the founding of his earthly Church, and so the same scenes from the life of Christ introduce St. Paul's memorial church in Rome, which resulted directly from Pentecost. Paul, of course, is featured in the scene at the top of a circular bench. Individual panels depict the martyrdoms of the twelve apostles— an appropriate subject for the memorial church of one of their number.

157
Saint Paul's Outside the Walls, bronze
doors. The bronze portal was restored and
reinstalled in the interior of the church for
protection. Over time, the fifty-four
incised and inlaid metal panels have
become detached and put back, and the
original sequence of scenes is uncertain.

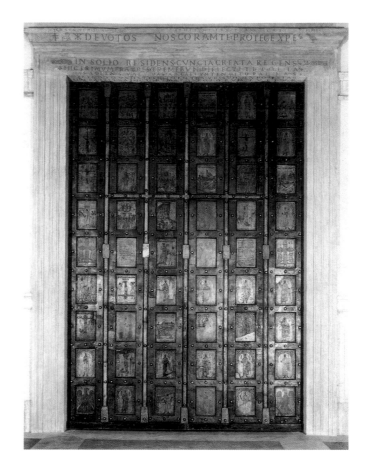

Opposite bottom:
160
Saint Paul's Outside the Walls, interior,
painting by G. B. Panini, 1750. The paint-
ing accurately depicts the original
church's richly veined, fluted marble
columns, stuccoes, frescoes, and gilt
openwork ceiling. Also faithful to the
original are the mosaics of the triumphal
arch and apse and Arnolfo di Cambio's
baldachin over the apostle's grave. The
hodgepodge of clerics, pilgrims, urban
aristocrats, bourgeoisie, and pets reflects
the mixture of seriousness and curiosity
that attracted visitors to St. Paul's during
the eighteenth century (and engendered
demand for paintings such as this one).

Appropriately, several of the main plaques feature doors: the Annunciation,
where Mary stands before a door awaiting the arrival of the Holy Spirit; the
Entry into Jerusalem, where a statue of a pagan god high above the city gate will
topple with the advent of Christianity; the Harrowing of Hell, in which Christ
breaks down the doors of Hades; and the Appearance to the Apostles, where
Christ is himself the golden door of the Church. The portal theme is reiterated in
the dedicatory inscriptions, which refer to Christ as the *ianua vitae* (the door of
life) and invite the faithful entering the church to study the magnificent portals.

The bronze doors admit the pilgrim into a vast space divided into two dis-
tinct areas: a nave with aisles for congregational purposes and a transept that
shelters the apostle's tomb (fig. 160). Although by the time of the first Jubilee
the transepted basilica has become the standard plan for churches in Rome (Sta.
Prassede, for example, and, only recently, Sta. Maria Maggiore) and indeed
throughout the Christian world, St. Paul's is by far the oldest example that the
pilgrim has yet seen and the most impressive.

The nave. Entering the remarkable nave of St. Paul's, the visitor is awestruck
both by the grand scale and by the abundance of architectural and decorative

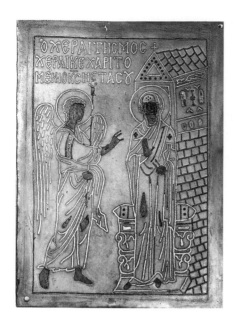

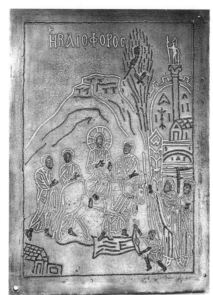

158
Saint Paul's Outside the Walls, bronze doors, detail, *Annunciation*. The faces and hands of the figures, inlaid in precious metal with incised details, are mostly lost. Because Mary conceived the Word by means of words, the Greek titulus in this panel not only identifies the subject as the Annunciation but also gives Gabriel's famous salutation: "Greetings, most favored one! The Lord is with you" (Luke 1.28).

159
Saint Paul's Outside the Walls, bronze doors, detail, *Entry into Jerusalem*. The statue atop a column identifies the ancient city of the Jews as a pagan stronghold; Christ's arrival transforms both the ancient and the Jewish worlds.

161

Saint Paul's Outside the Walls, archaeo-
logical passageway. A gallery of detached
column capitals and drums and other
architectural fragments from the medieval
church is maintained today outside the
basilica's right aisle.

162

Saint Paul's Outside the Walls, inscription
from aisle (north porch). Carefully pre-
served and inserted into the new north
porch, the inscription SIRICIUS EPISCO-
PUS TOTA MENTE DEVOTUS records the
participation of Pope Siricius (384–90) in
building this imperial basilica.

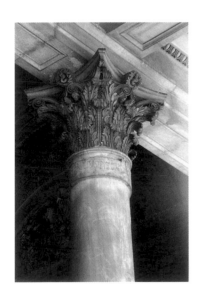

details. These call for comprehensive overviews at first and then close, patient
examination. Slabs of reused marble pave the floors, many bearing ancient epi-
taphs of those who, centuries ago, had sought to be buried near the martyred
apostle's remains. The sheer walls rest on handsome marble columns that, leg-
end has it, were stripped from Hadrian's tomb; the fine carving of the details
confirms the basilica's ancient pedigree (fig. 161). Apparently, however, even an
emperor's grandiose monument yielded insufficient materials for the apostle's
memorial, for fewer than half of the forty nave columns are of the fine, veined
marble that purportedly had graced the emperor's tomb; most of the supports
are imitations in more ordinary white marble. Smaller but otherwise nearly
identical columns, some eighty altogether, separate the double aisles on either
side of the nave (fig. 162). The impression is one of a surrounding wood. Car-
rying on the connotation of a forest, the nave columns support arches deco-
rated with leafy motifs in stucco on the undersides of the arches and on their
faces (fig. 163). Only a few years after the basilica's completion, the poet Pru-
dentius likened the arches to "meadows that are bright with flowers in the
spring" (Peristephenon, 12.54).

Papal portraits. Above the nave column capitals, the vines bear medallion
portraits of the popes, introduced just a few years ago by Nicholas III. These
are but the latest of several sequences, updating the papal portraits above the
arches that go back to the basilica's beginning. Arranged in pairs and set in imi-
tation porphyry, the popes are depicted in the original series together with the
length of their pontificates, precisely to the day, linking each incumbent to his
predecessor and, ultimately, to Peter, first bishop of Rome.

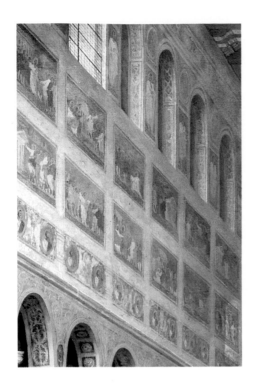

The natural impulse to begin at the beginning of a historical roster sends the pilgrim in search of Peter. Predictably, the first pope's portrait (fig. 164) is to be found at the farthest end of the nave from the entrance. Its position, on the right wall near the apse, conforms to the now-familiar order in Roman church decoration, in which proximity to the altar reflects importance. Thus, in St. Paul's, the papal lineage starts at the sanctuary end and progresses through time toward the basilica's doorway. In the portrait here, Peter is pictured in an ancient manner, within a circle framed in yellow and vermilion and with no sign of either his office or his sanctity—that is, he has neither a tiara nor a halo. To his right, the length of his reign is inscribed: twenty-five years, two months, and eight days.

Placement indicates the historical sequence in which the upper series of portraits was painted. In view of the fact that Pope Leo I (440–61) is the last pope in this sequence, it seems likely that these papal portraits date to the fifth century, when Leo restored the church after an earthquake damaged it. As time passed, subsequent popes were added to the series, eventually spilling into the transept and, finally, being inserted into the stucco ornament amid the vine scrolls. Curiously, the later portraits repeat the earlier series but in a new manner. The first-century pope Anacletus (76–81), for instance, is included in the original series, portrayed much in the manner of Peter; in the lower roundels, Anacletus appears again, now tonsured, framed in a halo, and wearing the pallium (fig. 165). (The pallium is the woolen band decorated with crosses that symbolizes the archbish-

163
Saint Paul's Outside the Walls, left nave wall, detail of G. B. Panini's painting (see fig. 160). Panini's painting brilliantly captures the lavishness of the fourth-century marble, stucco, and fresco.

164
Saint Paul's Outside the Walls, portrait of Peter from nave. Like other elements bearing on the papacy, the frescoed portraits were preserved to the extent possible and mounted on the monastery's walls.

ops' participation in papal authority deriving from Peter.) These differences
record the changing conception of the papacy during the Middle Ages from the
simple servant of God to the elevated, saintly Pontifex Maximus.

The triumphal arch. The successful search for the first pope's portrait posi-
tions the pilgrim well to study the arch that divides the nave from the sanctuary
proper. The magnificent gold mosaic that adorns the arch (fig. 166) depicts a
theme familiar from the churches of SS. Cosmas and Damian, Sta. Prassede, and
Sta. Maria Maggiore—that is, the Adoration of the Twenty-Four Elders as
recounted in Revelation. In this, the earliest of these depictions, the presenta-
tion is particularly dramatic. Unlike the later churches, St. Paul's pictures the
elders bowing not simply before the Lamb of God but before an actual, half-
length portrait of Christ. Bearing a cross-staff on his shoulder, the Savior is por-
trayed among clouds in the manner of the *Sol invictus,* the victorious solar deity
of the ancient Romans, his face a source of streams of light. Fifth-century
mosaicists seem simply to have fashioned the portrait of Christ after that of a
pagan deity.

The composition and its elements reflect the mosaic's early date, which is

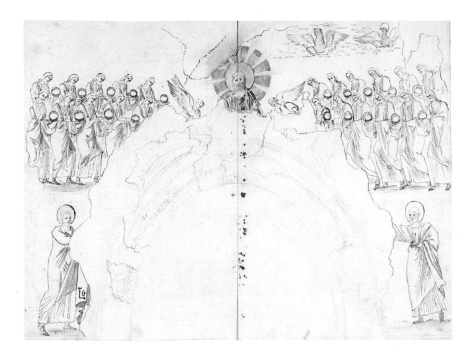

confirmed by an inscription stating that it was made through the patronage of Pope Leo and Galla Placidia (c. 390–450), daughter of the Emperor Theodosius. At that time there was little resistance to the idea that Christ could be shown as though physically present. As in the later churches, the theme of the elders adoring Christ, together with angels (fig. 167) and the four apocalyptic beasts, stands for the heavenly Church of which St. Paul's is but a material reflection; but here, the elders are distinguished by their headcoverings to make a point important to the early Church—namely, that Christianity has embraced both the "Church of the Gentiles" and the "Church of the Jews." The twelve on the right with covered heads are the Old Testament prophets; those on the left are the apostles. The division controls the rest of the decorations. Beneath the prophets, Peter, apostle to the Jews, stands gesturing upward; beneath the apostles is Paul, apostle to the Gentiles. Rendered in the finest mosaic technique, Peter's face, in particular, is arresting (fig. 168); the Prince of the Apostles is bearded in the manner of an ancient philosopher; his eyes, intense with life, capture each worshiper with a magnetic gaze.

The Old and New Testament frescoes. Frescoes arrayed in two registers above the papal portraits on both nave walls illuminate the concept of the unified Roman church introduced in the mosaic (see figs. 160 and 163). Like the series of papal portraits, each narrative register starts at the most holy apse end and proceeds from the triumphal arch toward the basilica's main entrance. To comprehend the entire program, therefore, the pilgrim must walk back and forth several times along the full 295-foot length of the nave. Fluted and spiral columns frame

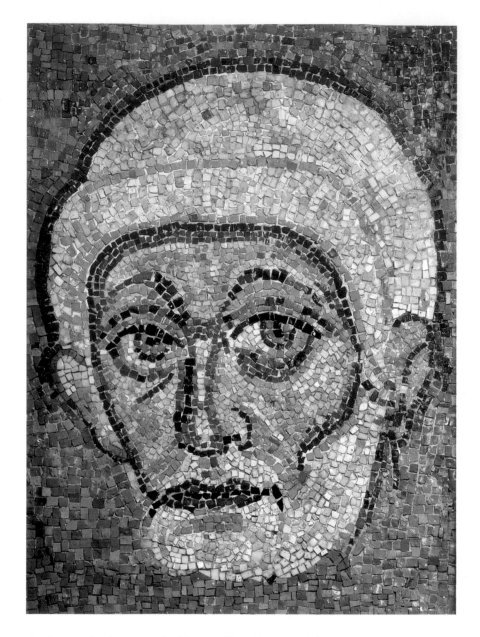

168

Saint Paul's Outside the Walls, triumphal arch, detail, *St. Peter* (Vatican grotto). The head of the standing apostle from the right spandrel of the triumphal arch was carefully preserved because of the special interest in portraits of the popes. Although heavily restored, the mosaic fragment still conveys the intensity and refinement of Late Antique art.

the forty episodes on each side, recalling historiated fourth-century sarcophagi similar to those the pilgrim has encountered elsewhere in her travels; perhaps the allusion is intentional, since the basilica does, in fact, shelter St. Paul's corpse.

The fresco sequence on the right wall begins with the Creation of the World in the upper tier, densely packed into a single composition—the creation of light and dark, sun and moon, water and dry land (fig. 169). Adjacent to the scene on the triumphal arch depicting the final coming together around the *Sol invictus,* the "new sun" who will govern a new creation at the end of time, the first scene shows the first Creation, which was also presided over by God, who

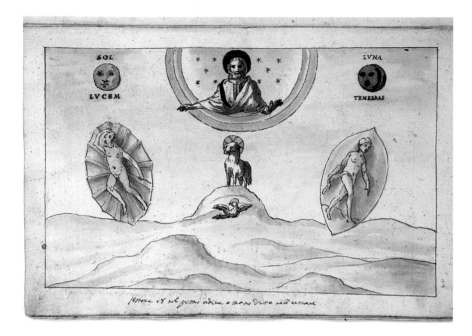

divided the sea and dry land, light and dark, stars, moon, and sun. It follows with a series tracing the creation and fall of humanity, Cain's sin, the rescue of the world through Noah, the covenant with Abraham, and the tale of Jacob and Esau. Humanity sins and is punished; then, in stages, God redeems his Chosen People.

The second register focuses on only two biblical figures: Joseph, who leads Israel into Egypt, and Moses, who brings it out. The cycles are beautifully orchestrated to reveal the purpose of Old Testament history. Thus, for instance, the scene abutting the arch tells the story of Joseph's Dream of the Stars (fig. 170); behind the sleeping Hebrew youth is a man not mentioned in the biblical account of Joseph's life (Gen. 37). He is the personification of Dream Prophecy, and his presence indicates that the vision of Joseph's brothers bowing down to him ("Must we come and bow low to the ground before you," Gen. 37.10) is truly fulfilled, not by the historical event in Egypt, but by the scene of the elders and angels bowing before Christ, to which he points. As in Sta. Maria Maggiore, the Old Testament is a prophecy of the New. In the Exodus sequence, moreover, Moses is accompanied throughout by Aaron, whom he meets after God sends him on his mission to free his enslaved people. Moses is shown, in this way, to be the precursor of Peter, who with Paul led a new Chosen People into a new Promised Land. The connection is patent.

The typology is an old one that was especially popular during the fifth and sixth centuries. Thus, the sixth-century Roman poet Arator compared the Old Testament heroes to the new apostolic brethren:

170

Saint Paul's Outside the Walls, nave, right wall, *Joseph's Dream of the Sun, Moon, and Stars,* seventeenth-century watercolor copy. The architecture behind the sleeping youth may be part of the late thirteenth-century repainting of the frescoes. Similar dollhouse-like structures appear in the Sancta Sanctorum paintings and Sta. Maria Maggiore mosaics. The personification of dream-prophecy, by contrast, may well be an Early Christian element. (BAV, Cod. Barb. Lat. 4406, fol. 43.)

171

Saint Paul's Outside the Walls, nave, left wall, *Paul Before Felix Agrippa,* seventeenth-century watercolor copy. The costume of the Roman governor and his guard and the lion-headed throne suggest authenticity; the various architectural elements indicate that the Baroque copyist was looking at a heterogeneous fresco, a late antique composition repainted late in the thirteenth century. In fact, the projects to restore Rome's Early Christian past, including the nave frescoes in St. Paul's, acquainted artists such as Pietro Cavallini with ancient traditions and, in that way, nourished the beginnings of the Renaissance. (BAV, Cod. Barb. Lat. 4406, fol. 123.)

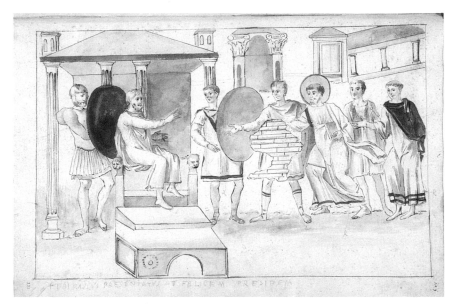

Egypt bears an image of the world; the people who deserved to be called from there were committed to two leaders for whom a fraternal origin bound their duties together. . . . And this free people, whom Pharaoh had previously fettered, put off the shadows of Egypt under the same number of leaders, and through the baptism of God, which at the time the prefiguring sea provided, [this people], obtaining the path of life, found heavenly food. In these [Apostles] also there was a brotherly love; their conduct imparted [this] in them more fully than nature; not the same but a single day pre-

172
Saint Paul's Outside the Walls, nave, left wall, empty landscape. A frieze with a continuous landscape ran the length of the nave directly below the rafters (see fig. 161); it suggested here the now-empty heavenly city. (After Uggeri)

sented them to heaven as twins, and [Paul's] passion has made sacred a day repeated in the revolving time of a year, and their conjoined grace gains the everlasting palm. (*De actibus apostolorum,* II)

Paul is the focus of the opposite wall, near his portrait on the arch mosaic (fig. 171). The apostle, who began as a persecutor of Christians and became converted to their cause, made his way as a Roman citizen to the capital city to plead the Christians' case. The sequence takes the apostle only to the gates of Rome, however. Digressing from the Book of Acts, which inspired the other scenes, it ends with Peter Embracing Paul at the city walls. In a parallel to Moses Meeting Aaron at the start of the mission to free Israel, pictured across the nave, the final scene represents the two apostles' encounter on the Ostia road—that is, near the entrance to the church—establishing in a picture what the Bible fails to do in writing. It shows Peter present in the city when Paul arrives. Peter, not Paul, has priority.

Above the double set of narratives, between the tall windows that illuminate the nave, are depictions of prophets, apostles, and saints—that is, the "lights" of the Church. And running beneath the gold-clad rafters, a frieze depicts a continuous row of unpeopled buildings; this is the heavenly city that awaits the faithful (fig. 172). Taken together, therefore, the decorations in St. Paul's manifest the unified Roman Church of Jew and Gentile, which offers salvation to those to enter.

The nave frescoes, for all the subtle concordance of their messages, seem inconsistent in style and, to a degree, in subject. Some figures are squat, others tall and elegant. Certain scenes, but not all, have explanatory captions—beneath the depiction of the tenth plague, for example, the pilgrim can make out the sentence SIC PRIMOGENITIS DATUR VASTITAS AB AETHRA (in this way, devastation is visited from heaven upon the firstborn [see fig. 174]). And in fact, the same episode appears a second time, several rows down, in another style. On the opposite wall, furthermore, symmetrical compositions interrupting the narrative look like votive panels; this may help to explain the inconsistencies. One shows a monk caressing the feet of the enthroned saint. Identified as URSUS

Saint Paul's Outside the Walls, triumphal arch. Two frescoes were added at either side when the ciborium was erected in 1285. Here the Abbot Bartholomew is shown praying to a sculpturesque St. Paul; below are the people of a walled city, either the Heavenly Jerusalem or Rome, and a gatekeeper holds open the door for pilgrims. (BAV, Cod. Barb. Lat. 4406, fol. 137.)

SACERDOS ET MONACHUS (Ursus, Priest and Monk), the cleric may be a member of the Orsini (Ursi) family, from which Pope Nicholas III also was descended. Nicholas's involvement with St. Paul's is attested elsewhere, and this painting may be evidence of his intervention in the refurbishing of the Early Christian frescoes. The painters employed in the task apparently learned much from their confrontation with Late Antique art; the style of the new frescoes evokes classical antiquity.

Frescoed portraits of Paul and Peter have been added beneath the older effigies on the transept arch, behind cities crowded with people and opened to the viewer through monumental portals. At Paul's side, the monastery's recently deceased Abbot Bartholomew (1282–97) appears kneeling in prayer (fig. 173).

Frescoes on the inner wall of the basilica's facade reflect an altogether different era, as the enormous monogram identifying Pope Sergius IV (1009–12) as patron makes clear. The four evangelists, with their symbols, frame the monogram, counterbalancing the four beasts flanking Christ in the triumphal arch mosaic before the apse. Below these are four scenes from Christ's Passion: Gethsemene, Bearing the Cross to Calvary, the Deposition, and the Maries at the

174

Saint Paul's Outside the Walls, inner
facade, eighteenth-century copy by J. B.
Seroux d'Agincourt. The artist recorded
what he could still see of the eleventh-
century paintings and could read of the
inscriptions; the interest in papal por-
traits and insignia is typical of
postmedieval students of Rome's past.
The scrap in the lower right was pasted
onto the same album leaf, but it records
the titulus of the last panel of the adjacent
wall, the Death of the Firstborn Egyp-
tians. (BAV, Cod. Vat. Lat. 9843, fol. 5.)

Tomb (fig. 174). In the second of these is Sergius's successor, Benedict VIII
(1012–24), who apparently had the work completed; here Pope Benedict is bare-
headed but wears the papal pallium.

The choice of subject matter seems pointed. Sergius had hardly been ele-
vated to the papacy when the Muslim caliph Al-Hakim destroyed the church
commemorating Christ's Crucifixion and burial, the Holy Sepulcher in
Jerusalem. The pope responded to the desecration with a call to arms, the first of
such appeals to the faithful that, later in his century, evolved into the great Cru-
sader movement, a wave of zeal that persists to this very day. Sergius seems to
have added the frescoes over the entrance in St. Paul's to recall the lost sites asso-
ciated with Christ's Passion, death, and Resurrection. The intent must have been
to elicit service to Christ by depicting not the Crucifixion but the Deposition,
in which Joseph of Arimathea and Nicodemus free Christ from the cross so that
he can be laid to rest in the sepulcher. (Curiously, when the basilica's bronze
doors were made, later in the eleventh century, the Deposition was repeated in
much the same fashion.)

Other popes besides Benedict and Sergius favored St. Paul's around the turn
of the second millennium; several even chose to be buried here. Among them
was John XIII (965–72), whose body lies buried directly beneath the scenes of
Christ's Passion. (John XIII has figured earlier in our traveler's peregrinations: it
was he who had hanged the insurrectionist prefect Peter from the equestrian
Constantine at the Lateran campus.) As in the fresco series in the nave, the pope
is portrayed bust-length within a clipeus (fig. 175); here, though, he is shown

Saint Paul's Outside the Walls, tomb of Pope John XIII, seventeenth-century watercolor copy. The arched form and clipeate portrait revive an Early Christian tradition. (BAV, Cod. Barb. Lat. 4406, fol. 139.)

blessing, and around his head is a halolike square frame, familiar from Sta. Prassede as a sign that the portrait was made from the living subject. Peter and Paul appear behind Pope John; smaller in scale, they represent not a follower or supplicant but the source of his authority. Like the square nimbus and circular portrait, the arched (*arcosolium*) form of the tomb and elaborate inscription on the sarcophagus derive from ancient prototypes. Perhaps this (as well as Pope John's involvement with the Lateran statue) reflects a genuine interest on his part in antique monuments.

In the Sanctuary

After pacing again and again, from triumphal arch to doorway and back, to survey the full scope of the basilica's fresco program, the pilgrim returns once more to the apse end to enter and peruse the sacred sanctuary beyond the triumphal arch. Framed by the centuries-old mosaic, a magnificent, newly made ciborium serves as the bridge between heaven, where the perpetual liturgy is shown being sung, and the altar over the apostle's grave, where the church reenacts that liturgy according to earthly time.

The ciborium. A waist-high platform, on which the ciborium stands (fig. 176) over the main altar, marks the threshold of the sanctuary. Although ceremonial canopies over altars are standard elements in Roman church furnishings, none is so glorious as the one in St. Paul's. In 1300, it is still fresh, having been erected only fifteen years ago through the generosity of Abbot Bartholomew.

The tradition of using a ciborium to mark the sanctity of a spot goes back to the beginnings of Christian Rome: Pope Sylvester had one placed over the altar of the Lateran church. The four porphyry columns that support the St. Paul's ciborium adhere to ancient Roman convention; but the older tradition has been reshaped here by the sculptor Arnolfo di Cambio and his colleague Peter, who have introduced the currently fashionable opus francigenum style. Specifically,

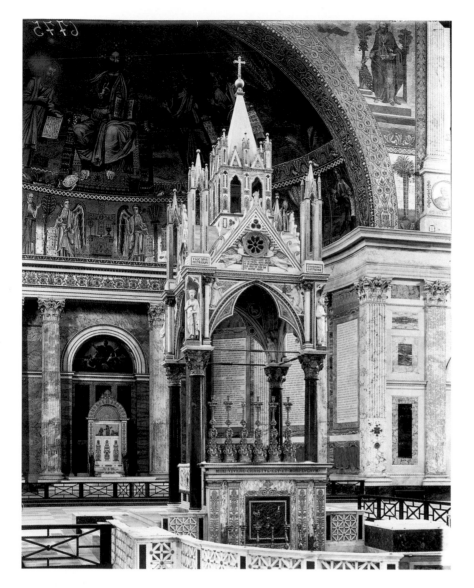

176

Saint Paul's Outside the Walls, ciborium. Because it survived the fire of 1823 almost intact, the shrine above the apostle's grave was considered a sign of God's grace and was carefully preserved and restored. Many of the details are nineteenth-century interpretations, but the general conception is thirteenth century. Inscriptions above the figures of Paul (left) and Peter (right) identify the two sculptors; their positioning associates Arnolfo di Cambio with the basilica's dedicatee, Paul, and Peter with his saintly namesake. The inscription beneath the central rose provides the date of 1285 and mentions the patron, the Abbot Bartholomew. Below at the right, the abbot presents the ciborium to the apostle (left). Inside, an angel can be seen swinging a censer. Behind the ciborium is the modern papal throne flanked by columns that, according to tradition, were salvaged from the fourth-century basilica.

this ciborium has been patterned after King Louis IX's tabernacle of the crown of thorns in his Ste.-Chapelle in Paris (the same palace chapel that inspired the Sancta Sanctorum). The St. Paul's ciborium also has two levels, a lower one housing an altar and an open, gabled upper story of pointed arches, rose windows, sprightly finials, and pinnacles topped by a spire. Moreover, in a radical departure from tradition, Arnolfo and Peter have laced the elaborate structure with sculptures that reinforce the architectural symbolism and make its meaning unmistakable.

The dark columns suggest the materiality of the terrestrial world. Above them, the elegant white marble arches and gables inset with gold tesserae evoke heaven. The spaces between represent the firmament, inhabited by angels bear-

ing wheel windows, which stand for Christ's Church. The celestial imagery continues inside, with angels fanning downward from the boss of the pointed vault and others holding a candlestick or bearing censers and descending toward the altar. Also inside, silhouettes of unicorns, harts, lambs, and birds in marble intarsia on a solid blue ground conjure up the blissful realm abandoned by the first humans and recovered by Christ.

Statues of Peter and Paul stand in two of the four corner niches; in the other two stand statues of Paul's companion Timothy, who lies buried at the center of the basilica's apse, and St. Benedict. In the sprandels of the cusped arches that bridge these niches, sculptures depict David and Solomon, the temptation and fall of Adam and Eve, the sacrifices of Cain and Abel, and Bartholomew, who holds his miter and scepter as he offers Paul a model of this very ciborium. The portrait of Bartholomew—looking for all the world like Benedict, the founder of his order—is carefully placed so that the abbot's gift to this church is juxtaposed to Abel's offering, which "God received with favor." Wherever possible, imagery creates links in the chain of sacred history. Adam and Eve, by eating the forbidden food, brought about the need for the new sacred food of the Eucharist, which is offered on the altar below. Abel sacrificed a lamb; God, in turn, offered up his Son as the *Agnus Dei*.

Beyond the ciborium, the papal throne stands at the cord of the apse. Behind it, a large altar marks the tomb of Timothy. At the back of the apse, a strigillated sarcophagus holds relics of the Holy Innocents, the children of Bethlehem whom Herod had executed in his campaign to kill Jesus.

The apse. A sumptuous mosaic crowns the sanctuary (fig. 177). This is the work not of Roman craftsmen, however, but of mosaicists whom Pope Honorius III (1216–27) summoned from Venice; in Honorius's view, no contemporary Roman was capable of producing such a work. And indeed, the refined forming of the figures, particularly the delicate shading in light and dark, is unlike anything else from its time. (How different Rome is at the end of the century, once again the artistic center of the world and home of some of the most inspired and skillful of all craftsmen!)

The pilgrim is hardly surprised to note that the apse mosaic in St. Paul's features Christ enthroned and holding a book in which are inscribed the words of Matthew 25.34: "You have my Father's blessing; come, enter and possess the kingdom that has been ready for you since the world was made." It is a welcoming sentiment but also a warning—a reminder of the Last Judgment, at which every soul will stand before the real Judge. As on the ciborium and triumphal arch, Paul and Peter flank the Savior; behind them are Luke and Andrew. Bowing low, a small figure of Pope Honorius in a radiant white-and-gold vestment caresses Christ's right foot (fig. 178).

A parallel composition fills a band beneath the main apse conch. At its center is the empty throne of the Second Coming, flanked by angels; on the throne

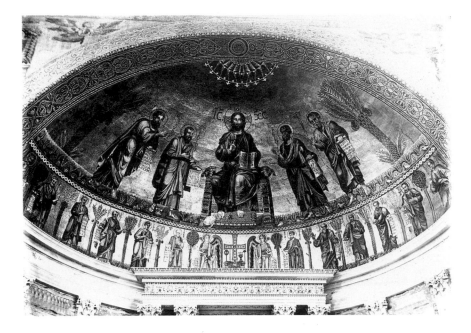

177
Saint Paul's Outside the Walls, apse
mosaic. The apse mosaic is heavily
restored; indeed, it is largely a remake
that follows the original composition
even in style. Several fragments of the
original mosaic are mounted in the
vestibule of the new church, but a few
were incorporated into the apse itself.

lie a sealed book, Christ's cosmic mantel, and the instruments of his torment
and death—the crown of thorns, lance, nails and chalice, and sponge of the Cru-
cifixion. Most prominent is a gemmed cross, at the center of which is a tiny
depiction of the enthroned Christ pictured above. Set into the altarlike throne on
a narrow tongue, the pictured cross recalls the cross carried in papal processions
from the Lateran and secured in holes in altar tops. The image thus condenses
into a spare handful of symbols the past present and future: Christ's death on
the cross, the reenactment of that death in the Eucharist, and the promise of
ultimate redemption at the Second Coming.

At either side of the angels beside the throne are the apostles; each bears a
prophetic text. And beneath the throne-altar, five sad-eyed youths hold gold
palm fronds (fig. 179). They are the martyrs described at the breaking of the fifth
seal in Revelation (6.9–11): "I saw underneath the altar the souls of those who
had been slaughtered for God's word and for the testimony they bore." More
specifically, they are the Holy Innocents in the sarcophagus directly below. To
either side of them, the sacristan Adinolfus and John of Ardea, the abbot of St.
Paul's responsible also for the magnificent cloister, kneel in prayer. The message
is clear and complete: by worshiping at the grave of the Holy Innocents and the
other saints, the faithful can prepare themselves for the judgment promised to
come at the end of time.

Saint Paul's crypt. Descending dimly lighted stairs, the pilgrim enters the
crypt to visit the apostle's grave. An inscription proclaims that the entranceway
has been provided by Leo III, "bishop of the People of God," an epithet familiar
from Leo I's great arch in Sta. Maria Maggiore asserting that the popes are the

178

Saint Paul's Outside the Walls, apse, detail. Reflecting the continuous fascination with authentic portraits of the medieval popes, the nineteenth-century mosaicists kept the depiction of Pope Honorius largely intact. The delicate modeling of the face and aquiline nose, and the sharp folds of the garments, are all features of contemporary Byzantine art and confirm the documentary evidence that Honorius had brought important artisans from Venice (who, in turn, had been trained by mosaicists from Constantinople) to decorate the apse of St. Paul's.

179

Saint Paul's Outside the Walls, apse, detail. The section of the mosaic depicting the two donors flanking the "holy innocents" is also largely original. Relics of the children massacred in Pilate's hunt for Christ were preserved directly beneath the apse; as so often, art is used here to reify and exalt the ugly remnants of sacred materials. Revelation indicates that innocents beneath the altar were clothed in white robes (6.11); the palm leaves in the young boys' hands are ancient symbols of triumph.

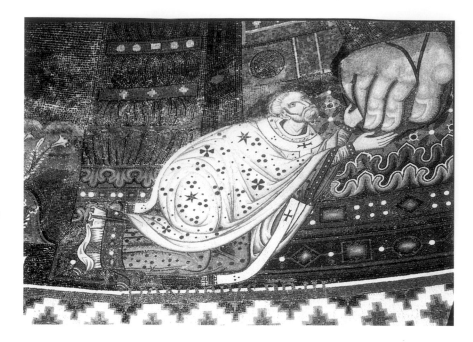

leaders of a new Chosen People of God, the faithful of the Church. The quotation identifies the ninth-century pope with his fifth-century predecessor and namesake. Unlike the corresponding semicircular crypt in Sta. Prassede, this one is squared and branched to go in two directions. Carefully placed lamps permit identification of several Early Christian sarcophagi of those who were interred close to St. Paul.

180

Saint Paul's Outside the Walls, marble slab
from Paul's tomb. The plaster cast of the
two slabs from the apostle's grave is
mounted in the church's museum. The
use of the dative in PAULO APOSTOLO
MART[YRO] indicates that the inscription
was originally part of a dedication bearing
the donor's name. Who that donor was
cannot, of course, be determined; but the
form of the letters suggests that it was
either one of the original patrons of the
basilica (Pope Siricius or the Emperor
Theodosius) or the fifth-century restorers
of the apse, Pope Leo I or the Empress
Theodora. The holes allowed pilgrims to
lower pieces of cloth (brandea) into the
grave to infuse them with the saint's aura.

Finally, the pilgrim comes upon a slab in which large holes have been cut.
On it has been etched, in bold, crude letters, the name of the martyred apostle
(fig. 180). Pilgrims are clustered around it, holding *brandea,* the cloth strips
brought to make contact with the holy remains, and saying prayers to God.

In the Transept

To enter the transept, the pilgrim must circumvent both the platform on which
the ciborium stands and a free-standing colonnade that, oddly, forms a miniature
church in outline. The great size of this portion of St. Paul's comes as a surprise;
from outside the church, the transept cannot be differentiated at all, because the
cluster of buildings that make up the monastery obstructs any view of this struc-
ture (see fig. 154). Only from inside can one discern that the transept is an enor-
mous, separate space, its triangular trusses set at right angles to those of the nave.
It is bisected, however, by an ungainly but necessary wall—a jerry-built affair of
reused ancient columns cobbled together more than a century ago when the
roof, struck by lightening, threatened to collapse.

An enormous columnar object of marble (fig. 181) stands near a side wall at
the far left. To the traveler who has lingered at Rome's pagan sites, the great, taper-
ing cylinder, which stands some ten feet tall, brings to mind the enormous ancient
columns still standing in the Forum and near the church of S. Lorenzo in Lucina,
carved with lively narratives of the victories of Emperors Trajan and Marcus Aure-
lius. Here at St. Paul's, however, the troops depicted in deep relief are massed not
against a military foe but against Christ. Specifically, the reliefs picture Christ before
Caiphas, the soldiers deriding the enthroned Messiah, Pilate condemning Christ
and then washing his hands, the Crucifixion (fig. 182), the Resurrection, and, at
the top, the Ascension. Although carved little more than a century ago, these scenes
on the column derive directly from ancient sarcophagi still to be seen all over
Rome. Indeed, the little sarcophagus pictured in the Resurrection scene from
which Christ is shown to rise duplicates the strigillated design commonly used

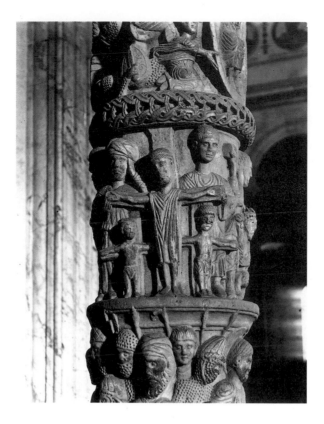

182

Saint Paul's Outside the Walls, candle-
stick, detail. The column also alludes to
the cross on which Christ died. The form
of the Crucifixion and, especially, the
sleeveless tunic that Christ wears (colo-
bium), indicate an Early Christian model
for the imagery.

during the century following Constantine's conversion. The column's base is carved
with confronted lions, rams, helmeted sphinxes, and lavishly dressed women.
Carved vines adorn the lower and upper portions of the shaft.

A poem inscribed on a band above the heads of the creatures at the base
states the column's function:

+ARBOR POMA GERIT
ARBOR EGO LUMINA GESTO
PORTO LIBAMINA
NUNTIO GAUDIA SED DIE FESTO
SURREXIT CRI[S]TUS
NAM TALIA MUNERA [CHRI]STO

(A tree carries fruit. I, too, am a tree, and I carry light. I carry the offering. I
announce the feast day, the good news that Christ is resurrected. I am the
witness of such a great gift.)

Though enormous, the column is simply a candlestick and quite like the smaller
one in S. Clemente's schola cantorum (see fig. 70). Its decorations are intended to
equate its light to the resurrected Christ. Each Easter, it is fitted with a candle, which
a deacon lights on Holy Saturday as he sings the *Exultet*, a hymn couched in lan-
guage of light and liberation. The candle is extinguished on each Ascension Day,

Opposite:
181

Saint Paul's Outside the Walls, candle-
stick. The marble candlestick is largely
intact, except for the vaselike crown that
is part of the restoration after the fire.
Like the depiction in the Vatican Exultet
Roll (see fig. 71), the form refers to the
Tree of Life; it also makes reference both
to the column of fire that led the
Israelites from Egypt and to the pagan
emperors' triumphal columns.

forty days later; the narrative sequence thus provides the historical foundation for liturgical reenactment. The *Exultet,* moreover, is a victory hymn, and so the reference to the Roman triumphal columns is well made; it contains the words "O sin of Adam that was canceled with the death of Christ." This helps to explain the imagery of the reliefs, the reference to the Tree of Life, from which Adam and Eve ate the fruit, and the focus on Christ's Passion, death, Resurrection, and Ascension.

The *Exultet* also offers clues to the meaning of the column's more esoteric imagery. Fantastic hybrid creatures on the base are demons of darkness. Copied from ancient monuments, they are, in fact, specifically the demigods of paganism vanquished by the light Christ brought into the world. On the eve of Easter, the deacons chant, "How delightful the earth radiant with so many flames and illuminated by the splendor of the eternal king." The woman who rides on the backs of one sphinx and one lion is the "whore of Babylon" of John's Apocalypse.

Again, as is so often the case, the references are also to Jewish Scripture. When fitted with a candle, the column itself evokes "the column of fire" that preceded the Jews in their journey through the parted Red Sea to the Holy Land. As phrased in the *Exultet,* "The night in which our fathers, the Children of Israel, were conducted across the Red Sea with dry feet is the night that the darkness of sin was removed by the light of the column of fire." Brilliantly, the various references to imperial columns, ancient demons, Early Christian sarcophagi, Old Testament liberation from Egypt, and apocalyptic victory construct a comprehensive lesson of Christian triumph: Christ's death on the cross at the hands of the Roman governor Pilate was but a prelude to his ultimate victory over paganism and the forces of evil.

The message is a heartening one to carry on the last leg of the pilgrimage in Rome to the burial place of the Prince of the Apostles. Finally emerging from St. Paul's, the pilgrim sets off toward her ultimate destination, the great church on the Vatican hill marking the grave of the ultimate founder of the Church. It was to Peter that Christ charged the establishment of his community: "Upon this rock you shall found my church." Even though the Acts of the Apostles makes no mention of Peter's ever having come to Rome, his grave was venerated as early as the second century at the racecourse of Gaius and Nero (circus Gai et Neronis) built by the Emperor Caligula. And as the last fresco in St. Paul's has brought to mind, legend has it that Peter was already preaching in the capital when Paul arrived here. The two met death here on the same day.

Saint Peter's
On the Road to the Vatican

Although the pilgrim could simply follow the Tiber all the way to the Vatican, she has chosen instead to take a last walk through Rome's streets. Heading north, she reenters the city at one of the most impressive gates in the Aurelian wall, the

Porta Ostiensis, through which the Apostle Paul himself had entered the city. Adjacent to the gate stands the gray marble *sepulcrum Remi,* a four-sided pyramid that rises to a peak almost ninety feet above the road (fig. 183). As the name indicates, this monument is thought to be the tomb of Remus, one of the twin founders of Rome. In fact, however, it marks the burial of the first-century praetor Caius Cestius, whose name and titles are inscribed on its face. From here, the route north crosses over the Aventine Hill, which offers not only a brief pause to gaze at the lofty fifth-century basilica of Sta. Sabina but also a breathtaking view of the Tiber and even, in the distance, of the Vatican and St. Peter's basilica.

At the crest of the Aventine's north slope, the pilgrim stands in awe for a moment to admire the ruined imperial edifices in the middle distance on the Palatine Hill. She then descends to the east bank of the Tiber, where the waters, split by the Tiber island upstream, rush to reunite. From here, the pilgrim's riverside route, which heads toward the congested campus Martius sector of the city (field of Mars, named for the pagan war god because, in the deep past, it was an area given over to the military and to sporting activities), now passes the churches of Sta. Maria in Cosmedin (fig. 184) and Sta. Maria Egiziaca, which is

183
Pyramid of Cestius and Porta Ostiensis. Like the tomb of the baker outside the Porta Maggiore (see fig. 3), the funerary monument of this first century B.C.E. magistrate was located near a main city gate just outside the wall to attract maximum attention (the Porta S. Paolo gives access to the via Ostiense). During the Middle Ages, the pyramid was considered a memorial to Remus, one of Rome's legendary founders.

184

Santa Maria in Cosmedin. The spectacular seven-storied tower calls attention to the twelfth-century church. Santa Maria Cosmedin incorporates a fourth-century portico into its structure; inside the church, columns of a fourth-century secular building and arches decorated with stuccoes quite like those on the interior of St. Paul's Outside the Walls are visible.

installed in the old Temple of Portunus (fig. 185). Beyond these, the Theater of Marcellus—its arches not so overwhelming as those of the Colosseum but certainly similar and impressive enough—forces the pilgrim's route inland to where it is possible finally to meet up with the Street of the Pilgrims. Living up to its name, the street is the bed for a human river of pilgrims and equally zealous Romans numbering in the many thousands; were they not all headed the same way, toward St. Peter's church, this narrow road would be impassable.

Approaching the Borgo. Finally, over the crowd and down passageways between huddled buildings, an enormous, round structure (fig. 186) looking like no other the pilgrim has ever seen looms into view beyond the pons S. Pietri (St. Peter's bridge), the only bridge spanning the Tiber anywhere near here. Some in the advancing crowds pass a marker engraved into a building's cornerstone to record the high-water mark reached by the Tiber when it overflowed its banks just twenty-three years ago (fig. 187). Floods have ravaged Rome almost as often as have earthquakes and epidemics. So dense is the throng on the bridge and impassioned with zeal for the goal that it is a marvel that the span does not collapse.

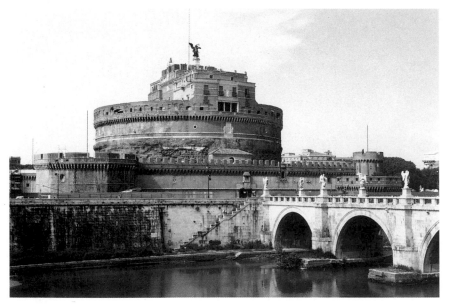

185

Santa Maria Egiziaca (Temple of Portunus). Built in the Republican period (second century B.C.E.), the temple near the Tiber first served the Roman river god. Under Pope John VIII (872–82), it was transformed into a church by the insertion of an apse and the introduction of frescoes depicting the life of Mary, Mary of Egypt, and other saints. In the distance is the so-called Casa dei Crescenzi, an eleventh–twelfth century fortified residence constructed largely of ancient spolia.

186

Castel Sant'Angelo. Completed in 139 C.E. as the mausoleum of the Emperor Hadrian, the structure on the northwest bank of the Tiber occupied an important position at a bend in the river. It has undergone repeated transformations. The large stones at the base of the cylinder are from the mausoleum but have been stripped of the original marble revetment. The upper part of the cylinder and outer walls and ramparts date from the Middle Ages and Renaissance. The medieval tower (beneath the eighteenth-century statue of St. Michael) is characteristic of the structure in art; but it is largely obscured by the papal apartments built during the Renaissance and graced by the loggia of Pope Julius II (1503–13). The span that in the Middle Ages was "Hadrian's Bridge" has been superseded by today's pedestrian Ponte S. Angelo.

Like so many of Rome's buildings, the gigantic, peculiar structure on the far bank, too, embodies multiple histories and uses. But there its similarity to all else stops. Atop a massive, rectangular base of stone masonry, surrounded by a moat, rises a great, cylindrical structure from the top of which protrudes a tower. It was built as the tomb of the Emperor Hadrian (117–38), but already in the late third century, when Aurelian decided to encircle most of Rome with defensive walls, it was converted into a fortress (*castrum*). Aurelian left this bend of the Tiber undefended, relying on Hadrian's massive tomb to safeguard the primary

187
Flood memorial. A plaque records the
level the flooded Tiber reached near the
Castel Sant'Angelo in 1277.

bridge into the city. In 547, the Ostrogothic King Totila (511–52) closed this gap
with a low rampart, creating a kind of castle with the fortified tomb at its center.
From then on, whoever controlled Hadrian's tomb controlled Rome. Three cen-
turies later, after the Saracens had sacked the area, Pope Leo IV (847–55) enclosed
the entire Vatican area, creating a section named after him, the civitas Leonina
(City of Leo).

The fortress-tomb itself passed from one powerful family to another: the
name of the Crescenzi has stuck best, and the structure is still known as the
Castello di Crescenzio, even though the Orsini family now has possession of it.
More commonly, however, it is called the Castel Sant'Angelo (Castle of the Holy
Angel). This name derives from the legend that, in 590, the Archangel Michael
appeared atop its tower to Gregory I when the pope, holding the *Maria Regina*
icon from Sta. Maria Maggiore, was conducting a litany to stem a plague that
was ravaging the people of Rome. For centuries, therefore, a chapel dedicated
to the Archangel Michael has occupied the tower; one of the highest points in
the city and, hence, close to heaven, the chapel is a particularly appropriate place
for the prince of the celestial guardians.

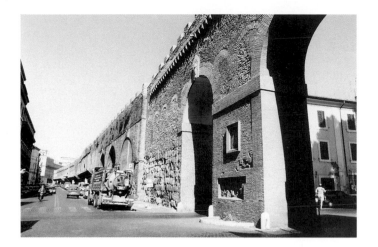

When Giovanni Gaetano Orsini became Pope Nicholas III in 1277, he conceived the idea of integrating the Castel Sant'Angelo into his planned renovation of the Vatican. Even though he had rebuilt the Sancta Sanctorum in the papal palace at the Lateran, Nicholas disliked the Lateran area and sought to establish the administrative center of the papacy adjacent to St. Peter's. For this reason, he constructed a new papal palace at the Vatican and built a passageway atop Leo IV's wall to give popes sheltered access from it to the fortress (fig. 188).

In antiquity, the Vatican lay outside the city and hence could be used for a tomb in the first place. Indeed, just beyond the Castel Sant'Angelo is the so-called sepulcrum Romuli (tomb of Romulus), another funeral monument, pyramidal in design just like its counterpart north of St. Paul's, only larger. It has become emblematic of the Vatican area, appearing for instance, in the depiction of St. Peter's martyrdom in the Sancta Sanctorum (see fig. 41). Less ostentatious burials took place in the area, too, including those of Christians. The grave of Christ's apostle Peter, for instance, has long ago been identified in a cemetery farther from the river just north of the Racecourse of Gaius and Nero. And during the second and third centuries, Christians, wishing to be interred near it, were buried in the same place.

It was there that the Emperor Constantine, within the decade of his conversion, began to construct the enormous basilica to honor Peter, forever changing the area's character. Over the centuries, monasteries and nunneries have grown up nearby to serve the spiritual needs of pilgrims who flock to pray at Peter's grave. In turn, pilgrims visiting the site have required services and attracted commerce; hostels, baths, latrines, and hospitals have been built to meet their physical needs. Among these is the vast hospital of the Holy Spirit sprawling along the southern wall near the Tiber, the counterpart of the hospital of the Savior at the Lateran and one of the first buildings encountered by anyone entering the Leonine city. As so often happens, the line between spiritual and

physical requirements has become indistinct. Although the hospital was established to care for the ill and needy, it has also become a sacred destination. Every January, the pope leads a solemn procession here from St. Peter's, bearing the *Veronica* in a gold-and-silver reliquary covered with gems; a rival to the *Acheropita,* the Lateran's greatest treasure, the Veronica is another image of Christ, but only of his face, created when the saintly woman Veronica wiped the Savior's visage as he carried the cross to Golgotha. In a pun on the Latin phrase *vera icona,* meaning "true image," the cloth bearing the Holy Face is called the "Veronica." The procession has a history of less than a century; it was established in 1208 by Pope Innocent III, who was otherwise so preoccupied with St. Peter's, clearly with the Assumption Day eve procession in mind. The pope chose the Feast of the Marriage at Cana to evoke Christ's charity and, hence, to inspire participants to give to the poor and sick of the Holy Spirit hospital; those who participate in it are granted a forty-day indulgence. Innocent's biography, the *Gesta Innocentii Papae,* describes the ceremony: "The Christian populace gathered [at the hospital] to see and venerate the *sudarium* of the Lord, which was carried by a procession from St. Peter's to that place, singing hymns and psalms by torchlight. They also want to hear the sermon preached there by the Roman pontiff on the works of compassion and the remission of sins." Earlier this year, when Pope Boniface led the procession, the size of the crowds and their generosity so impressed him that he was inspired to establish his *annus iubileus et remissionis*—the Jubilee—and to grant plenary indulgence to participants in it.

Near Peter's grave. From the covered street that connects Castel Sant'Angelo and St. Peter's, the pilgrim can pause in the *cortina,* the irregular city square in front of the church. It is paved with white marble slabs stripped long ago from the sepulcrum Romuli. Visible to the left is a great red granite obelisk (fig. 189) erected by the Emperor Caligula and set up on the central spine of the Racecourse of Gaius and Nero; the account in the pilgrim's *Graphia* tells that the ball atop the obelisk contains the ashes of Julius Caesar. The obelisk stands exactly in line with an unusual round building, a chapel dedicated to Peter's brother, Andrew. Barely visible behind it is a nearly identical structure, the mausoleum of Emperor Honorius (395–423) and his family. By the beginning of the fifth century, even the emperor wanted to be buried close to the saints; although Honorius was one of the imperial patrons of St. Paul's, he preferred to be interred near the remains of St. Peter. To this day, the basilica's administrators allow the interment of people who wish to be close to the martyred apostle; after all, most people believe that it is he who holds the keys to the kingdom of heaven.

To the right of the cortina stands a cluster of recently constructed buildings of an entirely different character (fig. 190). From the portal and arched loggia of one, which is surmounted by a tower, the traveler can tell that this is a residential structure—surely a papal palace. Although popes have lived until recently in the Patriarchium at the Lateran, they have always had to travel often to St. Peter's,

189

Obelisk. A trophy set up along the spine of the spine of the hippodrome of Gaius and Nero, this Egyptian obelisk remained in place even after the racetrack was demolished for the construction of St. Peter's. In 1586, it was moved a few meters north, into the piazza before today's St. Peter's.

190

Saint Peter's. Giacomo Grimaldi's *Description of the Ancient Basilica of St. Peter's* of 1618 (BAV, Cod. Barb. Lat. 2733) is the most reliable surviving record of the ancient complex. Here Grimaldi renders the buildings at the top of the stairs: at the left, a possible vestige of the ninth-century residence built by Leo III; in the center, the gatehouse with its mosaic; next, Pope Alexander VI's (1492–1503) Renaissance loggia, with the medieval bell tower behind it; and at the far right, the corner of the papal palace.

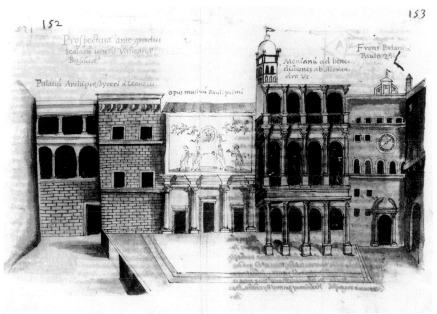

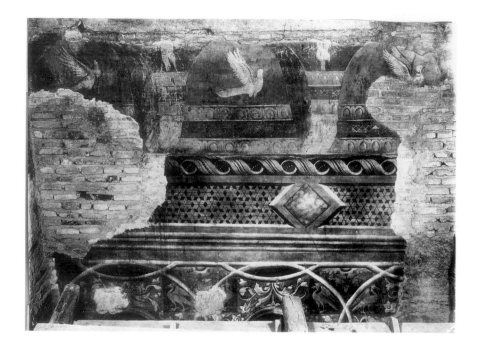

191

Saint Peter's, Nicholas III's palace.
Although friezes with birds and trompe
l'oeil architecture had been painted for cen-
turies, those in the late thirteenth-century
papal palace translate the conventional
motifs into the current illusionistic idiom.

and from time to time they have established lodgings and administrative struc-
tures nearby. In imitation of the Lateran, for instance, Leo III had erected a tri-
clinium near the Vatican obelisk. Eugenius III (who commissioned the portico
of Sta. Maria Maggiore) constructed a palace nearby. In the early thirteenth cen-
tury, Innocent III converted Eugenius's palace into proper papal living quarters,
with amenities that included bedrooms, a chapel, an audience hall, and a kitchen.
Like other grand Roman residences, Eugenius's palace features an enormous
tower. These residences were all provisionary, however; the principal papal palace
remained at the Lateran.

Pope Nicholas III, of the patrician Orsini family, significantly changed the
importance of the Vatican by building the two large audience halls, living quar-
ters, and a chapel, which now dominate the north side of St. Peter's. There is
even a park with wild animals brought from the far reaches of the world (see fig.
5), a sign that, in a very real sense, the pope is a sovereign ruler.

Nicholas III has had his chambers decorated with appropriate splendor. In
one room, the lower surfaces are covered with frescoes that imitate textiles, and
the window embrasures are painted with luxuriant vine scrolls. In another, a
frieze running along the top of the walls symbolizes Nicholas's earthly and spir-
itual authority through the repeated use of griffin images; a hybrid with a lion's
body and eagle wings, the griffin replicates a common image in imperial textiles.
Another majestic touch is a marvel of art's newly discovered powers of decep-
tion: as in the transept of Sta. Maria Maggiore (see fig. 145), it creates, with paint
alone, the illusion of an elaborate antique cornice (fig. 191). These decorations

192
Saint Peter's, atrium. Giacomo Grimaldi's view of the courtyard shows the great fountain, the Palace of Pope Innocent VIII (1484–92) at the right, the portico, and the cavetto facade's mosaic. (BAV, Cod. A 64 ter, fol. 10.)

193
Token. An example of the rather crude lead tokens sold at sites such as St. Peter's and worn by pilgrims to attest to their sacred journeys; this one may date from the time of the first Jubilee.

are the work of Jacopo Torriti, whose name the pilgrim knows from the apse mosaic of Sta. Maria Maggiore.

Entry to Peter's basilica. The palace buildings only frame the central structure, the church built to honor the first bishop of Rome and the predecessor of all popes. Saint Peter's basilica stands on a high platform some 750 feet long, which must be reached by a broad staircase. As at the Lateran, Constantine's architects used an ancient building as a basis, actually incorporating some of its walls—in this case a racecourse rather than barracks. But here, the builders still had to excavate into the slope of the Vatican hill to create a sufficiently large, level foundation for the colossal church complex. Because of the site's topography, the basilica's apse lies at the west end, and its face confronts the city to the east. Like most Early Christian churches (and, in turn, later buildings copied from them, such as Sta. Prassede), St. Peter's is preceded by an atrium. Over the years, however, the easternmost side—that facing the cortina—has been elaborated upon and put to new uses. The gatehouse over the central entrance has become a chapel dedicated to the Virgin, Sta. Maria in Turris. Long ago, the facade of the now-consecrated gatehouse was decorated with a mosaic picturing Christ enthroned within a starry orb supported by angels and with four martyrs offering crowns. To the north of the chapel is a bell tower built in the eighth century.

The moment the pilgrim enters the atrium (fig. 192), merchants hawking bread, water, clothes, and other necessities surround her. Arrays of badges made of lead on tin and stamped with holy images (fig. 193) are for sale in stalls; ever since the time of Innocent III, St. Peter's has had a monopoly on these signs of

194

Saint Peter's. The Roman bronze pinecone incorporated into the atrium fountain of the ancient church (see fig. 192) is now mounted in the exedra of the Cortile della Pigna of the Vatican Museum, where it is flanked by replicas of the peacocks (for preservation, the originals are kept inside). The magnificent third-century capital that now serves as a base for the pinecone is not related to the medieval monument.

devotion. The pilgrim chooses one showing Peter and Paul together; this will be a fitting souvenir of her travels to the city of the two apostles.

At the center of the courtyard a bronze cupola encloses a fountain. The canopy stands on four porphyry columns and is decorated with an enormous bronze pinecone (fig. 194) of ancient manufacture. Bronze dolphins spring from the corners, and on each of the cupola's four faces are set elegant peacocks—the birds of paradise from which has come *paradisus,* the popular name for the atrium. The base of the fountain, too, has fine decoration, consisting of marble slabs carved with reliefs of confronting griffins. Nearby, another smaller water fountain made from a circular bronze basin offers travelers a refreshing drink of water.

The Church of the First Pope

The facade looming overhead gleams in the morning sunlight, which etches shadows around a white marble cross at the pinnacle (fig. 195). With its upper zone elegantly curving outward to form the currently modish cavetto, the facade of St. Peter's recalls that of Sta. Maria Maggiore. It reflects the extensive remodeling undertaken by Pope Gregory IX (1227–41). Although the raising of the

facade has required a remaking of the earlier mosaic, the subject matter is nearly as old as the church itself. As early as the mid-fifth century, the Roman consul Marianus (423–48), with his wife, Anastasia, commissioned a mosaic for this surface to show the twenty-four elders worshiping Christ; Gregory's mosaicists had only to refashion it when the *cavetto* facade was raised. The hybrid composition that resulted provides a unique variant on a well-known and appropriate theme of the Church of the saints in heaven that will descend at the end of time to replace the terrestrial Church. On the facade of St. Peter's (as on the transept arch in St. Paul's Outside the Walls and the apsidal arches in SS. Cosmas and Damian, Sta. Prassede, and Sta. Maria Maggiore), the imagery signifies that the *ecclesia Romana* is the interim surrogate for the heavenly Church, and that the bishop of Rome is, by implication, Christ's representative on earth.

To adjust the old subject to the newly created field on the raised facade, Gregory IX added the four evangelists and Mary and Peter beside the enthroned Savior; he also incorporated his own portrait (fig. 196). These additions build on the essential claim. Holding books inscribed with the opening words of their respective texts and acclaiming the enthroned Lord, who displays a book in his left hand, the evangelists affirm the ancient assertion that Christ is the source of the four Gospels. Directly to Christ's right and below the pope's portrait, Matthew adds a nuance to the imagery: the text he displays, "Assumpsit Jesus Petrum Jacobum et Joannem" (Jesus raised Peter, James, and John), is the beginning of the description of the Transfiguration. This is the event that revealed Christ's divine nature, to which Peter was a primary witness.

An unusual change in the standard imagery reinforces Peter's special station. Peter is the only one of the three apostolic witnesses of the Transfiguration depicted in the mosaic, the right-hand member of a triad that caps the composition. His counterpart at the left is Mary, who raises her hands in the familiar gesture of advocacy; the *Madonna avvocata* here recalls images on both the Byzantine reliquary in the Sancta Sanctorum (see fig. 50) and the facade of Sta. Maria Maggiore, which also incorporate the familiar motif. Usually—as on the facade of Sta. Maria Maggiore and in the Zeno Chapel of Sta. Prassede—John the Baptist stands at the right. Peter's substitution here conveys to worshipers that praying at his church is a step toward entrance into heaven. A second point is also suggested: Mary symbolizes *ecclesia,* the Church, and Peter the Church of Rome. Thus, together, they state St. Peter's unique position on the path to salvation. A portrait of the papal patron furthers the idea: wearing the pallium and tiara that signify his station, Gregory bows down at Christ's feet. Like so many others in Rome, Gregory's mosaic was a gift, proffered in the hope that it would assist the donor to gain entrance into heaven.

The value of the pilgrim's arduous journey will be reaffirmed when the traveler enters the basilica of St. Peter and his successors and gains access to a terrestrial church that Christ himself had founded on the "rock" Peter. More even

195
Saint Peter's, grotto. The austere marble cross that adorned the facade pediment (see fig. 192) is preserved intact in the new St. Peter's.

196
Saint Peter's, facade, *Gregory IX.* Though heavily restored, the mosaic of the papal donor of the facade decoration conveys a sense of real portraiture.

197
Saint Peter's, facade, *Mary.* The face of Mary is more stylized, but it expresses an intensity appropriate to the role of intercession on humankind's behalf.

than the other churches she has visited, St. Peter's reflects the heavenly Church pictured on its facade.

Another departure from the norm is the way this variant on a standard theme is rendered in the mosaic. Broad modeling in light and dark and bold detailing of forms endow the figures with great presence and individuality. Mary (fig. 197), for instance, conveys sympathy and seriousness. Luke (fig. 198), though rendered in an abstract, linear style, suggests strength and character. And Gregory is a convincingly real person.

The length of the atrium arcade abutting the facade forms the basilica's narthex; its central intercolumniation has been extended to provide a porch built out into the courtyard. Scenes on the walls provide a perfect account and authentication of the apostles' presence in Rome, the disposition of their relics in the basilicas dedicated to them, and their role in papal politics. Peter's mission as reported in the New Testament is pictured on the interior wall, and sixteen legendary episodes are represented on the exterior: Peter and Paul confronting Simon Magus in the Forum and exposing his trickery before Nero; Christ stopping Peter from fleeing the city to avoid punishment (and asking, "Domine, quo vadis?"); Peter's crucifixion, upside down, exactly on this spot between the "pyramid of Romulus" and the obelisk from Nero's racetrack; the beheading of Paul

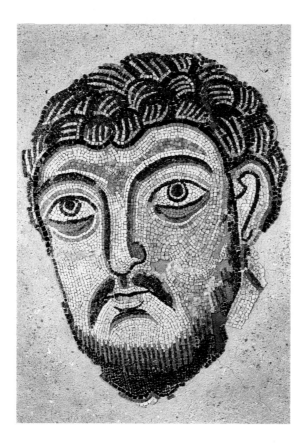

(which, as in the Sancta Sanctorum, features the three streams that flowed from where Paul's head bounced); the two bodies thrown into a well, the bodies retrieved, and the proper burial of Peter in a strigillated sarcophagus; Constantine's dream in which Peter and Paul appear to him; and Sylvester showing Constantine the apostles' icons (figs. 199 and 200; the very icons now preserved in the Sancta Sanctorum [see fig. 55]), thereby confirming the dream's validity. A porphyry disk set into the narthex pavement marks the central doorway. It is on this spot that, during coronation ceremonies, the ruler and pope pause before entering the church (such porphyry disks were also used in imperial rites in Constantinople).

In the nave. Entering one of the side doors, the pilgrim remarks on the resemblance of St. Peter's to St. Paul's. Saint Peter's is larger, though—the largest church in Rome, in fact. Saint Peter's is often described as the *caput et speculum omnium ecclesiarum* (head and mirror of all churches), and now that meaning is clear: it is the source of architectural design and the inspiration for decoration of many other buildings, establishing its dominance through its very form. Not only St. Paul's but Sta. Prassede copies St. Peter's, in a general sense of having an atrium, a nave flanked by aisles, and a transept before the apse. Here, twenty-two columns (as usual, salvaged ancient spolia) line the main nave, supporting a magnificent architrave (figs. 201 and 202). As in St. Paul's, scenes in fresco in

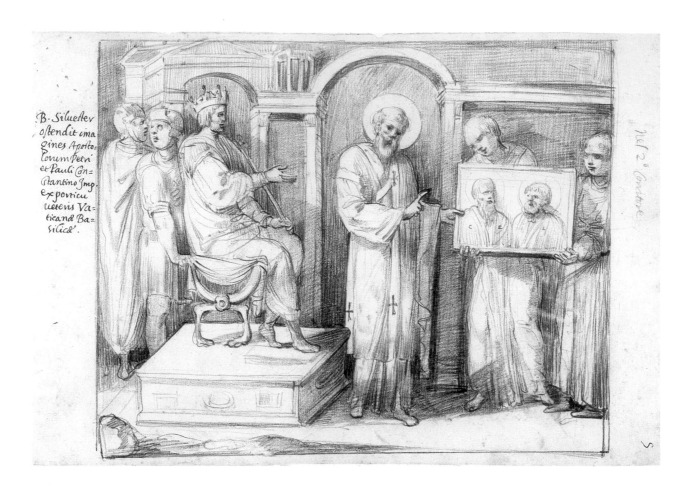

199

Saint Peter's, portico, *Pope Sylvester Showing Constantine the Portraits of Peter and Paul*. In this scene, icons of the apostles confirm the authenticity of the emperor's dream vision; in turn, the episode validates the important relics kept in the papal chapel at the Lateran (see fig. 55). (BAV, Cod. A 64 ter, fol. 40.)

200

Saint Peter's, portico, *Sts Peter and Paul*. Only the fresco portraits of the two apostles from the dream episode are still preserved in the Reverenda Fabbrica di S. Pietro. These attest to the most advanced style of painting of the period, associated in Rome with the Sancta Sanctorum and, elsewhere, at Assisi.

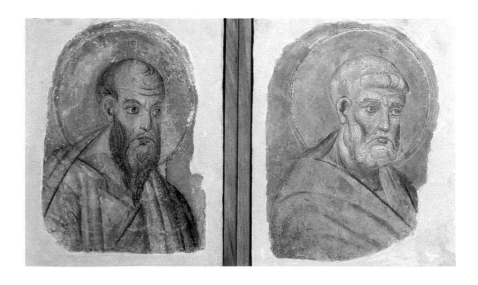

201

Saint Peter's, nave. During a visit to Rome in the 1530s, Marten van Heemskerck recorded the construction of the central arches of the new church. In the foreground, the remaining nave colonnades, clerestory windows, and even traces of the paintings of Constantine's basilica are indicated.

202

Saint Peter's, nave, column. A few fragments of the original columns and bases can still be seen beneath the current church.

Picturæ antiquissimæ et iam vetustate quasi obliteratæ, iussu Formosi primi Pont. Max. factæ in muro maioris nauis versus palatium Aplicum.

203

Saint Peter's, nave, right wall. Domenico Tasselli was still able to discern many of the Old Testament scenes when he made the final drawings of the ancient basilica early in the seventeenth century. These depict episodes from the stories of Noah, Abraham, Isaac, and Moses in Egypt. Giotto's angel is identified at the far left of the clerestory level; it must have been added to restore the wall's decorative coherence after the new windows were introduced. (BAV, Cod. A 64 ter, fol. 13.)

two registers narrate sacred history. The pictures on the right are immediately familiar (fig. 203). Exactly as in St. Paul's, panels in the upper tier tell of the Creation and Fall, Noah and the Flood, Abraham and Isaac, and Jacob; below are Joseph's conflict with his brothers and his life in Egypt, and Moses with Aaron winning the release of Israel. The story starts deep within, near the apse, and it ends near the door, with a double composition showing the Crossing of the Red Sea. This event is an even more appropriate conclusion of Old Testament history than the Death of the Egyptian Firstborn, with which the nave narrative in St. Paul's ends. Here Moses and Aaron, saintly prototypes of Peter and Paul, do more than defeat the pagan enemy; now they lead the Chosen People into the Promised Land. The implication in St. Peter's, moreover, is that the Promised Land is just outside the church—that is, Rome itself. The frescoes on the left also parallel those in St. Paul's, but here, of course, they tell the story of the Prince of the Apostles (fig. 204). Indeed, the general duplication in the architecture and decoration of the two basilicas cements in the pilgrim's mind the

relationship of the two Roman saints. But unlike Paul, who never met Christ on earth, Peter was a disciple, and so his story is integrated with that of Jesus. The cycle begins with the Annunciation to the Virgin and from there traces Christ's entire history, ending near the portal, just before the Ascension.

The scenes within the sequence are also ingeniously arranged, so that the Calling of Peter appears first at the beginning of the second register, directly beneath Gabriel's bid to Mary: Peter and Mary, two sainted people enlisted to do God's work. And Peter is featured again at the end, as the leader of the apostles summoned into Christ's service: "Full authority in heaven and on earth has been committed to me. Go forth therefore and make all nations my disciples; baptize men everywhere in the name of the Father and the Son and the Holy Spirit, and teach them to observe all that I have commended you. And be assured, I am with you always, to the end of time" (Matt. 28.18–20). Once more, the pilgrim is impressed by how exactly art reinforces the sanctity of each place by tying it to biblical history. In Peter's church, the authority conferred on him by Christ is

204

Saint Peter's, nave, left wall. Domenico Tasselli could distinguish much less of the New Testament cycle: only the Baptism, Crucifixion, Harrowing of Hell, and Christ's Farewell to the Apostles. Beneath the Crucifixion is the altar of Simon and Jude, which preserved a fragment of the True Cross. (BAV. Cod. Barb. Lat. 2733, fols. 113–14.)

demonstrated to be part of a preordained plan. In turn, the frescoes also authorize those who have succeeded him on the papal throne, as in St. Paul's, through the series of papal portraits arranged in rows above the architrave and below the fresco cycles. Between the windows (which have recently been refitted in the new French style) are saints and prophets; on the right, the series includes a fresco of an angel by the master painter Giotto, who came to Rome from Florence just four years ago at the bidding of Pope Boniface.

Not far into the church, two prominent altars constrict the nave. The one on the right is dedicated to SS. Philip and James, that on the left to Simon and Jude. Each preserves a relic of the true cross and, appropriately, is decorated with a large cross, one of silver, the other of gold. The lighting in the nave signals the altars' importance: great chandeliers in double rows extend from the triumphal arch only as far as these altars. Confirming the special significance of this spot, an enormous porphyry disk set in the pavement—as the one outside the main portal signaling exceptional ceremonial importance—lies between the two altars. Moreover, above the altar of Simon and Jude, the fresco cycle is interrupted by an enormous depiction of the Crucifixion, occupying four times the space given to the other episodes. To the pilgrim standing before it, the arrangement suggests an enormous altarpiece related to the relic directly below.

Farther along in the nave, against the south colonnade just before the triumphal arch, stands a precinct set off by a parapet. This is the canons' choir, and it is here that the priestly corps of St. Peter's says Mass when the pope is at the Lateran or at one of the stational churches. Overhead, a mosaic on the triumphal arch depicts Constantine presenting a model of the church to Christ, with Peter opposite him. An enormous inscription states,

QUOD DUCE TE MUNDUS SURREXIT IN ASTRA TRIUMPHANS
HANC CONSTANTINUS VICTOR TIBI CONDIDIT AULAM
(The victor Constantine has built this royal hall for Christ, because the world has risen in triumph to the stars with Him as guide and leader.)

The militant tone suggests the context in which the mosaic was made—Constantine's victory over Licinius in 324—and the consequent Christianization of the entire (Roman) world.

As the pilgrim has seen in S. Clemente and in many other churches, a schola cantorum interrupts the nave below. Here, as elsewhere, it is fitted with pulpits for Gospel and Epistle readings and with a paschal candlestick. This candlestick is the work of Vassalletus, a master of the Cosmatesque school of stone inlay who worked some seventy years ago. The schola cantorum in St. Peter's leads to an awesome pergola, comprising parallel colonnades supporting an architrave. Together these provide a dramatic frame for the altar over St. Peter's grave. The columns in particular are remarkable, twisted with alternating sections of fluting and vine scrolls alive with putti (fig. 205). They are said to have come from

Saint Peter's, pergola. The magnificent
twisted columns from the Constantinian
pergola were inserted into the relic
edicules in the piers that support
Michelangelo's great dome.

Solomon's Temple, and some, at least, were already in place when Constantine completed the basilica in Peter's honor.

The sanctuary. Enormous candles mounted atop the pergola illuminate the gold apse mosaic above. This was a gift of Pope Innocent III, and it creates a spectacular focus for the basilica's most sacred space (fig. 206). Christ sits enthroned in Paradise, flanked by Peter and Paul, who stand in a field filled with flora and playful children. At either end of the field are two palms—trees of life— and at Christ's feet are the four rivers that, according to Genesis, irrigated Eden. As the pilgrim has come to expect from seeing the familiar motif elsewhere, two deer approach to the fountain, symbolizing the faithful souls that find refreshment in Christ. In the frieze below, the twelve apostolic lambs emerge from Jerusalem and Bethlehem; behind each is a tree, and in the trees behind the foremost two, Peter and Paul, is the phoenix that stands for eternal life. At the center, directly below Christ, is the empty throne with its gemmed cross, which signals the Second Coming. Below it is the lamb on a hillock, again with the four rivers. The pilgrim is familiar with virtually every detail, having encountered the imagery throughout Rome. But here, for the first time, it comes together: this is the source and mirror (*caput et speculum*).

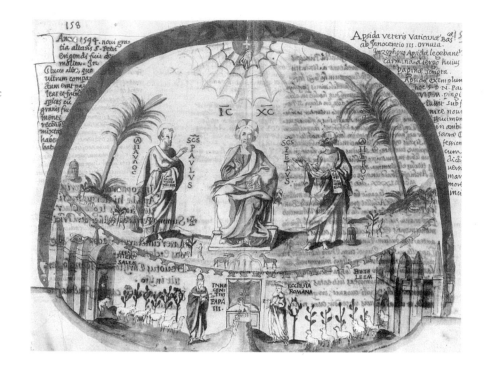

206

Saint Peter's, apse. Innocent III's mosaic combined traditional imagery and new details to assert the authority of the See of St. Peter. (BAV, Cod. Barb. Lat. 2733, fols. 158–59.)

Amid this standard Roman iconography are innovative elements, a portrait of Pope Innocent III on one side and a personification of the Roman Church, carrying a banner emblazoned with Peter's keys, on the other (fig. 207). Running beneath it all, an inscription declares the authority of the pope and the triumph of the Church:

SUMMA PETRI SEDES EST HEC SACRA PRINCIPIS AEDES
MATER CUNCTAR[UM] DECOR ECCLESIAR[UM] . . .
(This is the See of St. Peter, this the Temple of the Prince [of the Apostles], the glory and mother of all Churches.)

A partisan note in the rivalry between Lateran and Vatican is evident. Until now, the basilica at the Lateran has declared itself the "mother of all churches." Clearly, St. Peter's is staking its claim.

Saint Peter's remains lie buried at the cord of the semicircular apse below. The entire basilica has in fact been designed from the beginning to focus on the apostle's grave. In Constantine's church, the *tropaion,* the monument erected in the second century on the venerated site, had been allowed to protrude above the apse pavement; the main altar was simply placed in front of it. The whole precinct was enclosed within a tabernacle consisting of the twisted columns and covered by two crossed arches. Under Pope Gregory I (590–604), however, the area of the grave was systematized. Inspired, perhaps, by the same vision of the martyrs described in Revelation that centuries later led the mosaicists in St. Paul's

to depict the five innocents beneath the altar throne (see fig. 179), Gregory had
the apse floor raised and the tropaion converted into the altar block. Since then,
the pope has stood directly over Peter's relics when saying Mass; the remnants
can be seen through a grate-covered window, the *fenestrella confessionis* (window
of confession), which opens on the face of the podium. A baldachin is raised
over the altar, and the pope's throne stands behind it in the apex of the apse.
Most important, stairways and a passageway follow the curve of the apse to its
apex and then lead in a straight arm to the subterranean tomb. Gregory's
inspired solution to the problem of creating a separate space for the liturgy while
allowing the faithful to venerate the saint's relics was repeated in St. Paul's and
was often copied (for instance, in Sta. Prassede).

Over the centuries, though, further changes were wrought in St. Peter's. In
1123, Pope Callixtus II (1119–24) remodeled the main altar. His additions
included a mosaic, behind the niche in the confession, showing Christ blessing;
the implication was that Christ himself was guarding the holy martyr (fig. 208).
Later in the same century, Honorius III erected a magnificent new baldachin
clad in silver and supported on four porphyry columns. But the greatest change
was made in 1215 by Innocent III, who was himself a canon of St. Peter's, on the
occasion of the Fourth Lateran Council. Innocent provided not only the new

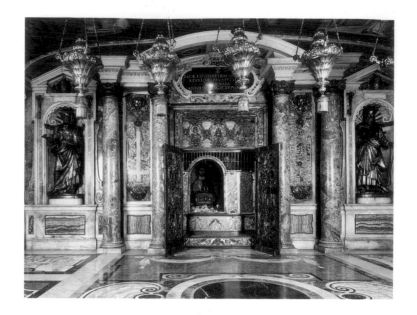

apse mosaic but also a beautiful new bronze grate for the opening at the front of the altar podium. He decorated the wall of the confession behind it with a bronze lunette and champlevé enamels imported from Limoges in France (fig. 209). The enamels, depicting Christ surrounded by the four evangelist symbols and accompanied by the twelve apostles, present a standard program of imagery that, once again, asserts the apostles' authority to continue Christ's mission on earth and to prepare the world for his return. And it inserts the reigning pope, Innocent, into the line of succession. The inscription reads:

SIC CUM DISCIPULIS BIS SEX XPS RESIDEBIT CUM REDDET POPULIS
CUNCTIS QUOD QUISQUE MEREBIT
TERCIUS HOC MUNUS DANS INNOCENTIUS UNUS SIT COMES IN VITA
TIBI PETRE COHISRAELITA

(In this way, Christ with his twelve disciples will sit over all the peoples. He will render justice to each according to his merit. Innocent III, who has furnished this monument, to be joined with you as your companion, Peter, as a citizen with you in Israel.)

The essential reference here is to Christ's prophecy of the future world in the Gospel of Matthew (19.28): "I tell you this: In the world that is to be, when the Son of Man is seated on his throne in heavenly splendor, you my followers will have thrones of your own, where you will sit as judges of the twelve tribes of Israel. And anyone who has left brothers or sisters, father, mother, or children, land or houses for the sake of my name will be repaid many times over, and gain eternal life." The message is a reassuring one, especially for pilgrims who have sacrificed much to visit Peter's tomb. When the door that Innocent placed here is

209

Saint Peter's, confession, enamels. The
enamel figures of Christ and his apostles
seem to have been attached to the outside
of the confession, beneath the grate and
the lunette.

210

Saint Peter's, confession, lunette. Like the
bronze doors of St. Paul's, the lunette
contains references to doors: above the
central disk, it pictures a gateway and the
inscription identifies Christ as the
entranceway to the sheepfold.

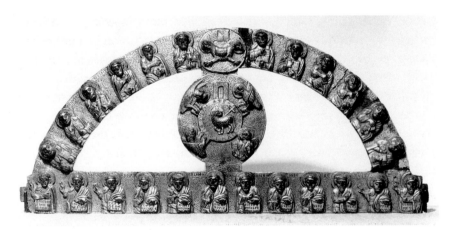

closed, the faithful kiss the bronze gate before the enamel Christ figure; when
the door stands open, they kiss the sacred statuette.

The lunette over the doorway (fig. 210), in contrast, reflects one of the con-
fession's specific functions. Featuring the Lamb of God beneath a gate, sur-
rounded by the four evangelist symbols, the central medallion is inscribed "ego
sum ostium i[n] ovile ovium" (based on John 10.1–18: I am the door of the
sheepfold . . . anyone who comes into the field through me shall be safe).
Directly above are the symbols of the pope's pastoral authority, his miter and
throne adorned with the heads of a lion and griffin (see fig. 1). Around the frame
are half-length portraits of the apostles, separated by alternating inscriptions of
Sanctus Dominus and *Agnus Dei,* and twelve major prophets bearing inscriptions.
The pastoral aspect of the program relates to a particular function of the confes-

sion, namely, the consecration of the archepiscopal pallia. The wool of which the pallia are woven is blessed each year on St. Agnes's Day to the accompaniment of the *Agnus Dei* sung by a priestly choir, and the pallia are distributed by the pope from the confession of St. Peter's with the prayer, "Accept the pallium, taken up from the body of blessed Peter." Innocent III introduced a change in the ceremony, which may explain his commissioning of the bronze decorations; the pallia were actually kept in the confession overnight before being bestowed. Engraved on the lunette's inner surface are the images of twenty-three bishops, without pallia, and a pope (holding the keys) wearing one; these are counterparts to the apostles and prophets on the other side (fig. 211). An inscription around the papal portrait completes the program:

SP[IRITUS] C[ONSILII] ALMUS EGO TEGAS UT TEGENDA TE TEGO.
VIR DICO PASCE GREGES QUIA NULLIS EPULIS EGES.
(I, the nourishing spirit of the council cover you so that you, in turn, can invest those who should be.
I say to you, man, feed your flocks so that you deprive no one of nourishment.)

Like so much of the art in Rome, Innocent's enamel and bronze entranceway to the pallium niche deploys visual imagery to tie multiple biblical references with liturgical functions.

In the Transepts and Crypt

Turning left, the pilgrim moves through the basilica's south transept, stopping to pray at each of the many altars arrayed there—dedicated to SS. Sixtus, Leo, and Hadrian, all sanctified popes buried close to their apostolic progenitor. Passing the first, she follows a number of fellow travelers leaving the church through a door to the left and with them enters a small chapel to the left of the imposing

cylindrical apse; this is the oratory of St. Martin. Elevated behind the chapel's altar, is a magnificent bronze statue of Peter, looking ever so much like the pagan philosophers still to be seen around Rome, with forceful but dignified features and gestures and a seated body that breathes life (fig. 212). In striking contrast to the ancient works are the bright hues that color nearly every surface of the figure and suggest that the St. Peter is newly made.

As the pilgrim returns to the basilica, she pauses to read the epitaph on Pope Hadrian's tomb, elegantly inscribed in black letters on black stone framed with a continuous spiral vine (fig. 213). The beautifully formed letters recall nothing so much as the noble ancient inscriptions around Rome (see fig. 16). In this case, however, it is none other than Charlemagne (768–814) himself who wrote the pope's eulogy; the epitaph must therefore have been made in far-off France. The great emperor in 795 mourns Hadrian's passing with tender sentiments,

POST PATREM LACRIMANS KAROLUS HAEC CARMINA SCRIBSI
TU MIHI DUCIS AMOR, TE MODO PLANGO, PATER . . .
NOMINA IUNGO SIMUL TITULIS CLARISSIME NOSTRA:

213
Saint Peter's, portico, epitaph of Pope
Hadrian I. The verses written in fine
square capitals are generally ascribed to
Alcuin of York (c. 735–804), the father of
the so-called Carolingian Renaissance.
The black marble is from northern
Europe, confirming that it was carved in
Charlemagne's realm and from there sent
to Rome.

Opposite:
214
Saint Peter's, apse, throne of St. Peter.
Made for Charlemagne's grandson,
Charles the Bald (823–77), who is por-
trayed at the top, and perhaps taken by
him to Rome for his imperial coronation
in 875, the ivory throne has long been
considered to be the apostle's own chair
and hence an instrument of papal author-
ity. Today, it is kept inside Bernini's great
cathedra in the apse of the new church.

HADRIANUS KAROLUS, REX EGO TUQUE PATER.
(O father, thee beweeping, I Charles these lines have writ,
For thee, sweet love and father mine, with sorrow bowed.
Illustrious man, our names and titles now I join,
O Hadrian and Charles the king, the pontiff thou). [Trans. J. I. Mombert]

How remarkable it is that the greatest of all Franks would humble himself so before a
pope! How differently have later rulers behaved, including Henry IV of Germany,
Robert Guiscard, and the current pontiff's nemesis, Philip the Fair of France!

Moving on, the pilgrim pauses near the altar of St. Alexis, where for most of
the year the throne of St. Peter is kept (fig. 214). The throne is surely one of the
most curious objects she has seen so far. It is a wood chair that has been cov-
ered with plaques of elaborately carved ivory. The plaques at the base depict the
signs of the zodiac and the labors of Hercules in a dazzling technique of etched
gold inlaid in the creamy white of elephant tusks. The upper surfaces are revetted
with a different type of carving altogether, deep-cut reliefs of men fighting, cos-
mic signs. And at the top is the portrait of a king being venerated by angels.
Seemingly ancient in both its subject matter and style of presentation, accord-
ing to her guides, this is the very chair on which Peter sat to rule the Roman see.
That is why, every February 22, on the Feast of the Cattedra Petri, the throne is
removed from the transept, carried to the main altar, and displayed within a
wreath of candles, a relic symbolizing the pope's—and the Vatican basilica's—
authority. And that is why, earlier this year, Boniface chose the Feast of Peter's
Throne as the day on which to proclaim the Jubilee year from here as well as
from the Lateran.

As the pilgrim continues, she enters the rotundas aligned with the transept,
which she had glimpsed from outside, each fitted with an antechamber. In the
tomb of the Emperor Honorius and his family, the funerary niches have long
since been fitted with altars to saints at which to offer prayers: to Anastasia,
Mary, Petronilla, and Theodore, among others. In the second rotunda, the ora-
tory of Andrew, are shrines honoring Martin, Apollinaris, Thomas, Cassian,
Vitus, Lawrence, and, of course, Peter's brother, Andrew.

Returning to the transept, the pilgrim passes the altar of SS. Processus and
Martianus, the Roman soldiers who were converted at the moment of the apos-
tle's crucifixion (see fig. 40). She then descends into the crypt, which is illumi-
nated with lamps every few feet and warm from the bodies of myriad fellow
worshipers; though crowded with visitors, the passageway is mysterious and
silent. The pilgrim takes her place in line for a turn to touch the tomb with her
brandea. Clutching a cloth strip—which is now imbued with the spirit of Peter—
she exits the crypt by a stairway that takes her up into the right (north) transept,
where she continues her circuit. She kneels first before the altar of the bones of
the apostles, wherein are housed vestiges of both Peter and Paul.

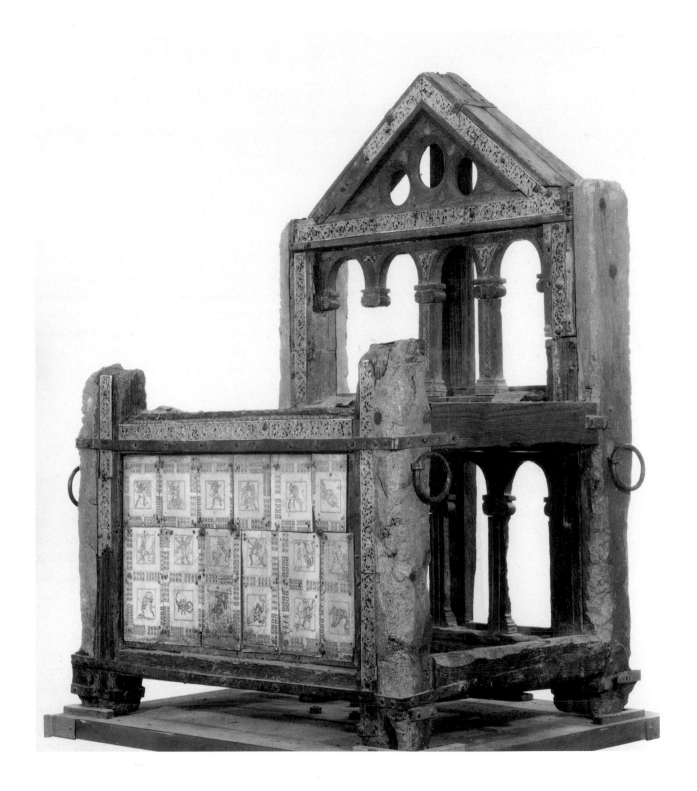

Saint Peter's, north transept. Marten van Heemskerck was standing in the baptistery when he drew this view of the right transept. The two columns with composite capitals supporting an architrave that set off the baptismal area frame the Tigurium built around St. Peter's grave to protect it during construction of the new church.

On the wall above are scenes of the apostles' lives together in Rome and of their martyrdoms (fig. 215), appropriately placed near the relics. These pick up where the cycle on the left wall of the nave leaves off, with the depiction of Christ's departure from earth; unlike the sequence in the main body of the church, however, that in the transept is in mosaic, not fresco, to reinforce, with material preciousness, the sacredness of the location. Some of the subjects come from the Acts of the Apostles and depict how Peter and Paul worked together to continue Christ's mission by converting others to the faith through preaching and miraculous works; others are from legends that recount the apostles' encounter with Nero in the Forum, the contest with Simon Magus, and the executions—all in places the pilgrim has visited within the past few days. Most of the same stories are rendered in the portico, but the mosaic in the transept is much older and more impressive because of its proximity to the relics. The pilgrim then passes between the two columns at the end of the transept to where the baptistery is situated. This is a lower chamber housing an enormous basin. In the nave aisles, she passes still other shrines, to St. James and to Mary Magdalene, to Nicholas, and to Abbondius.

The chapel of the Holy Face. Finally, the pilgrim reaches one of the most important of all of the shrines in St. Peter's, the oratory of the *Veronica*. Here is the repository of an ancient cloth that bears the actual imprint of Christ's face (fig. 216). This relic is set off by a marble parapet at the facade wall in the north aisle, paved with porphyry and marble. An aura of divine power surrounds the *Veronica*. The pilgrim has seen nothing like it since she watched the divinely

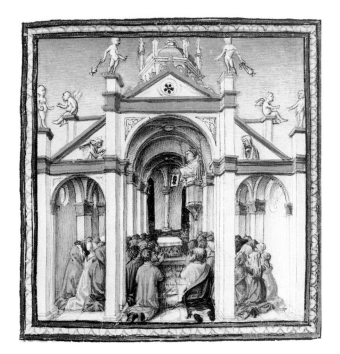

wrought *Acheropita* pass by. Indeed, there is a certain rivalry between the two images of Christ "made without hands." The *Veronica,* however, was not merely painted by St. Luke with the assistance of an angel; it came into being miraculously, through direct contact with the Lord's face. The cloth is like the brandea onto which the pilgrim receives spiritual power; and its image has true archetypal status. Although no one can say just when the miraculous *Veronica* was brought to Rome, one account states not only that it has been here as long as the *Acheropita* but also that it came in the same hands—those of the Emperor Titus, who brought it from the Holy Land to cure his ailing father, Vespasian. Its unique importance derives from the fact that Christ, alive in heaven, left few true relics behind; the impression of his face on the cloth comes as close as anything to a remnant of the Lord made flesh.

A ciborium given by Pope Celestine III (1191–98) safeguards the Holy Face; an altar occupies the lower level, sheltered beneath a roof supported on columns. A bronze grid and doors framed by twisted columns protect the relic itself. In Celestine's day, the precious image of Christ's face was seldom shown; one of the rare visiting dignitaries to view it was King Philip Augustus of France, who was accorded the privilege when he passed through Rome on his return from Jerusalem. But ever since Celestine's successor, Innocent III, instituted the procession to the hospital of the Holy Spirit, it has been displayed to the flocks of the faithful once a year, and it is now the most popular relic in all Rome. During this Jubilee year, moreover, it is shown once every week. All the faithful now kneel at the shrine and recite the prayer *Ave facies praeclara* (Behold the splendid

217

Saint Peter's, inner facade wall. Giacomo Grimaldi recorded the Gothic windows of the recently raised facade, the saints and evangelists between them, and the clipeate portraits of the popes. At the far left is the tomb of Pope John VII, which had become incorporated into the Oratory of the Veronica. Of the other altars and tombs, only the two altars to the right, dedicated respectively to Anthony and Tridentius, were in place in 1300, and the tomb of Boniface VIII at the farthest right of the nave. (BAV, Cod. Barb. Lat. 2733, fols. 120–21.)

face), which may have been written by Pope Innocent IV (1243–54). In itself, recitation of the prayer merits ten days' indulgence.

Behind Celestine's tabernacle in the precinct is the imposing tomb of Pope John VII (705–7), built directly into the facade wall and marked by an enormous porphyry disk in the floor (fig. 217). Although other popes have been interred in St. Peter's basilica, John was the first to institute a true funerary monument here—indeed, a church in miniature. An arch supported on twisted columns frames its doorway, recalling the pergola in the apse; its wall is revetted in beautifully carved marble spolia (fig. 218). Above is an icon, in mosaic, of Mary as Queen, with Pope John beside her. As donor, John is depicted offering a model of the chapel. An inscription asserts that John, the servant of the Mother of God, is the maker:

†IOHANNES INDIGNUS EPISCOPUS FECIT BEATAE DEI GENITRICIS
SERVUS
(John, the unworthy bishop and servant of the blessed Mother of God, made this.)

Framing the Virgin are scenes from the life of Christ (fig. 219), beginning with the Annunciation. Gabriel's greeting to Mary is inscribed here, the charged words through which Christ was conceived: AVE GRATIA PLENA DOMINUS TECUM (Greetings, most favored one, the Lord is with you). Although the Visitation and Nativity follow in the customary fashion, the emphasis in the Nativity is on midwives bathing the Christ Child; these figures, though not

218

Saint Peter's, Oratory of John VII, frames. The decorations of the pope's tomb were adorned with magnificent spolia, now inconspicuously mounted at the exit of the Vatican grottoes.

219

Saint Peter's, Oratory of John VII. The life of Christ is depicted in mosaics framing an enormous icon of Mary as Queen of Heaven. Pope John is portrayed at Mary's right, presenting his oratory. (BAV, Cod. Barb. Lat. 2732, fols. 76–77.)

220

Saint Peter's, Oratory of John VII. The idea of service to God was conveyed in the inscription and in details such as this one in which midwives at the Nativity bathe the newborn Christ. The same theme recurs on the enamel cross reliquary in the Sancta Sanctorum, made a century later for another pope (see fig. 51).

mentioned in the Gospels, occupy the entire right corner (fig. 220). The message is one of humble submission to God: as Pope John is the servant of Mary, so the midwives are servants of the Lord. Next comes the Adoration of the Magi, then the Presentation in the Temple, the Baptism, the Healing of the Blind, the Healing of the Hemorrhaging Woman, Zacchaeus in the Sycamore, the Raising of Lazarus, the Entry into Jerusalem, the Last Supper, the Crucifixion, and the Anastasis. As in the Zeno Chapel in Sta. Prassede, the Anastasis, newly invented in the early eighth century, was deemed appropriate for a tomb because it pictures Christ lifting the blessed from Hades. On the wall that forms the left side of the oratory, a picture cycle is dedicated to Peter. It begins by showing the apostle preaching in Jerusalem, Antioch, and Rome. Here again art serves a political purpose where Scripture falls short. The inclusion of Peter's preaching in Rome is an important bit of papal propaganda, for the Book of Acts has Peter in the first two cities but not in the third. Thus, the picture, not the Word, gives evidence that establishes Peter's presence in Rome. The mosaic then continues with the familiar series of the apostolic martyrdoms, now repeated in the portico and in the right transept. In Peter's memorial church in

Sepulchrum Bonifacÿ VIII. si=
tum ad parietem Altaris sub Cibo=
rio, ut sequens pagina demonstrat

221

Saint Peter's. Tomb of Boniface VIII. The composite funerary monument consisted of an altar containing the remains of Pope Boniface IV (which Boniface had transported to his own sepulcher), Boniface VIII's tomb and effigy, with angels drawing a sculptured curtain, and a mosaic of Boniface praying before Mary and Christ. Torriti's mosaic of the Virgin was recently found in an unlikely place, the basement of the Brooklyn Museum of Art. (BAV, Cod. Barb. Lat. 2733, fol. 7v.)

Rome, it seems, the story of the apostle's sacrifice on the inverted cross cannot be told too often.

A tomb for a pope (who is still very much alive). Returning now to the nave in preparation for leaving St. Peter's, the pilgrim notes more portraits of Peter, of four saints, and of the four evangelists painted on the inside wall of the facade, along with additional rows of papal portraits. More arresting, however, is the newly completed tomb of the reigning pontiff (fig. 221), inset above an altar that contains the remains of his namesake, St. Boniface IV (608–15). Almost from the day of his elevation, the pope who initiated the Jubilee has been making plans for his own sepulcher. Although many of Boniface's enemies have criticized him for so extravagant a monument, it has already been ready for him for three years. It is the combined handiwork of two preeminent masters in Roman church decoration, the sculptor Arnolfo di Cambio and the painter and mosaicist Jacopo Torriti, who has only recently completed work on the apse mosaic of Sta. Maria Maggiore. Boniface's tomb sets up a distinct contrast between the worldly pontiff and his aspiration for eternity. The lower story contains the sarcophagus itself with a recumbent effigy of the pope (fig. 222); the

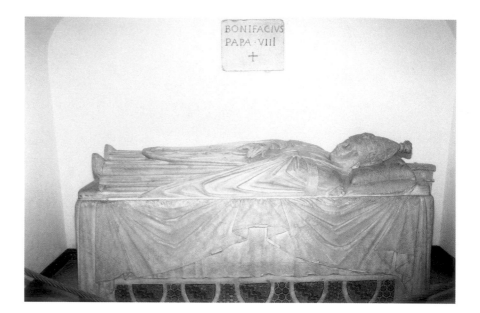

222
Saint Peter's, tomb of Boniface VIII.
Arnolfo di Cambio was able to capture
the power of the pope, even in death.
(Grotte vaticane.)

second register is decorated with a mosaic depicting Peter and Paul standing in a paradisaical landscape planted with palms and to be entered through a gateway adorned with the cross, the true "tree of life." Peter conducts Boniface, who usurps Peter's prerogative by holding the keys in *his* hands, into the presence of the Virgin and Child (appearing through an icon enclosed in a wreath and inscribed with the traditional epithet).

In virtually every respect, Boniface's sepulcher recalls the Gonsalves tomb the pilgrim saw in Sta. Maria Maggiore (see figs. 136–37)—in the juxtaposition of the earthly remains and entrance to heaven and in the use of materials to establish an ascent from this world to the next. Even though the memorial to Boniface is earlier, it is far more audacious in concept and detail. The pope portrayed is sponsored not simply by local saints but by the apostolic protectors of the Christian capital. And he is not pictured on a diminutive scale, which could demean him in the exalted company of the saintly figures; instead, he is presented as their equals and, indeed, in conversation with God. When Boniface conceived his tomb, his predecessor, Pope Celestine, was alive, after all, and Boniface's legitimacy was still in question. (It was surely to establish a papal genealogy that Boniface VIII had his namesake, Boniface IV, canonized and reinterred beneath his own tomb, and had such an unusual memorial made soon after his elevation.)

Leaving St. Peter's at last, the pilgrim finds herself once more in the hot, late summer sunlight of the atrium (fig. 223). Passing the fountain, she stops to buy a second souvenir from one of the vendors there, this one a token adorned with the *Veronica* (fig. 224); she can pray to it every day and perhaps retrace, in

223

Saint Peter's, atrium. A reconstruction of the atrium as viewed from the entrance to St. Peter's. (BH)

224

Token of the Veronica. Like brandea, copies of the Holy Face were believed to participate in the aura of the relic itself.

her mind, her Jubilee year pilgrimage through Rome. Heading toward a small edicule to the right of the portal, a memorial to many saints, she scans the portraits of the blessed and a depiction of the Annunciation to the Virgin.

An enormous mosaic spreads out overhead, a great billboard that obscures the chapel dedicated to Mary above the gatehouse (fig. 225). This is the *Navicella,* a dazzling new work in mosaic by the great Giotto. Based on the biblical account of Christ rescuing Peter from the storm on the sea (Matt. 14.22–33), it is a gift of young Cardinal Stephaneschi, Pope Boniface's nephew, and can only be understood as an allegory of modern times. Tossed by waves and ravaged by winds, the little ship is a metaphor for the Church, buffeted by political conflict. Peter, drawn to shore by the Lord himself, stands for the hope of salvation that Pope Boniface has offered to all the faithful in Rome. As the titulus explains:

QUEM LIQUIDOS PELAGI GRADIENTEM STERNERE FLUCTUS
IMPERITAS, FIDUMQUE REGIS, TREPIDUMQUE LABANTEM
ERIGIS, ET CELEBREM REDDIS VIRTUTIBUS ALMUM
HOC IUBEAS ROGITANTE DEUS CONTINGERE PORTUM
(When you commanded Peter to walk over the watery waves
You bid him to have faith, and you raised him up when he began to sink
You restored his fame and kindness of virtues
Praying to you, God, may we also reach our harbor)

On one level, the picture is quite literal. But the harbor and lighthouse at the far left, with the fisherman in front, evoke Rome and the "fisher of men," Peter, who alone among the apostles hearkened to Christ's call. Boniface VIII's proclama-

225
Saint Peter's, Giotto's *Navicella*. Although two minor fragments (heads of angels from the border) are preserved, Giotto's masterpiece is known only from copies, such as this drawing by Aretino Spinelli. Like so much medieval art, it couched a contemporary message in biblical language. (New York, Metropolitan Museum of Art.)

tion of the Jubilee year echoes that earlier summons, bringing thousands upon thousands of pilgrims to the newly refurbished harbor of faith. They will leave with their souls cleansed of sin and their prospects for eternity brightened by a wave of Pope Boniface's gloved hand.

BIBLIOGRAPHY

ESSENTIAL BOOKS
This book depends heavily on the research and interpretations in the following studies.

Andaloro, Maria, ed. *Fragmenta picta: Affreschi e mosaici staccati del Medioevo romano*. Rome: Àrgos, 1989.

Belting, Hans. *Likeness and Presence: A History of the Image Before the Era of Art*. Translated by Edmund Jephcott. Chicago: University of Chicago Press, 1994. [Originally published as *Bild und Kult: Eine Geschichte des Bildes vor dem Zeitalter der Kunst*. Berlin: C. H. Beck, 1990.]

Blaauw, Sible de. *Cultus et decor: Liturgia e architettura nella Roma tardoantica e medievale: Basilica Salvatoris, Sanctae Mariae, Sancti Petri*. Translated by M. B. Annis. *Studi e testi*, vols. 355–56. Vatican City: Biblioteca Apostolica Vaticana, 1994. [Originally published as *Cultus et decor: Liturgie en architectuur in laatantiek en middeleeuws Rome: Basilica Salvatoris, Sanctae Mariae, Sancti Petri*. Delft: Eburon, 1987.]

Krautheimer, Richard. *Rome: Profile of a City, 312–1308*. Princeton: Princeton University Press, 1980.

Krautheimer, Richard, Spencer Corbett, Wolfgang Frankl, and Alfred K. Frazer. *Corpus Basilicarum Christianarum Romae*. 5 vols. Vatican City: Pontificio Istituto de archeologia cristiana 1937–77.

Waetzoldt, Stephan. *Die Kopien des 17. Jahrhunderts nach Mosaiken und Wandmalereien in Rom*. Vienna: Schroll-Verlag, 1964.

Wolf, Gerhard. *Salus populi Romani: Die Geschichte römischer Kultbilder im Mittelalter*. Weinheim: VCH, 1990.

GENERAL STUDIES
Armellini, Mariano, and Carlo Cecchelli. *Le chiese di Roma dal secolo IV al XIX*. Rome: Ruffolo, 1942.

Belting, Hans. "Papal Artistic Commissions as Definitions of the Medieval Church in Rome." In *Light on the Eternal City,* edited by Helmut Hager and Susan Scott Munshower, 13–20. *Papers in Art History from the Pennsylvania State University,* 2. University Park: Pennsylvania State University Press, 1987.

Birch, Debra J. *Pilgrimage to Rome in the Middle Ages.* Woodbridge, England: Boydell, 1998.

Blaauw, Sible de. "Campanae supra urbem: Sull'uso delle campane nella Roma medievale." *Rivista di storia della chiesa in Italia* 47 (1993): 367–414.

——. "Die Krypta in Stadtrömischen Kirchen: Abbild eines Pilgerziels." In *Akten des XII. Internationalen Kongresses für christliche Archäologie,* 559–67. Münster: Aschendorff, 1995.

Bloch, Herbert. "The New Fascination with Ancient Rome." In *Renaissance and Renewal in the Twelfth Century,* edited by Robert L. Benson and Giles Constable, 615–36. Cambridge: Harvard University Press, 1982.

Brentano, Robert. *Rome Before Avignon: A Social History of Thirteenth-Century Rome.* New York: Basic Books, 1974.

Coarelli, Filippo. *Roma.* Rome: Laterza, 1983.

Claussen, Peter Cornelius. "*Renovatio Romae:* Erneuerungsphasen römischer Architektur im 11. und 12. Jahrhundert." In *Rom im hohen Mittelalter: Studien zu den Romvorstellungen und zur Rompolitik vom 10. bis zum 12. Jahrhundert,* 87–125. Sigmaringen: Thorbecke, 1992.

——. *Magistri doctissimi Romani: Die römischen Marmorkünstler des Mittelalters.* Stuttgart: Steiner, 1987.

Deichmann, Friedrich W. "Frühchristliche Kirchen in antiken Heiligtümer." *Jahrbuch des deutschen archäologischen Institutes* 54 (1939): 105–36.

Duffy, Eamon. *Saints and Sinners: A History of the Popes.* New Haven and London: Yale University Press, 1997.

Fagiolo, Marcello, and Maria Luisa Madonna, eds. *Roma Sancta: La città delle basiliche.* Rome: Gangemi, 1985.

Gardner, Julian. "Inscriptions and Imagination in Late-Mediaeval Italy." In *Epigraphie et iconographie,* 101–10. *Actes du Collogue tenu à Poitiers, 1995.* Poitiers: Centre d'Etudes supérieures de civilisation médiévale, 1996.

——. *The Tomb and the Tiara: Curial Tomb Sculpture in Rome and Avignon in the Latter Middle Ages.* Oxford: Oxford University Press, 1992.

Glass, Dorothy. "Papal Patronage in the Early Twelfth Century: Notes on the Iconography of Cosmatesque Pavements." *Journal of the Warburg and Courtauld Institutes* 32 (1969): 386–90.

Gregorovius, Ferdinand. *History of the City of Rome in the Middle Ages.* Translated by Anne Hamilton. London: J. Bell, 1900–1906.

Herklotz, Ingo. *"Sepulcra" e "Monumenta" del Medioevo: Studi sull'arte sepolcrale in Italia.* Rome: Rari Nantes, 1985.

Huelsen, Christian. *Le chiese di Roma nel Medio Evo.* Florence: Olschki, 1927.

Ihm, Christa. *Die Programme der christlichen Apsismalerei: 4.-8. Jahrhundert.* 2d ed. Stuttgart: Steiner, 1992.

Kinney, Dale. "Rape or Restitution of the Past? Interpreting *Spolia.*" In *The Art of Interpreting,* edited by Susan C. Scott, 53–67. *Papers in Art History from the Pennsylvania State University,* 9. University Park: Pennsylvania State University Press, 1995.

Kitzinger, Ernst. "The Arts as Aspects of a Renaissance Rome and Italy." In *Renaissance and Renewal in the Twelfth Century,* edited by Robert L. Benson and Giles Constable, 637–70. Cambridge: Harvard University Press, 1982.

Lachenal, Lucilla de. *Spolia: Uso e reimpiego dell'antico dal III al XIV secolo.* Milan: Longanesi, 1995.

Ladner, Gerhart B. *I ritratti dei papi nell'antichità e nel Medioevo.* 3 vols. Vatican City: Pontificio Istituto di archeologia cristiana, 1941–84.

Lavin, Marilyn Aronberg. *The Place of Narrative: Mural Decoration in Italian Churches, 431–1600.* Chicago: University of Chicago Press, 1990.

Maddalo, Silvia. *In Figura Romae: Immagini di Roma nel libro medioevale.* Rome: Viella, 1990.

Marrocchi, Mario. *I Giubilei.* Ciniselli Balsamo: San Paolo, 1997.

Matthiae, Guglielmo. *Mosaici medioevali delle chiese di Roma.* Rome: Istituto poligrafico dello stato, 1967.

———. *Pittura politica del Medioevo romano.* Rome: Artistica editrice, 1964.

———. *Pittura romana del Medioevo.* Rev. ed. 2 vols. Rome: Fratelli Palombi, 1987–88.

Nilgen, Ursula. "Texte et image dans les absides des XIe–XIIe siècles." In *Epigraphie et iconographie,* 153–64. *Actes du Colloque tenu à Poitiers, 1995.* Poitiers: Centre d'Etudes supérieures de civilisation médiévale, 1996.

Noehles, Karl. "Die Kunst der Cosmaten und die Idee der Renovatio Romae." In *Festschrift Werner Hager,* 17–37. Recklinghausen: Bongers, 1966.

Oakeshott, Walter. *The Mosaics of Rome from the Third to the Fourteenth Century.* Greenwich, Conn.: New York Graphic Society, 1967.

Pace, Valentino, and Martina Bagnoli, eds. *Il Gotico europeo in Italia.* Naples: Electa, 1994.

Panvinio, Onofrio. *Le sette chiese principali di Roma.* Translated by Marco Antonio Lanfranchi. Rome, 1570.

Parlato, Enrico, and Serena Romano. *Roma e il Lazio.* Milan: Jaca, 1992.

Paravicini Bagliani, Agostino. *Le chiavi e la tiara.* Rome: Viella, 1998.

Poeschke, Hans Joachim. "Der römische Kirchenbau des 12. Jahrhunderts und das Datum der Fresken von Castel S. Elia." *Römische Jahrbuch für Kunstgeschichte* 23–24 (1988): 1–28.

Romanini, Angiola Maria. *Arnolfo di Cambio.* Florence: Sansoni, 1980.

Romanini, Angiola Maria, ed. *Roma Anno 1300.* Rome: L'Erma di Bretschneider, 1983.

———. *Roma nel Duecento: L'arte nella città dei papi da Innocenzo III a Bonifacio VIII.* Turin: Seat, 1991.

Romano, Serena. *Eclissi di Roma: Pittura murale a Roma e nel Lazio da Bonifacio VIII a Martino V (1295–1431).* Rome: Àrgos, 1992.

Schimmelpfennig, Bernhard. *The Papacy.* Translated by James Sievert. New York: Columbia University, 1992. [Originally published as *Das Papsttum: Von der Antike bis zur Renaissance.* Darmstadt: Wissenschaftliche Buchgesellschaft, 1982.]

———. *Die Zeremonienbücher der römischen Kurie im Mittelalter.* Tübingen: Niemeyer, 1973.

Schudt, Ludwig. *Le guide di Roma: Materialien zu einer Geschichte der römischen Topographie.* Vienna: Filser, 1930.

Stopani, Renato. *Le vie del Giubileo.* Rome: Erre emme edizioni, 1996.

Strinati, Carlo, et al., eds. *La storia dei Giubilei.* Prato: BNL edizioni, 1997.

Toubert, Hélène. *Un art dirigé: Réforme grégorienne et iconographie.* Paris: Editions du Cerf, 1990.

Tronzo, William. "I grandi cicli pittorici romani e la loro influenza." In *La pittura in Italia: L'Altomedioevo,* 355–68. Milan: Electa, 1994.

Wollesen, Jens T. *Pictures and Reality: Monumental Frescoes and Mosaics in Rome Around 1300.* New York: Peter Lang, 1998.

Wilpert, Josef. *Die römischen Mosaiken und Malereien der kirchlichen Bauten vom IV. bis XIII. Jahrhundert.* Freiburg: Herder, 1916.

Zchomelidse, Nino Maria. "Der Osterleuchter im Dom von Capua: Kirchenmobiliar und Liturgie im lokalen Kontext." *Mededelingen van het Nederlands Instituut te Rome. Historical Studies,* 55 (1996): 18–43.

INTRODUCTION

L'Arte degli Anni Santi: Roma, 1300–1875. Milan: Mondadori, 1984.

Capgrave, John. *Ye Solace of Pilgrimes: Una guida di Roma per i pellegrini del Quattrocento,* edited by Daniela Giosue. Rome: Roma nel Rinascimento, 1995.

Coleman, Simon, and John Elsner. *Pilgrimage: Past and Present in the World Religions*. Cambridge: Harvard University Press, 1995.

d'Onofrio, Cesare. *Visitiamo Roma mille anni fa*. Rome: Romana Società Editrice, 1988.

Nichols, Francis Morgan, ed. and trans. *The Marvels of Rome: Mirabilia Urbis Romae*. 2d ed. New York: Italica Press, 1986.

Nardella, Cristina. *Il fascino di Roma nel Medioevo*. Rome: Viella, 1997.

Paravicini Bagliani, Agostino. *Il corpo del Papa*. Turin: Einaudi, 1994.

———. *Il trono di Pietro*. Rome: La nuova Italia scientifica, 1996.

LATERAN

Belting, Hans. "Die beiden Palastaulen Leos III. im Lateran und die Entstehung einer päpstlichen Programmkunst." *Frühmittelalterliche Studien* 12 (1978): 55–83.

Blaauw, Sible de. "Jerusalem in Rome and the Cult of the Cross." In *Pratum Romanum: Richard Krautheimer zum 100. Gerburtstag,* ed. Renate L. Colella et al., 55–73. Wiesbaden: Ludwig Reichert, 1997.

———. "The Solitary Celebration of the Supreme Pontiff: The Lateran Basilica as the New Temple in the Medieval Liturgy of Maundy Thursday." In *Omnes Circumadstantes: Contributions Toward a History of the Role of People in the Liturgy: Presented to Herman Wegman,* 120–43. Kampen: J. H. Kok, 1990.

Gramaccini, Norberto. "Die Umwertung der Antike-Zur Rezeption des Marc Aurel in Mittelalter und Renaissance." In *Natur und Antike in der Renaissance,* 51–83. Frankfurt: Liebieghaus, 1985.

Herklotz, Ingo. "Der Campus Lateranensis im Mittelalter." *Römisches Jahrbuch für Kunstgeschichte* 22 (1984): 13–43.

———. "Francesco Barberini, Nicolo Alemanni, and the Lateran Triclinium of Leo III: An Episode in Restoration and Seicento Medieval Studies."*Memoirs of the American Academy in Rome* 40 (1995): 175–93.

Koenen, Ulrike. *Das "Konstantinskreuz" im Lateran und die Rezeption frühchristlicher Genesiszyklen im 12. und 13. Jahrhundert*. Worms: Wernersche Verlagsgesellschaft, 1995.

Lauer, Philippe. *Le Palais de Latran: Etude historique et archéologique*. Paris: E. Leroux, 1911.

Maddalo, Silvia. "Bonifacio VIII e Jacopo Stefaneschi: Ipotesi di lettura dell'affresco della loggia Lateranense." *Studi romani* 31 (1983): 129–50.

Mitchell, Charles. "The Lateran Fresco of Boniface VIII." *Journal of the Warburg and Courtauld Institutes* 14 (1951): 1–6.

Pietrangeli, Carlo, ed. *Il Palazzo Apostolico Lateranense*. Florence: Nardini, 1991.

———. *San Giovanni in Laterano*. Florence: Nardini, 1990.

Radke, Gary. *Viterbo: Profile of a Thirteenth-Century Papal Palace*. Cambridge: Cambridge University Press, 1996.

Rohault de Fleury, Georges. *Le Latran au Moyen Age*. Paris: A. Morel, 1877.

Varagnoli, Claudio. *S. Croce in Gerusalemme: La basilica restaurata e l'architettura del Settecento romano*. Pescara: Bonsignori, 1995.

Wolf, Gerhard. "Sistitur in solio: Römische Kultbilder um 1000." In *Bernward von Hildesheim und das Zeitalter der Ottonen,* 1:81–90. 2 vols. Hildesheim: Bernward Verlag, 1993.

SANCTA SANCTORUM

Cormack, Robin. "Painting After Iconoclasm." In *Iconoclasm: Papers Given at the Ninth Spring Symposium of Byzantine Studies, University of Birmingham, March 1975,* edited by Anthony Bryer and Judith Herrin, 147–63. Birmingham: Centre for Byzantine Studies, University of Birmingham, 1977.

Grisar, Hartmann. *Die römische Kapelle Sancta Sanctorum und ihr Schatz.* Freiburg: Herder, 1908.

Herklotz, Ingo. "Die Fresken von Sancta Sanctorum nach der Restaurierung Überlegungen zum Ursprung der Trecentomalerei." *Pratum Romanum: Richard Krautheimer zum 100. Geburtstag,* edited by Renate L. Colella et al., 149–80. Wiesbaden: Ludwig Reichert, 1997.

Sancta Sanctorum. Milan: Electa, 1995.

Thunø, Erik. "Image and Relic Under Paschal I (817–24): Translatio et renovatio." Ph.D. diss., Johns Hopkins University, 1999.

Weitzmann, Kurt. "*Loca Sancta* and the Representational Arts of Palestine." In *Studies in the Arts at Sinai,* 19–62. Princeton: Princeton University Press, 1982.

Wollesen, Jens. "Die Fresken in Sancta Sanctorum. Studien zur römischen Malerei zur Zeit Papst Nikolaus' III (1277–1280)." *Römisches Jahrbuch für Kunstgeschichte* 19 (1981): 37–83.

——. "Eine 'vor-cavallineske' Mosaikdekoration in Sancta Sanctorum." *Römisches Jahrbuch für Kunstgeschichte* 18 (1979): 11–34.

PROCESSION I

Bauer, Franz Alto. *Stadt, Platz und Denkmal in der Spätantike.* Mainz: P. von Zabern, 1996.

Bonne, Jean-Claude. "De l'ornement à l'ornementalité: La mosaïque absidiale de San Clemente de Rome." In *Le Rôle de l'ornament dans la peinture murale du Moyen Age.* Poitiers: Centre d' Etudes supérieures de civilisation médiévale, 1997.

Boyle, Leonard. "An Ambry of 1299 at San Clemente." In *San Clemente Miscellany,* 2:36–59. Rome: San Clemente, 1978.

Guidobaldi, Federico. *San Clemente: Gli edifici romani, la basilica paleocristiana e le fasi altomedievali. San Clemente Miscellany,* 4. Rome: San Clemente, 1992.

Lloyd, Joan Barclay. *The Medieval Church and Canonry of S. Clemente in Rome. San Clemente Miscellany,* 3. Rome: San Clemente, 1989.

Lumbroso, Matizia, and Antonio Martini. *Le confraternite romane nelle loro chiese.* Rome: Fondazione Marco Besso, 1963.

Romano, Serena. "La facciata medievale del Palazzo Senatorio: I documenti, i dati, e nuove ipotesi di lavoro." In *La facciata del Palazzo Senatorio in Campidoglio,* 39–61. Rome: Pacini, 1995.

Telesko, Werner. "Ein Kreuzreliquiar in der Apsis?" *Römische Historische Mitteilungen* 36 (1994): 53–79.

Tiberia, Vitaliano. *Il mosaico restaurato: L'arco della basilica dei Santi Cosma e Damiano.* Rome: Gangemi, 1998.

——. *Il restauro del mosaico della basilica dei Santi Cosma e Damiano a Roma.* Todi: Ediart, 1991.

PROCESSION II

Baldracco, G. "La cripta del sec. IX nella chiesa di Santa Prassede a Roma." *Rivista di archeologia cristiana* 18 (1941): 277–99.

Brenk, Beat. "Zum Bildprogramm der Zenokapelle in Rom." *Archivo español de arqueologia,* 45–47 (1973–74): 213–21.

Dattoli, Michele. *L'aula del Senato Romano e la chiesa di S. Adriano*. Rome: Maglione and Strini, 1921.

Klass, Margo Pautler. "The Chapel of S. Zeno in S. Prassede." Ph.D. diss., Bryn Mawr College, 1972.

Mackie, Gillian. "The Zeno Chapel: A Prayer for Salvation." *Papers of the British School at Rome* 57 (1989): 172–99.

Mauck, Marchita B. "The Mosaic of the Triumphal Arch of S. Prassede: A Liturgical Interpretation." *Speculum* 62 (1987): 813–28.

Nilgen, Ursula. "Die grosse Reliquieninschrift von Santa Prassede: Eine quellenkritische Untersuchung zur Zeno-Kapelle." *Römische Quartalschrift für christliche Altertumskunde und Kirchengeschichte* 69 (1974): 7–29.

Pace, Valentino. "Cristo-Luce a Santa Prassede." In *Per Assiduum Studium Scientiae Adipisci Margaritam: Festgabe für Ursula Nilgen zum 65. Geburtstag,* edited by Annelies Amberger et al., 185–200. St. Ottilien: EOS, 1997.

Wisskirchen, Rotraut. *Die Mosaiken der Kirche Santa Prassede in Rom*. Mainz: von Zabern, 1992.

——. *Das Mosaikprogramm von S. Prassede in Rom*. Jahrbuch für Antike und Christentum, Ergänzungsband 17. Münster: Aschendorff, 1990.

SANTA MARIA MAGGIORE

Angelis, Paolo de. *Basilicae S. Mariae Maioris de Urbe . . . descriptio et delineatio*. Rome, 1621.

Deckers, Johannes G. *Der alttestamentliche Zyklus von S. Maria Maggiore in Rom*. Bonn: Habelt Verlag, 1976.

Eggenberger, Christoph. "Zur Marienkrönung des Franziskaner-Papstes Nikolaus IV. in Santa Maria Maggiore zu Rome." In *Das Denkmal und die Zeit: Alfred A. Schmid zum 70. Geburtstag,* 270–82. Lucerne: Faksimile Verlag Luzern, 1990.

Gardner, Julian. "The Capocci Tabernacle in S. Maria Maggiore." *Papers of the British School at Rome* 38 (1970): 220–30.

——. "Pope Nicholas IV and the Decoration of Santa Maria Maggiore." *Zeitschrift für Kunstgeschichte* 36 (1973): 1–50.

Henkels, H. "Remarks on the Late Thirteenth-Century Apse Decoration in Santa Maria Maggiore." *Simiolus* 4 (1971): 128–49.

Kahsnitz, Rainer. "Koimesis-Dormitio-Assumptio: Byzantinisches und Antikes in den Miniaturen der Liuthargruppe." *Florilegium in Honorem Carl Nordenfalk Octogenarii Contextum,* 91–112. Stockholm: Nationalmuseum, 1987.

Kemp, Wolfgang. *Christliche Kunst: Ihre Anfänge, ihre Strukturen*. Munich: Schirmer-Mosel, 1994.

Menna, Maria. "Niccolò IV, i mosaici absidiali di S. Maria Maggiore e l'Oriente." *Rivista dell'istituto nazionale d'archeologia e la storia dell'arte,* 3d ser., 10 (1987): 201–24.

Messerer, Wilhelm. "Zur Reconstruktion von Arnolfo di Cambios Praesepe-Gruppe." *Römisches Jahrbuch für Kunstgeschichte* 15 (1975): 25–35.

Morgan, Nigel. "L'opus Anglicanum nel tesoro pontificio." In *Il Gotico europeo in Italia,* edited by Valentino Pace and Martina Bagnoli, 299–309. Naples: Electa, 1994.

Pomarici, Francesco. "Il Presepe di Arnolfo di Cambio: nuova proposta di ricostruzione." *Arte medievale,* 2d ser., 2 (1988): 155–75.

Thunø, Erik. "The Dating of the Facade Mosaics of S. Maria Maggiore in Rome." *Analecta Romana,* 23 (1996): 61–82.

Tomei, Alessandro. "Dal documento al monumento: Le lettere di Niccolò IV per Santa Maria Maggiore." *Studi medievali e moderni* 1 (1997): 73–92.

———. *Iacobus Torriti Pictor*. Rome: Àrgos, 1990.

Tronzo, William. "Apse Decoration, the Liturgy and the Perception of Art in Medieval Rome: S. Maria in Trastevere and S. Maria Maggiore." In *Italian Church Decoration of the Middle Ages and Early Renaissance,* edited by William Tronzo, 167–93. Bologna: Nuova Alfa, 1989.

SAINT PAUL'S OUTSIDE THE WALLS AND SAINT PETER'S

Alfaranus, Tiberius. *De Basilicae Vaticanae antiquissima et nova structura,* edited by Michelle Cerrati. *Studi e testi,* 26. Vatican City: Biblioteca Apostolica, 1914.

Andaloro, Maria. "Ancora una volta sull'Ytalia di Cimabue." *Arte medievale* 2 (1984): 143–77.

———. "I mosaici dell'Oratorio di Giovanni VII." In *Fragmenta picta: Affreschi e mosaici staccati del Medioevo romano,* 169–77. Rome: Àrgos, 1989.

Andrieu, M. "La chapelle de saint Grégoire dans l'ancienne basilique vaticane." *Rivista di archeologia cristiana* 13 (1936): 61–99.

Arbeiter, Achim. *Alt-St.Peter in Geschichte und Wissenschaft.* Berlin: Gebr. Mann, 1988.

Bassan, Enrico. "Il candelabro di S. Paolo fuori le mura: Note sulla scultura a Roma tra XII e XIII secolo." *Storia dell'arte* 44 (1982): 117–31.

Belting, Hans. "Das Fassadenmosaik des Atriums von Alt St. Peter in Rom." *Wallraf-Richartz Jahrbuch* 23 (1961): 37–54.

Bruyne, Luciano de. *L'antica serie di ritratti papali della basilica di S. Paolo fuori le mura.* Vatican City: Pontificio Istituto di archeologia cristiana, 1934.

Campos, Deoclecio Redig de. *I palazzi Vaticani.* Bologna: Cappelli, 1967.

Carpiceci, Alberto. "La basilica Vaticana vista da Martin van Heemskerck." *Bollettino d'arte* 44 (1987): 67–128.

Carpiceci, Alberto, and Richard Krautheimer. "Nuovi dati sull'Antica Basilica di San Pietro in Vaticano." *Bolletino d'arte* 93–94 (1995): 1–70; 95 (1996): 1–84.

D'Achille, Anna Maria. "La tomba di Bonifacio VIII e le immagini scolpite del papa." In *La Storia dei Giubilei,* ed. Carlo Strinati et al., 224–37. Prato: BNL, 1997.

Deshman, Robert. "Servants of the Mother of God in Byzantine and Medieval Art." *Word and Image* 5 (1989): 33–70.

Eleen, Luba. "The Frescoes from the Life of St. Paul in San Paolo fuori le mura in Rome: Early Christian or Medieval?" *RACAR (Revue d'art canadienne/Canadian Art Review)* 12 (1985): 251–59.

Gandolfo, Francesco. "Il ritratto di Gregorio IX dal mosaico di facciata di San Pietro in Vaticano." In *Fragmenta picta: Affreschi e mosaici staccati del Medioevo romano,* edited by Maria Andaloro, 131–34. Rome: Àrgos, 1989.

Garber, Joseph. *Wirkungen der frühchristlichen Gemäldezyklen der alten Peters- und Pauls-Basiliken in Rom.* Berlin: Bard, 1918.

Gardner, Julian. "S. Paolo fuori le mura, Nicholas III and Pietro Cavallini." *Zeitschrift für Kunstgeschichte* 34 (1971): 240–48.

Gauthier, Marie-Madeleine. "La clôture émaillée de la confession de Saint Pierre au Vatican, lors du Concile de Latran, IV, 1215." In *Synthronon,* 237–46. Paris: Klincksieck, 1968.

Grisar, Hartmann. "Il prospetto dell'antica basilica vaticana." *Analecta romana* 1 (1899): 463–506.

Hetherington, Paul. *Pietro Cavallini: A Study in the Art of Late Medieval Rome.* London: Sagittarius, 1979.

Hueck, Irene. "Der Maler der Apostelszenen im Atrium von Alt-St. Peter." *Mitteilungen des Kunsthistorischen Institutes in Florenz* 14 (1969): 115–49.

Iacobini, Antonio. "L'albero della vita nell'immaginario medievale: Bisanzio e l'Occidente."

PHOTO CREDITS

Unless otherwise listed below, the photographs were provided by the museums or libraries that own the works and granted permission.